This book is dedicated to my children, Jack & Katie

Every shoot brings a different experience for a photographer and his or her subject. Sometimes the experience can be the best of everything—laced with humor, sometimes flirtatious, abounding in empathy. And then occasionally there are shoots where there is zero connection between the sitter and photographer, and the work can be challenging, to say the least. Always, the relationship I have with my subject colors the results. The shoot shows the interaction we had on that given day, at that particular moment.

For this book I wanted to find subjects that inspired me as an artist. I did not choose these subjects based on fame, gender, age or beauty. Each sitting was specifically created for this project, and many times I had never photographed the person previously, although in each instance I knew them on a personal level before their session. All of these people are, in one way or another, role models for me. I believe that all of them have a unique message or life lesson to impart, and as such taking photographs of them became a personal mission as well as an artistic one.

I view this book as something vaguely autobiographical. In each case the window these subjects have offered into their lives has given deeper insight into my own. I also decided that I would try something completely new; for the first time in my career I would interview my subjects after I

had photographed them. I have been on numerous shoots over the years where I have photographed someone and a professional journalist has subsequently conducted an interview. Now I, as a complete amateur, was going to ask the questions. I was not expecting I would have any great gift for this and the results took me by surprise. I found that despite my lack of experience, all of my subjects bared their souls and told their stories. They opened up about their pasts, told their inner dreams and deeply personal philosophies on life. I found myself having some deeply spiritual and profound conversations.

This led me to wonder what happens when a person spends a day as my photographic subject? The thought took hold in my mind that in some way the ritual and the vulnerability of having one's portrait created forges a trust between photographer and subject. In all of these cases, the shoot created a bond, which then allowed for the interviews to be so meaningful. It is as if a door had been opened during the photography sessions, and through this the words in the interviews just flowed.

I would like to thank everyone who has given their time to this project. In one way or another you are all my heroes and heroines. I hold you all as shining examples of how to live a life that is "from the heart."

Chris Craymer

"…what happens when a person spends a day with me as my photographic subject? The thought took hold in my mind that in some way the ritual and the vulnerability of having one's portrait created forges a trust between photographer and subject. In all of these cases, the shoot created a bond …"

Niki Taylor

Photographing Niki Taylor could be considered a daunting experience. In doing so I am putting my work up against previous covers of *Vogue, Elle, Allure, Marie Claire, Shape,* and *Self* (when Niki was twenty-one she was on all of those magazines in the same month - titled "The Niki Six") not to mention campaigns for Cover Girl, Liz Claiborne, Gap, and L'Oréal. Niki is often thought of as the quintessential all-American girl—sweet, confident, open and energetic—but I am intrigued by her as a woman whose life has been full of huge career accomplishments and extreme personal challenges. She has navigated marriage and motherhood at a young age; the death of her beloved younger sister; a divorce and car crash that almost killed her; the reality of addiction and getting clean. I believe that some people are born with it all together, and nothing much ever changes that, while others encounter tremendous setbacks and never get righted. But I'm most moved by people who face huge struggles and persevere, through force of personality and will and strength.

Success as a model came early for Niki, at the tender age of thirteen. She grew up in Florida, with a mother who was in the business: "My mother was a model/photographer and loved taking pictures, and I remember I was going to Mexico and she shot some pictures of me, and I was like, 'I think this is what I want to do.' I used to take my allowance and buy fashion magazines and practice poses. I remember I said I want to be one of these girls." Niki's mother took her to a number of agencies in Fort Lauderdale, all of which turned Niki down. But on a second visit, after just getting her braces off, one of them signed her, and before long she was modeling in New York and Paris. Niki did her first cover for *Seventeen,* at the age of fourteen. Although she found it surreal to be sitting next to Helena Christensen and Christy Turlington one day, and back in high school geometry class the next, Niki stayed grounded because she "always went home. I never moved to New York. I never moved to L.A. I was a tomboy and always went home to go to school, play sports and be normal. Family kept me rooted to who I really was."

Life started to change as Niki married at eighteen and became a mother at nineteen to twin boys; after a difficult delivery she was sent home with "a big old bottle of Percocet. That changed my life for several years," she tells me, "because I was like, 'Wow! Oh my gosh, I can do everything on this." Simultaneously her marriage was unraveling, and in the midst of this one of the worst moments in her life was about to occur. When she was twenty and her babies were six months old, Niki found her younger sister Krissy, who was seventeen at the time, collapsed on the floor one evening. It turned out that Krissy had died from an irregular heartbeat, a condition called ARVD, which could have easily been diagnosed and treated, except that no doctor had discovered it. I am wary of asking Niki to recall this traumatic time, but she talks about it openly and with love for her sister, even while the pain is clearly still with her. "My little sister, she was my best friend. We did everything together. She was starting a career in modeling. Beautiful, six foot, an amazing figure, she was doing really well."

In the wake of Krissy's death Niki says, "I've done every single emotion." But mostly at the time she "wanted to be numb," turning again to the prescription pills. "When you rely heavily on a substance to get you through you are left addicted to them and reliant on them, which I was." >

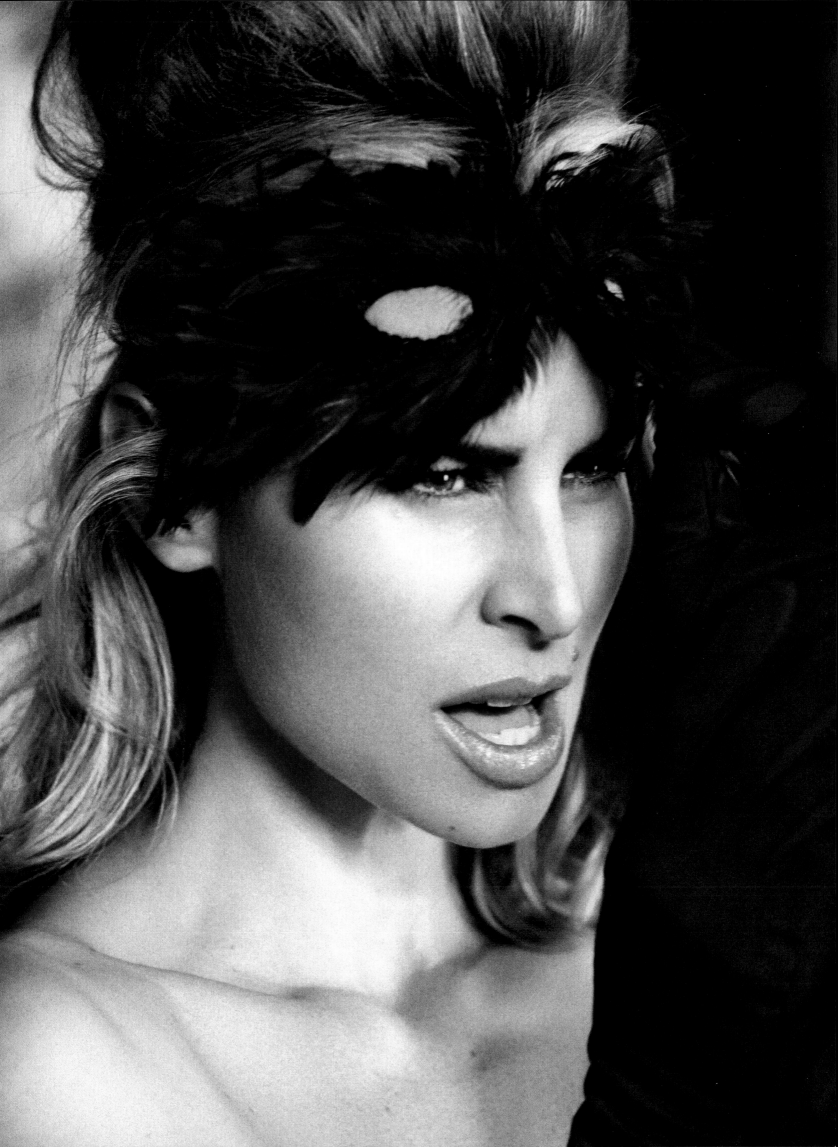

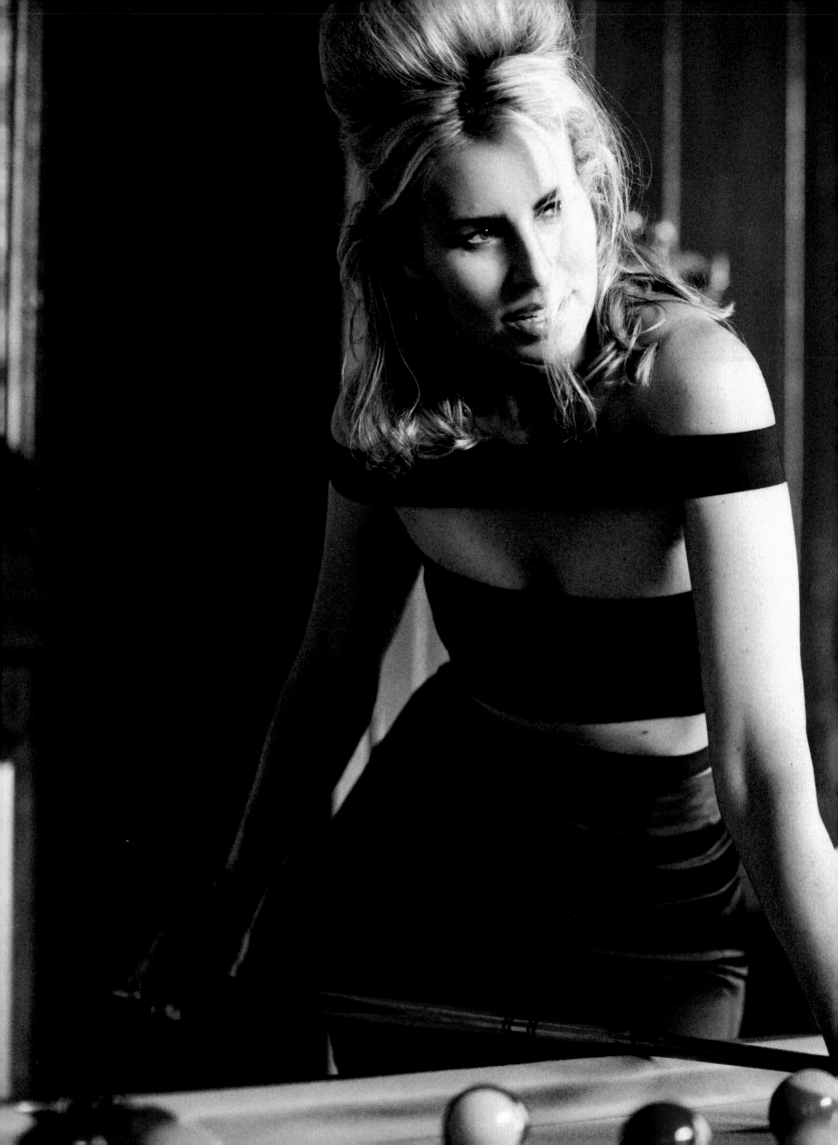

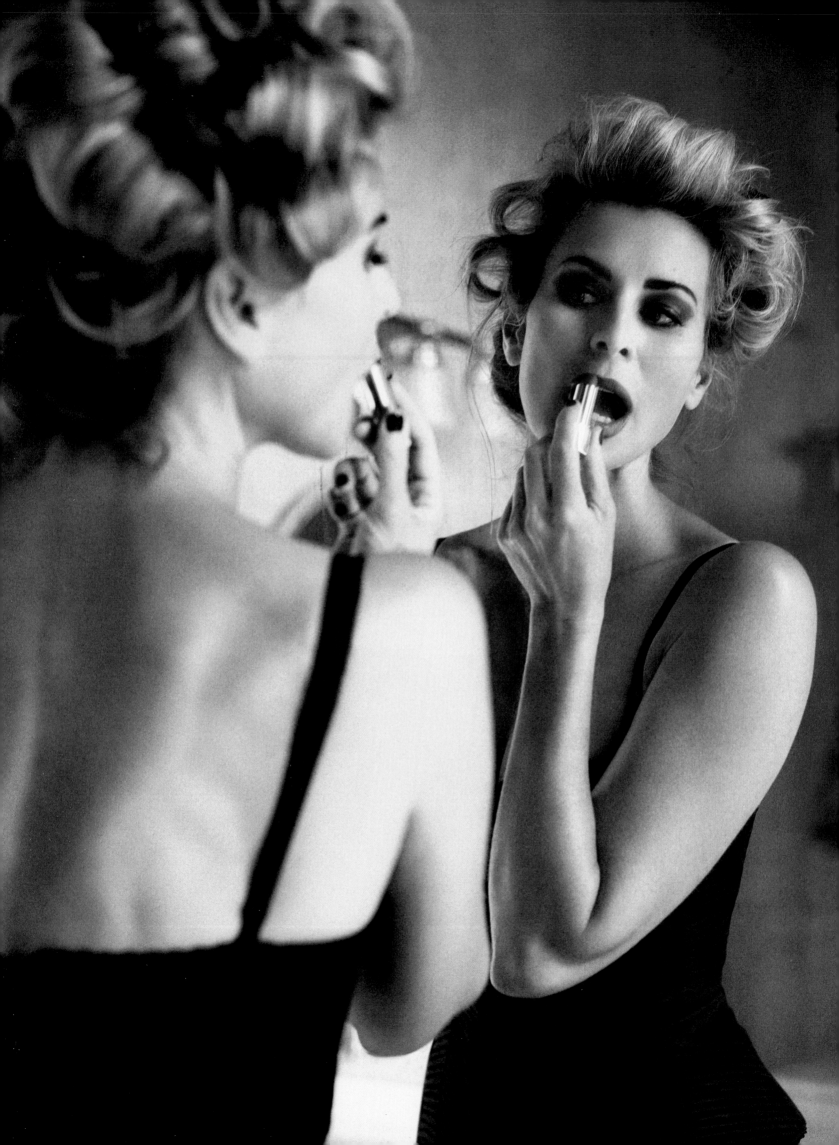

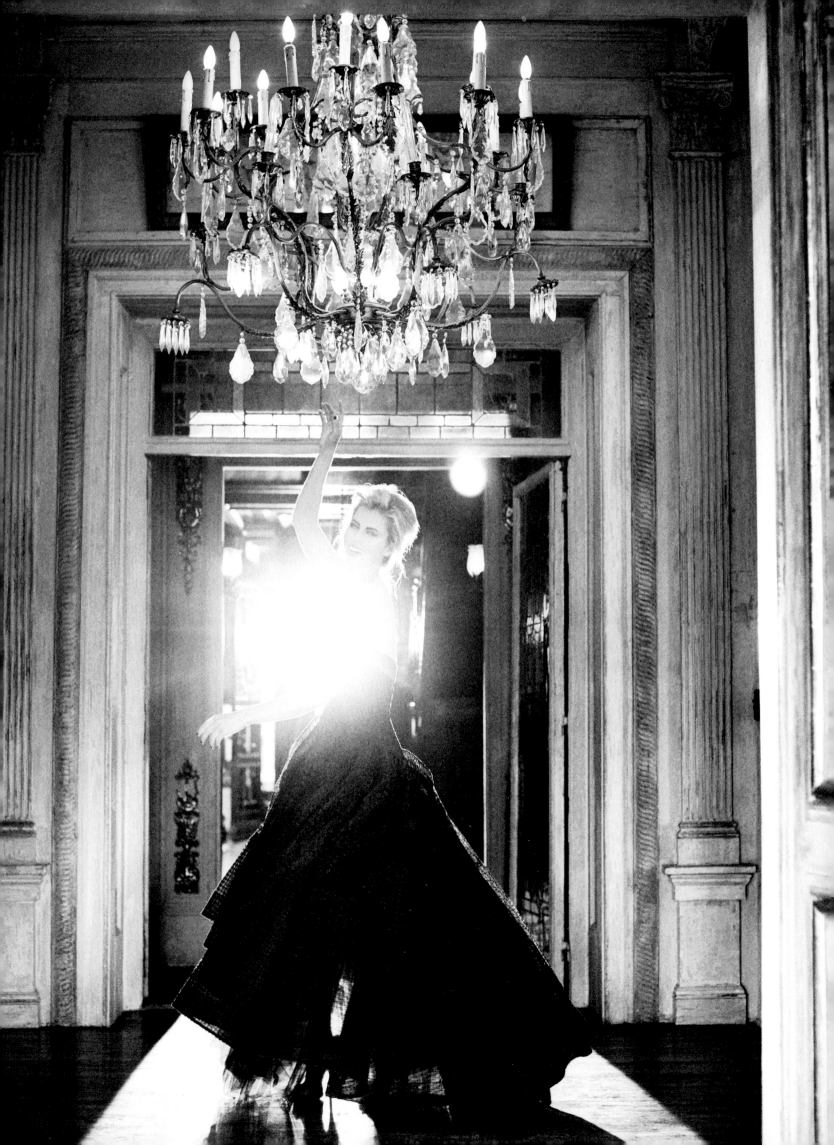

"Nothing's by accident. I believe that people come into your life at a certain time and a certain point to teach you something."

Just when it seemed like she was getting back to normal again—Niki says she was "trying to get healthy and just be Mom"—her car accident occurred in 2001. A friend was driving her home from a club on a rainy night when "he hit a utility pole going maybe twenty-three miles an hour. Not going fast at all, and I thought I was fine until I got out of the car and had terrible pain in my stomach and was taken to the hospital. Doctors determined the seat belt had torn my liver in half and I was bleeding internally." She had a grade five laceration of the liver, and was operated on three times in the first twenty-four hours. "I did die on the operating table twice," she says. She would have over fifty surgeries in the next three years, including one that implanted steel rods in her back. Again she was given multiple pills to manage her pain in the recovery process, and again she had a horrible time getting off them. "It was because really prescription pain medicine is synthetic heroin, and so it was like going through a heroin detox. Being one hundred-seventy pounds, I lost fifty pounds."

Niki is forty now, and I am continually inspired by how she has rebuilt her life. She has a great marriage to a man "whose strengths are my weaknesses for sure, and vice versa." She meditates, takes care of her body and is sober—"I don't do or take anything," she says, mentioning coffee as her only weakness.

Niki describes the new freedom she has found: "For me I just got to a place where it was like I stopped concentrating only on what people thought. Life is not about just me anymore. I lost my CoverGirl contract after ten years," she says bluntly, "I was getting ready to have my own line with Liz Claiborne, and they were going to put it in Target, and I lost twenty million dollars just like that. I've learned a lot over the years, like how it is important to laugh a lot and have a great support system around you. But now life is about my kids and family. Being able to raise them the best that I can, loving on them, loving on other people. Being present is my motto." It seems fitting that a woman who has endured so much would look for a greater truth in life, and I can't imagine a more profound one than the words she leaves me with. "Nothing's by accident. I believe that people come into your life at a certain time and a certain point to teach you something. Everything is for us to better each other, I think. There's a lot to say about love." ♥

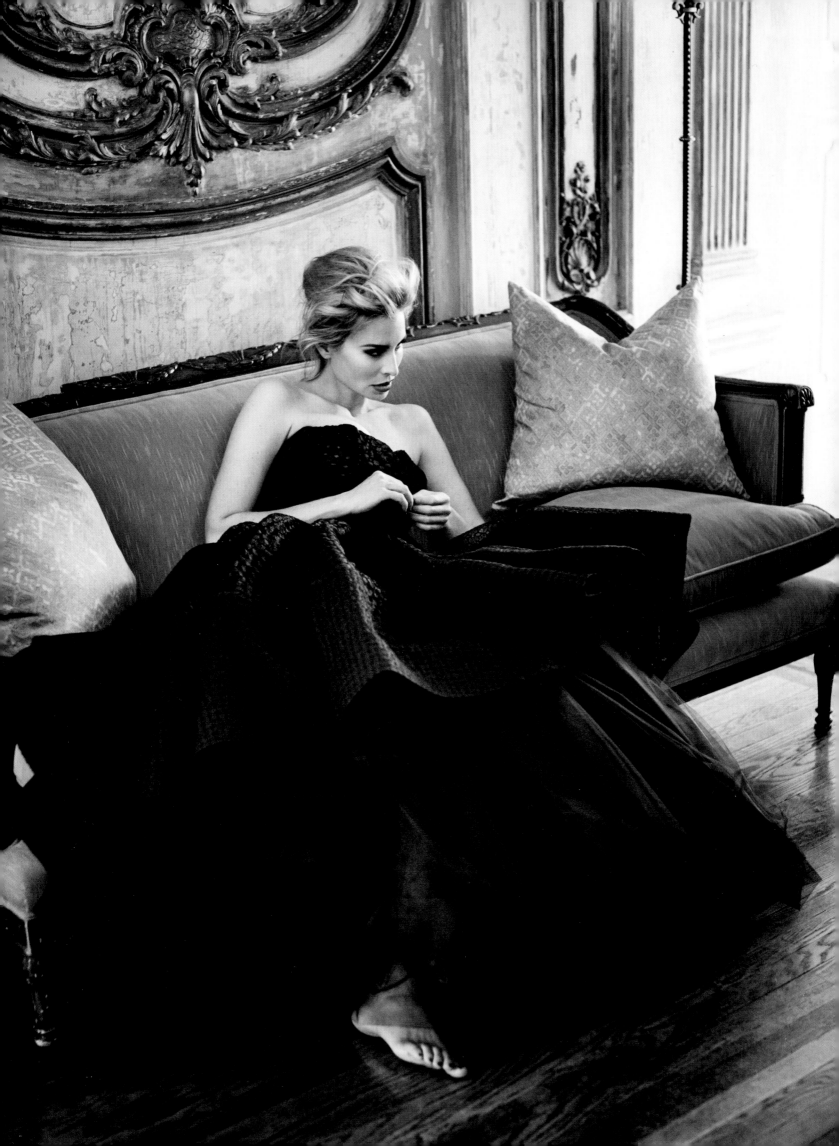

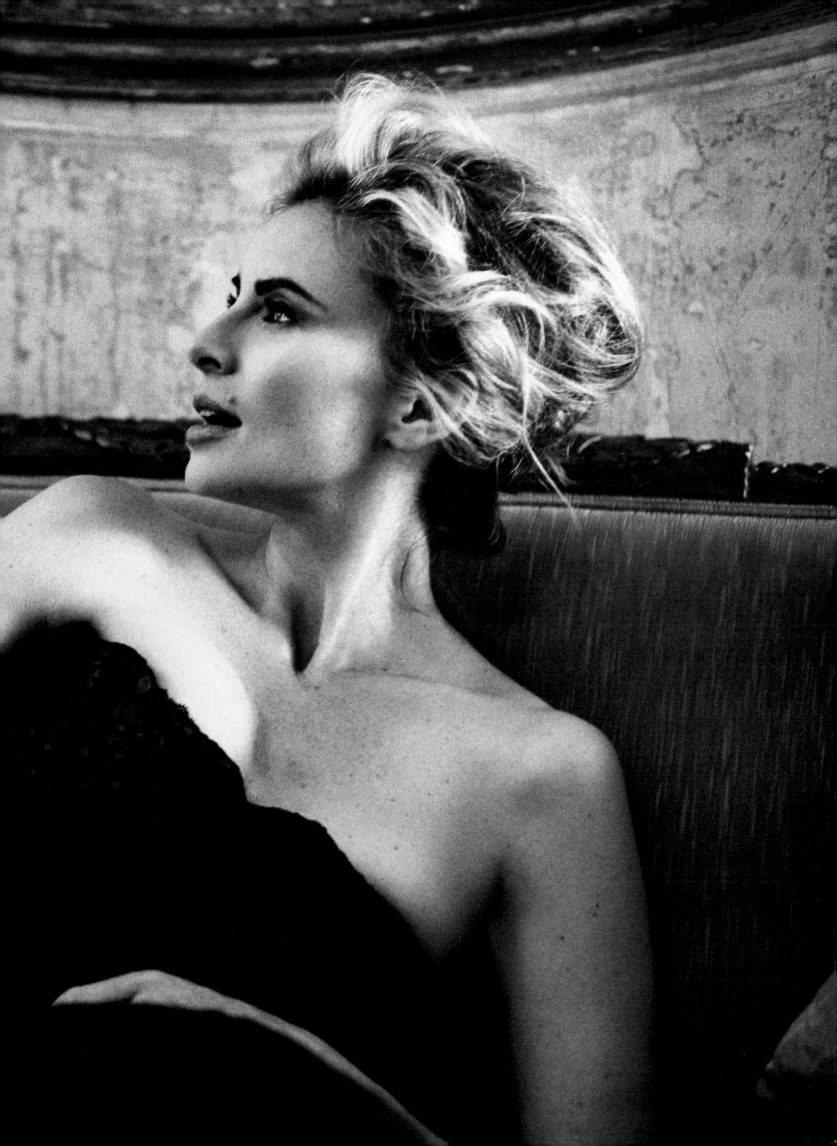

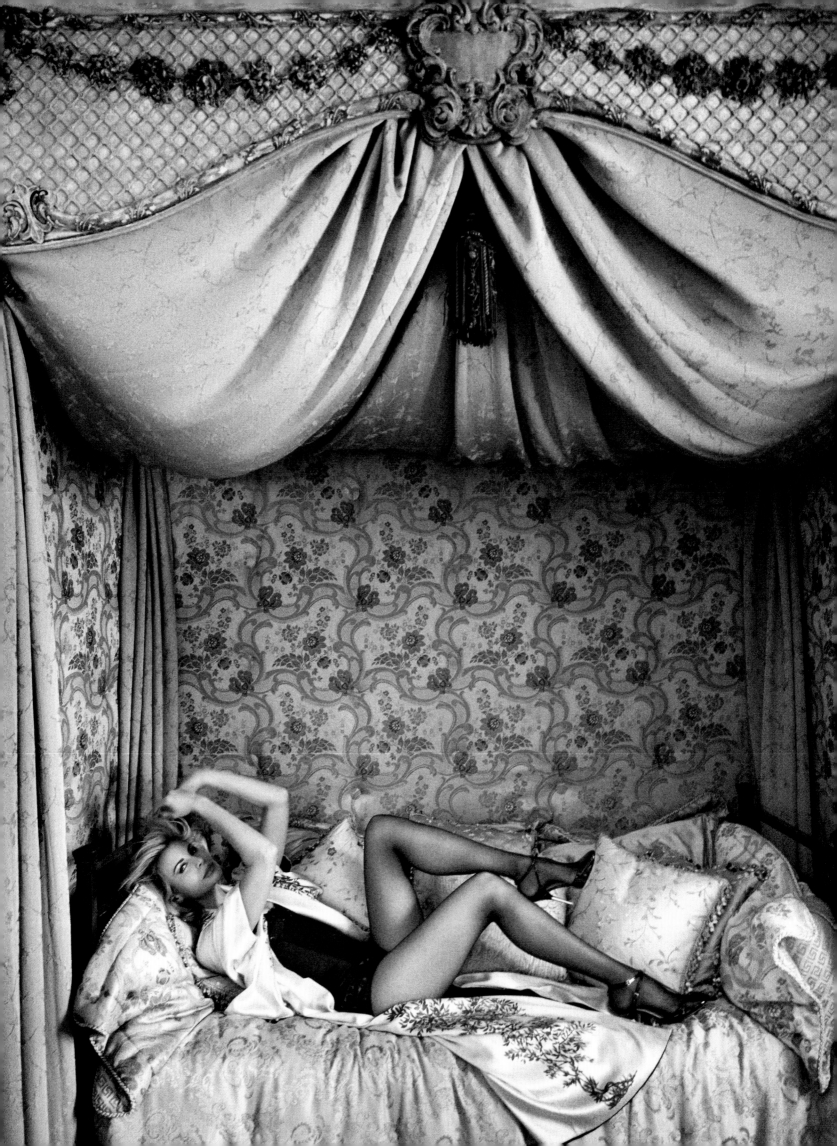

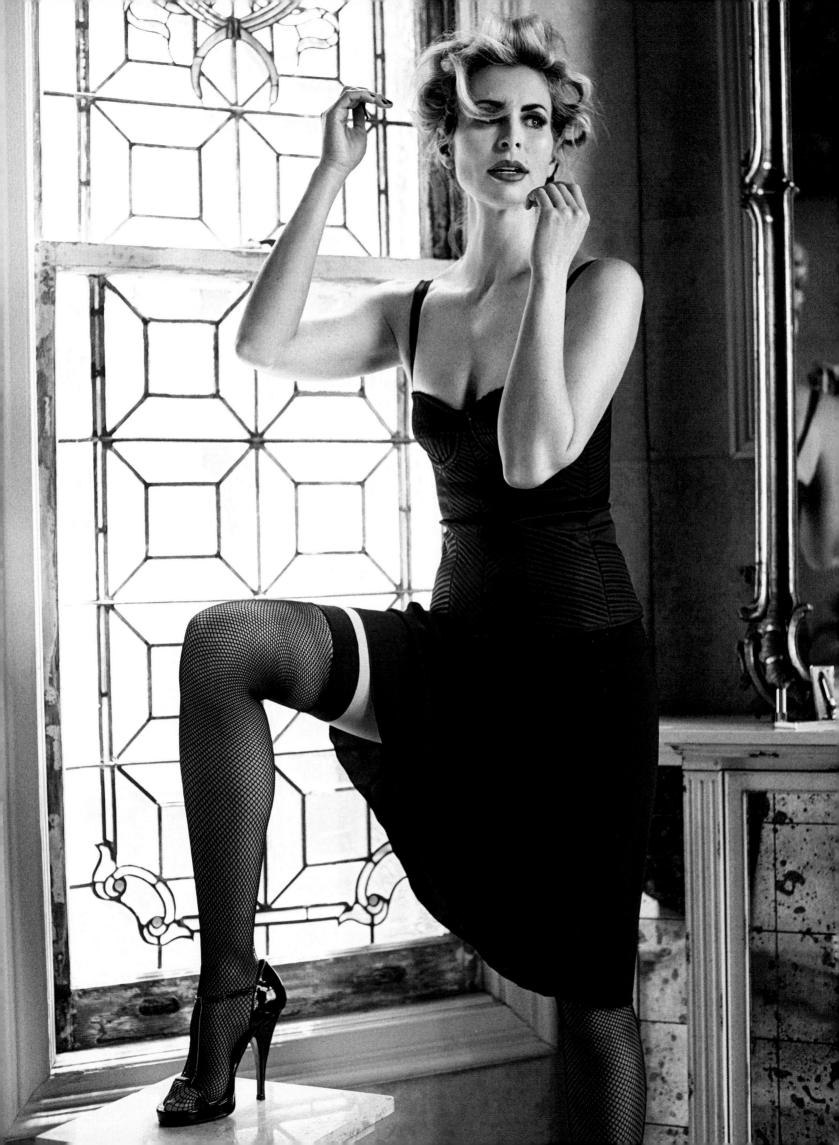

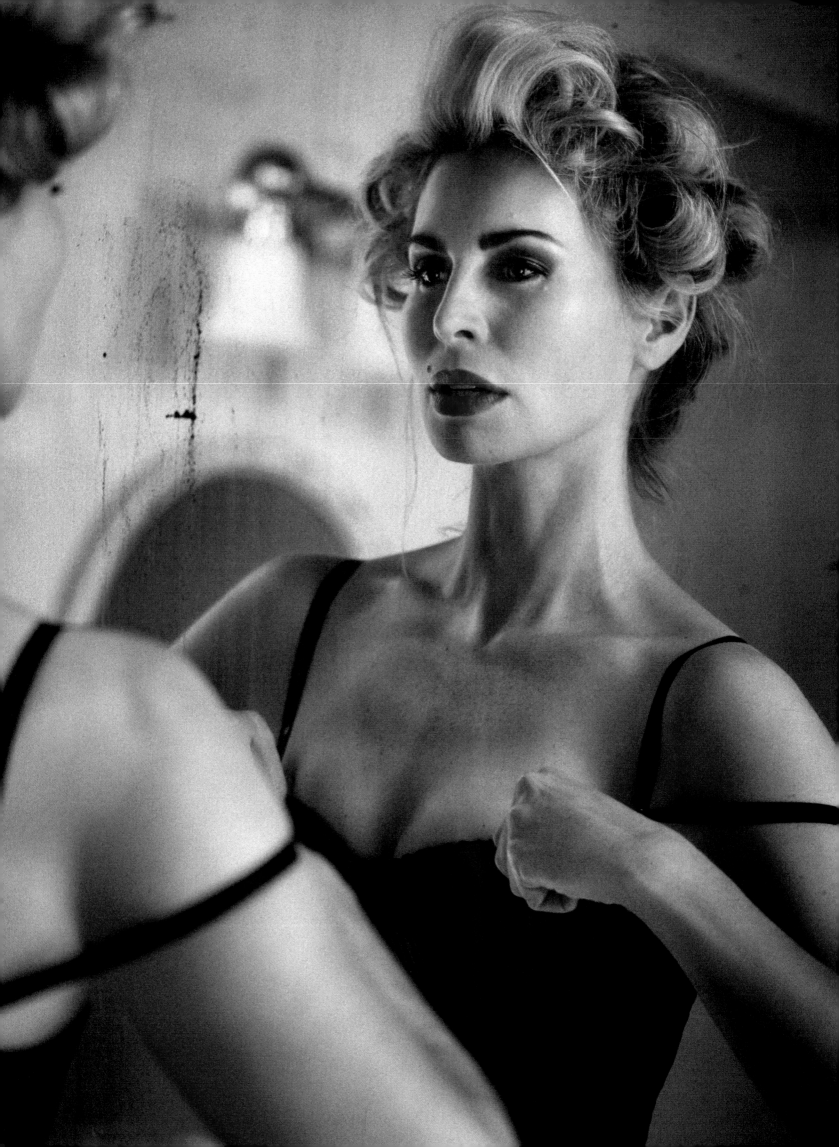

"Everything is for us
to better each other, I think.
There's a lot
to say about love."

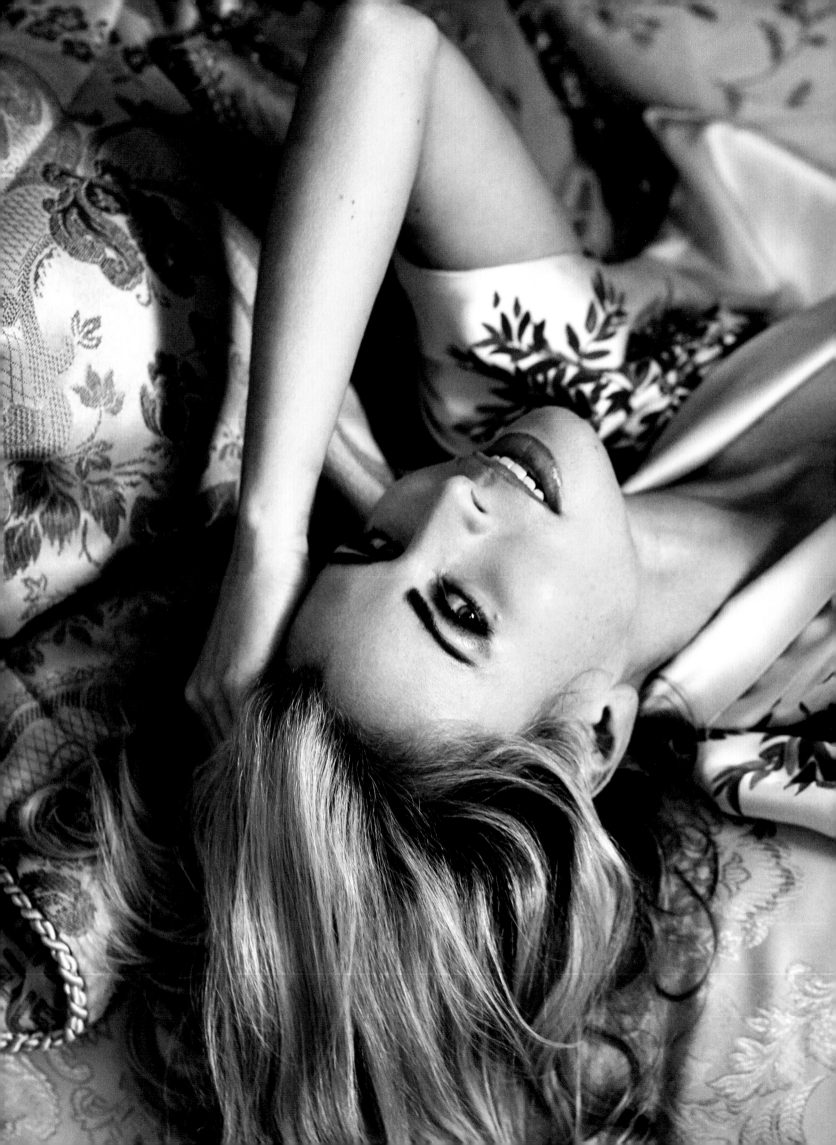

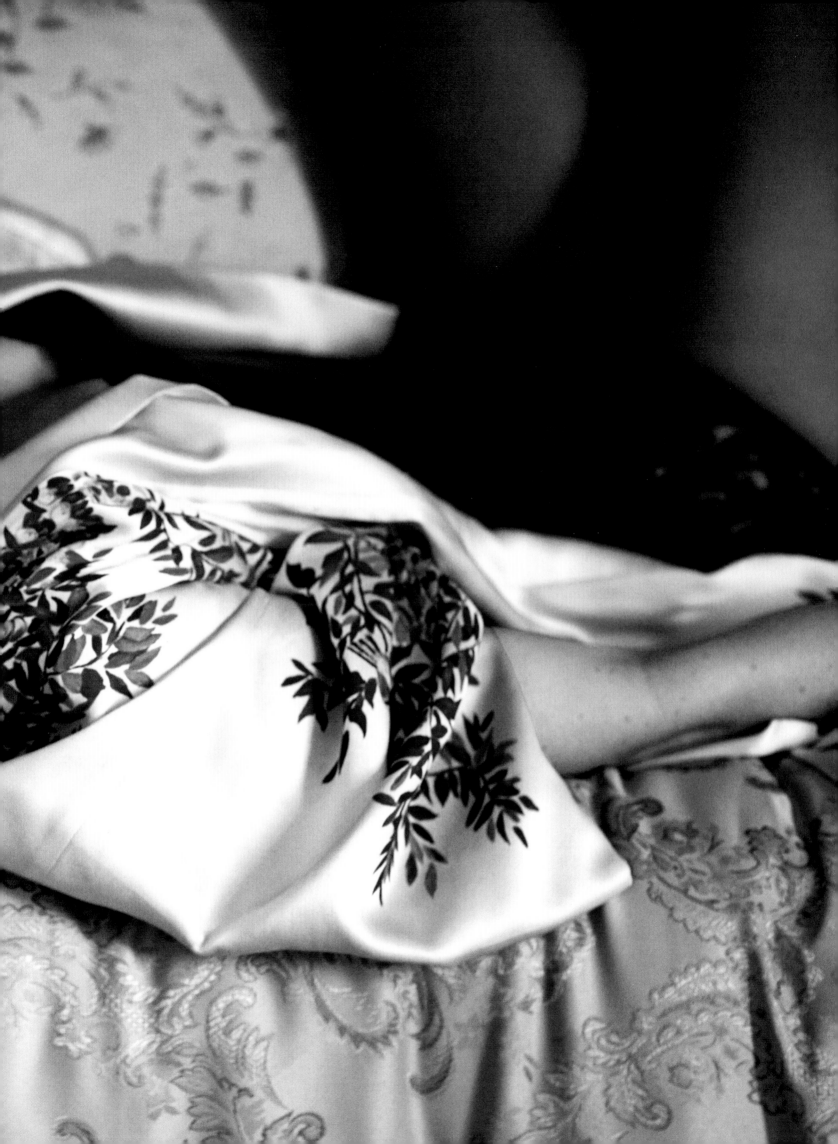

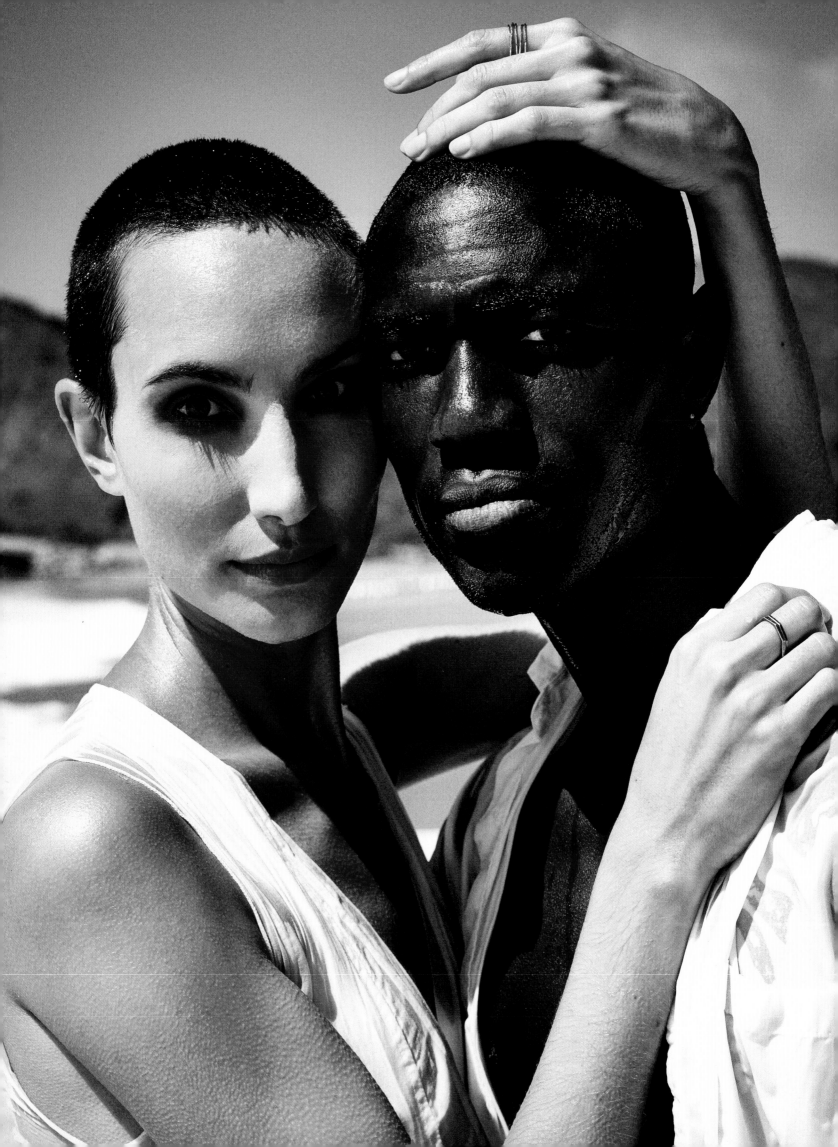

Yasmin & Rodney

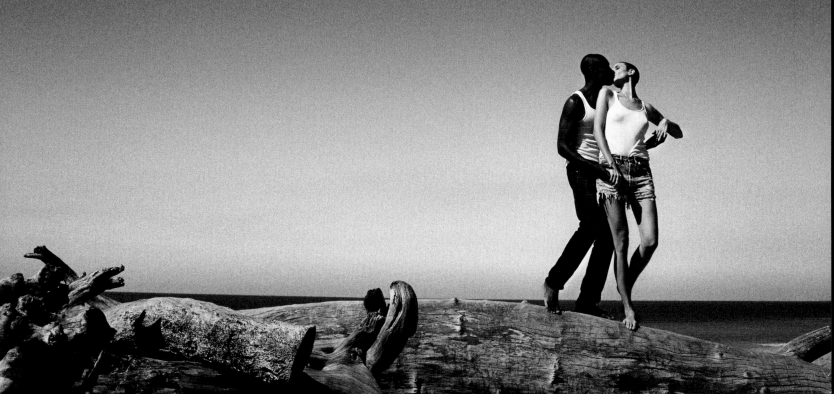

Sometimes you must be careful what you ask for. A few months before film producer Yasmin C. Rams met Rodney Charles, she was contemplating who might be the perfect man for her. She remembers thinking that a writer would be nice, that she would like a writer. Meanwhile a writer named Rodney was thinking who might be the perfect woman for him; a producer would be good, he thought.

When the two first met at the Berlin film festival they had no idea what would happen between them. They started talking about one of the lectures. Then for the entire day they just carried on talking, about their ideas on films, their philosophies on making art, everything that mattered to both. They talked from that morning until the late night. Yasmin remembers thinking "Wow, that was surprisingly beautiful. I remember after we had said goodbye, standing in the subway and that smile, there was a smile that suddenly came to my face and I didn't know what it was. What happened? What was that? I was somewhere between shocked and extremely happy. In the following days we kept meeting up and it started our relationship."

Rodney puts it his own way: "When Yasmin approached me, having that clarity, having that level of openness, I just thought, what a beautiful spirit. We just kept that. As we continued the conversation, it became clearer and clearer that we had to create something together. I didn't know quite what, but we both had complimentary skill sets." And so began their love affair and their collaboration as film-makers. Rodney noticed the change in his life immediately. When he had created his own projects, he was under constant strain. "When I made my first feature, I directed, produced, and to my fault, financed it. Yasmin wasn't in my life at that time. I ended up in hospital because I worked non-stop and there wasn't anyone available to correct that."

Rodney feels that Yasmin is his perfect collaborator because she is able to help him on the pragmatic level of refining ideas and giving notes on his scripts. "I write pretty effortlessly," he says, "but it's really important to have someone who can read the writing and be critical of its nature in a way that's conducive to the development of that work", but also with having a sense of the overarching passion that drives him. "If we're artists, most of us are very clear in terms of the things that motivate us in the realm of the beautiful," Rodney says. Yasmin, meanwhile, puts it like this: "It's just great because we can always push each other creatively, visually. So much of what I think about is film and the impact we can have, and how we can have an impact with imagery. If we didn't work together, I think it would be a pity because we really fuel each other a lot and I see it as a very creative thing."

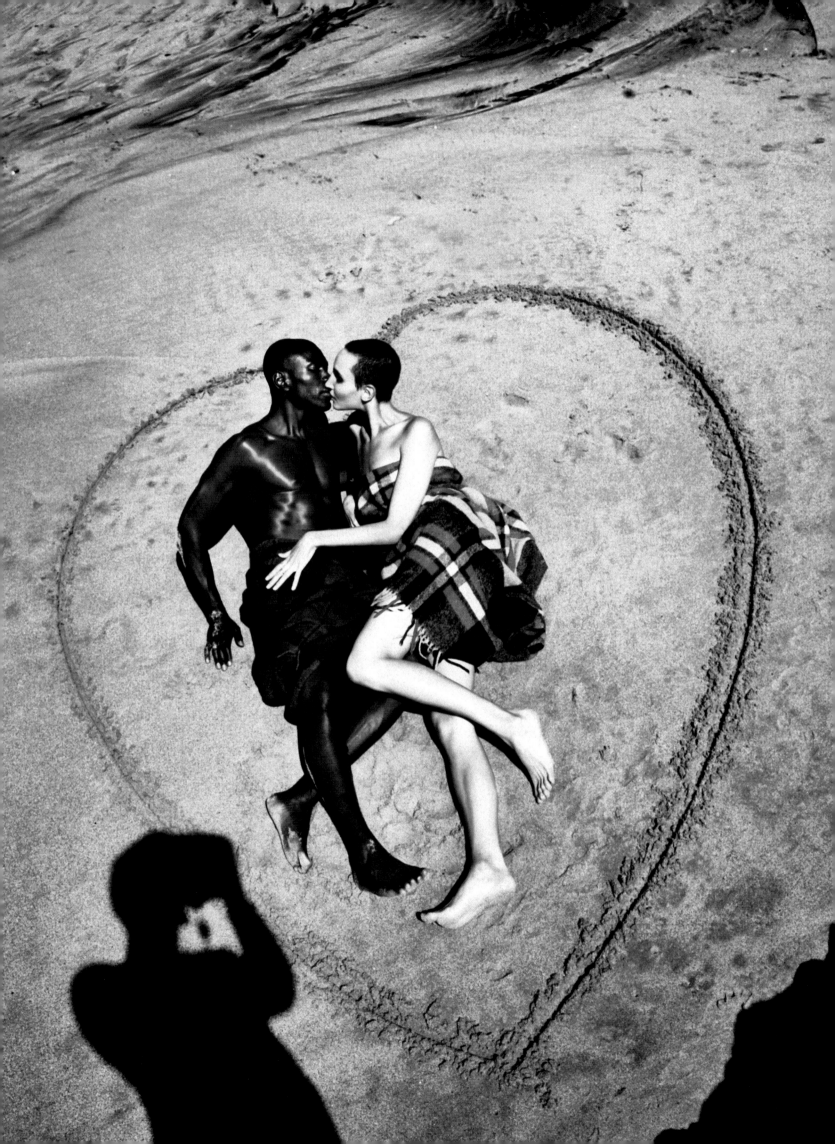

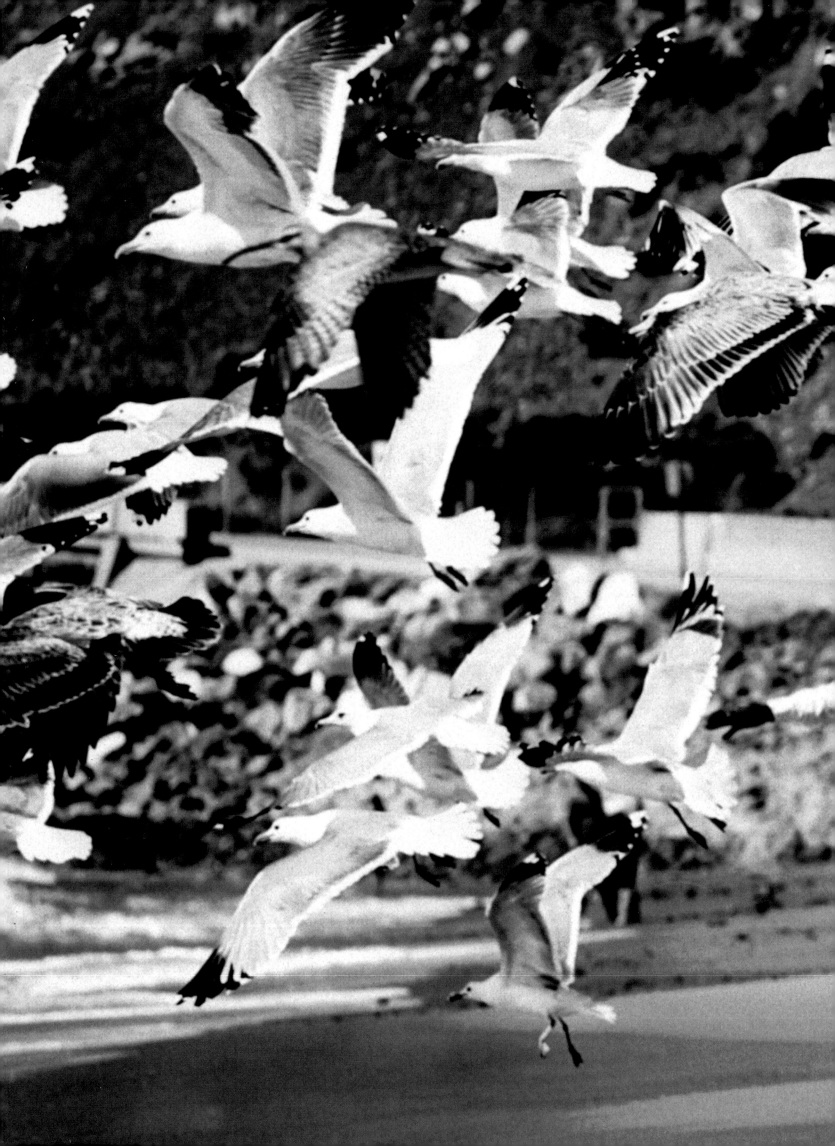

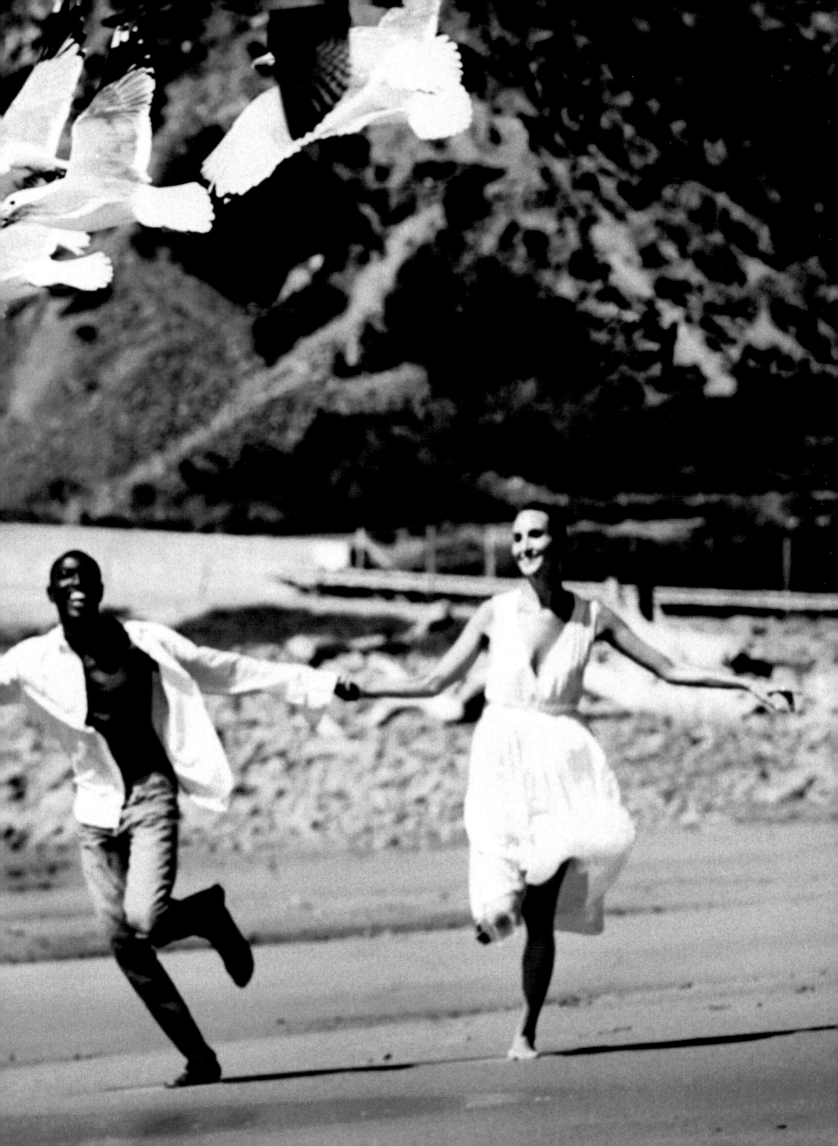

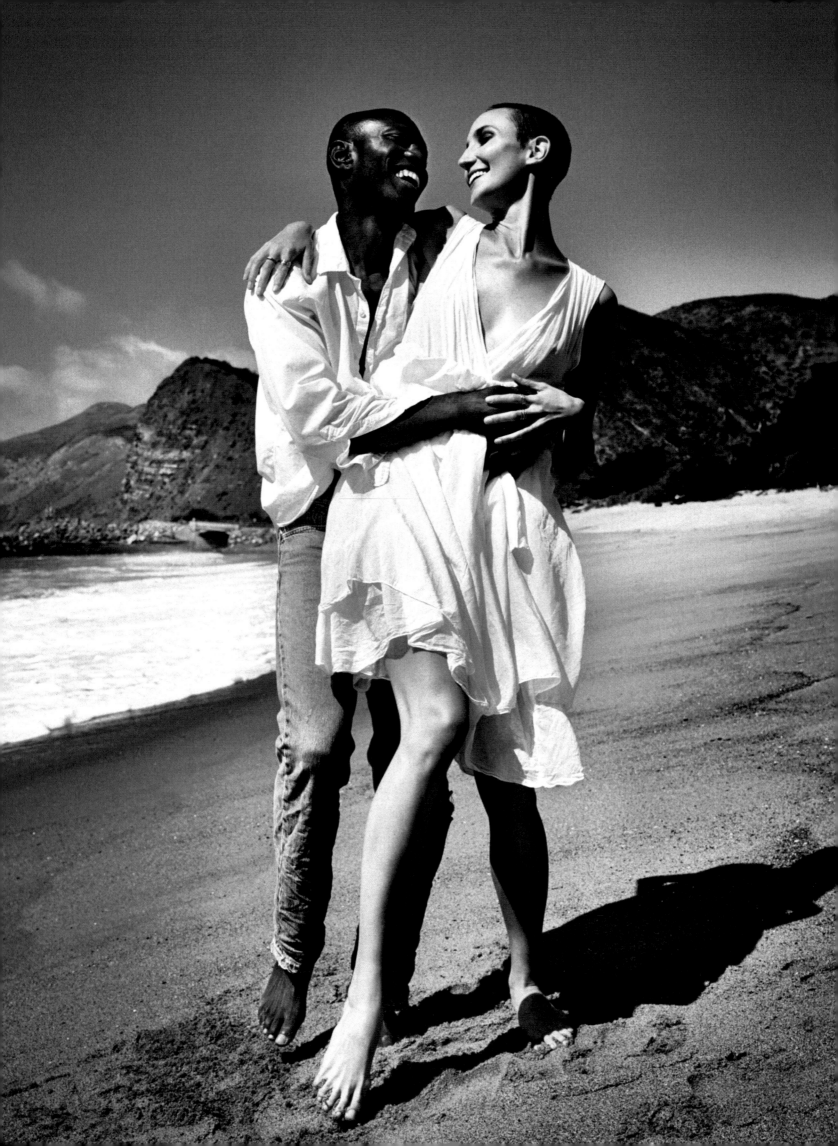

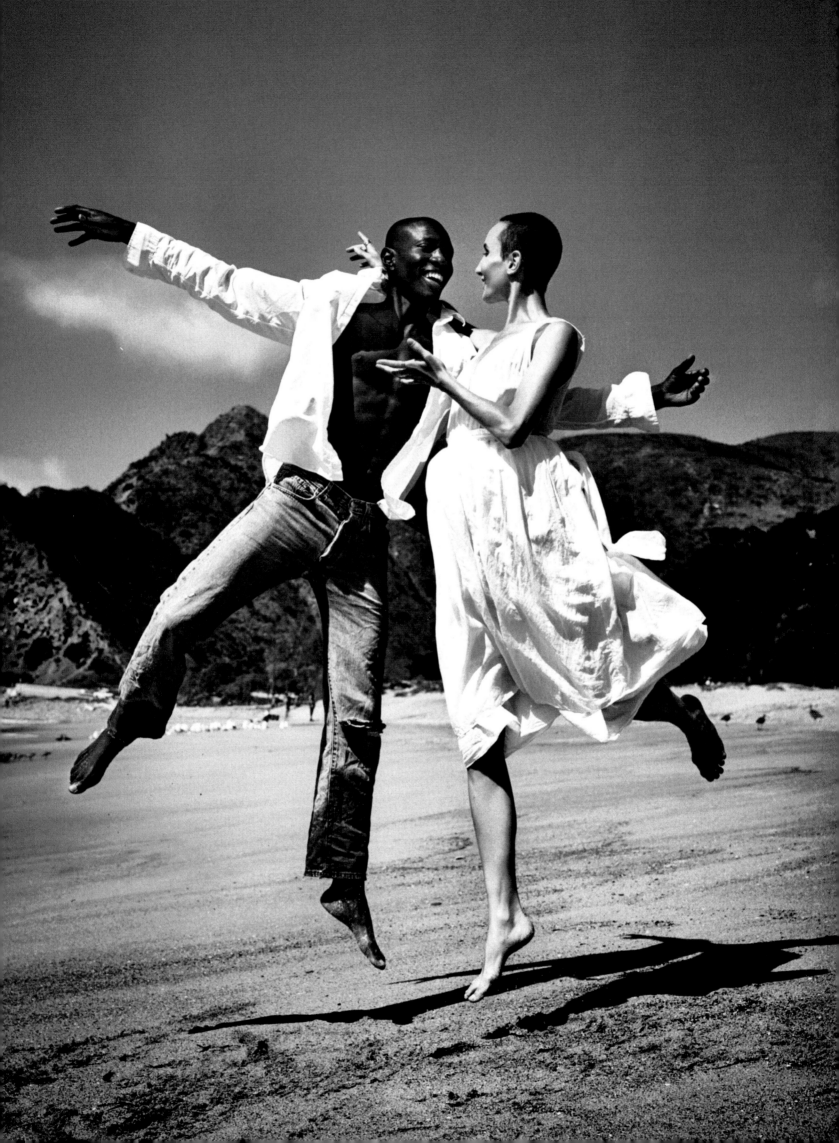

"If we didn't work together, I think it would be a pity because we really fuel each other a lot and I see it as a very creative thing."

Listening to them I am struck by how much their relationship drives the other professionally, which in turn increases their love. They have a mutual desire to make the world a little better and a little more functional through their films. Seeing them together, you could almost believe they were fated to meet. I asked Yasmin what she thought of this notion. "I think we're given opportunities. I don't think that it's all planned out, but I think step by step, whatever place we are at in our lives, the universe throws us good opportunities. Those are things that could match, things that could make us progress into a good direction and in the direction that we want to go emotionally or career-wise or whatever." She paused for a moment, as if thinking further, and addressed her next words to Rodney.

"I have to say when we met on that very first day, I was very struck by—there were many moments where I was just struck by you. I was struck by your thinking, your being, your center of being. What else is there? There were so many things that correlated to what I had thought before or to what ideologies that I had in my head before. When I met you, it felt like things suddenly made sense." ♥

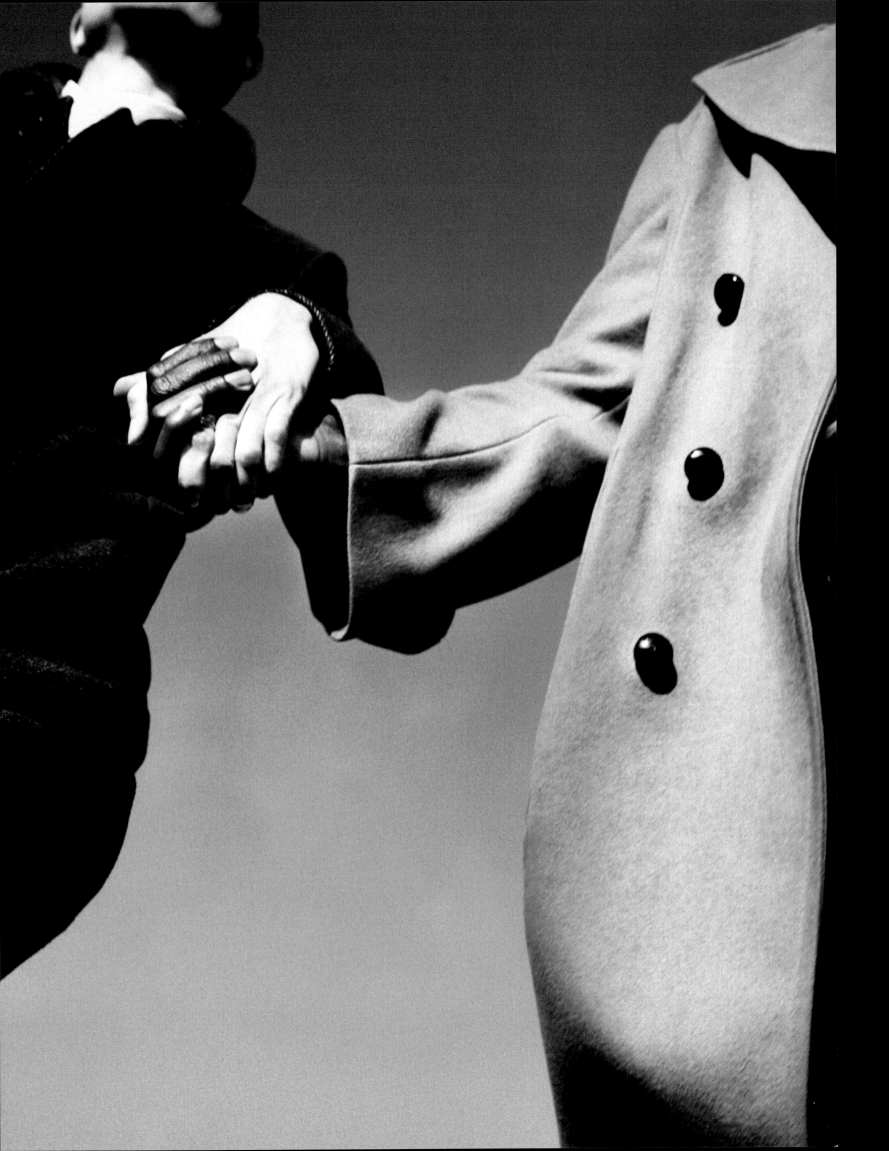

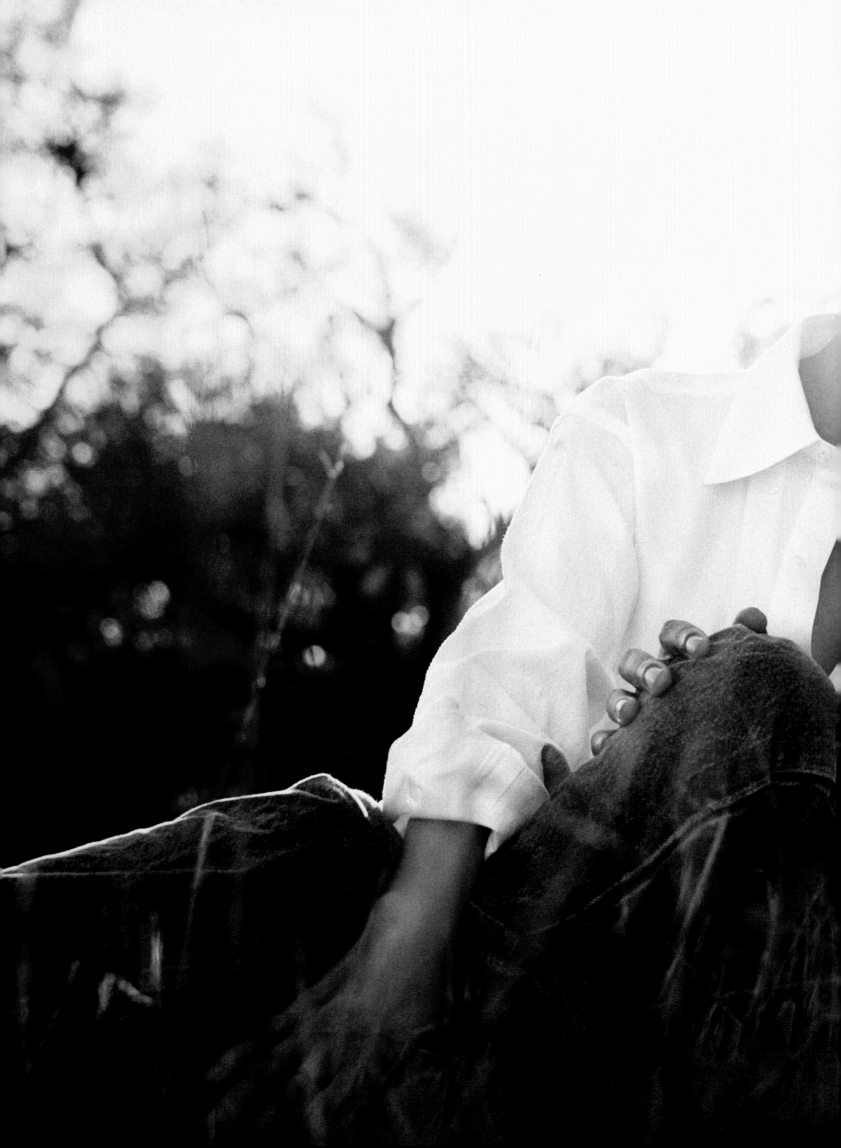

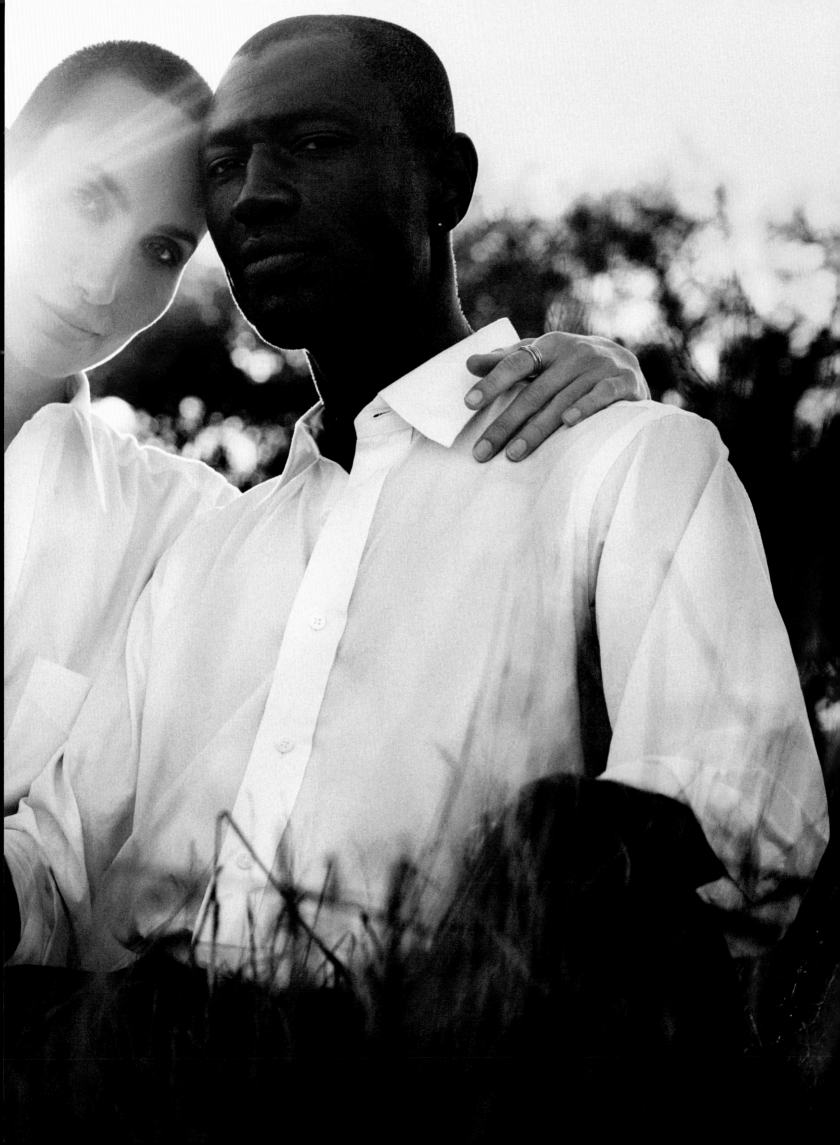

"I don't think that
it's all planned out,
but I think step by step,
whatever place
we are at in our lives,
the universe throws us
good opportunities."

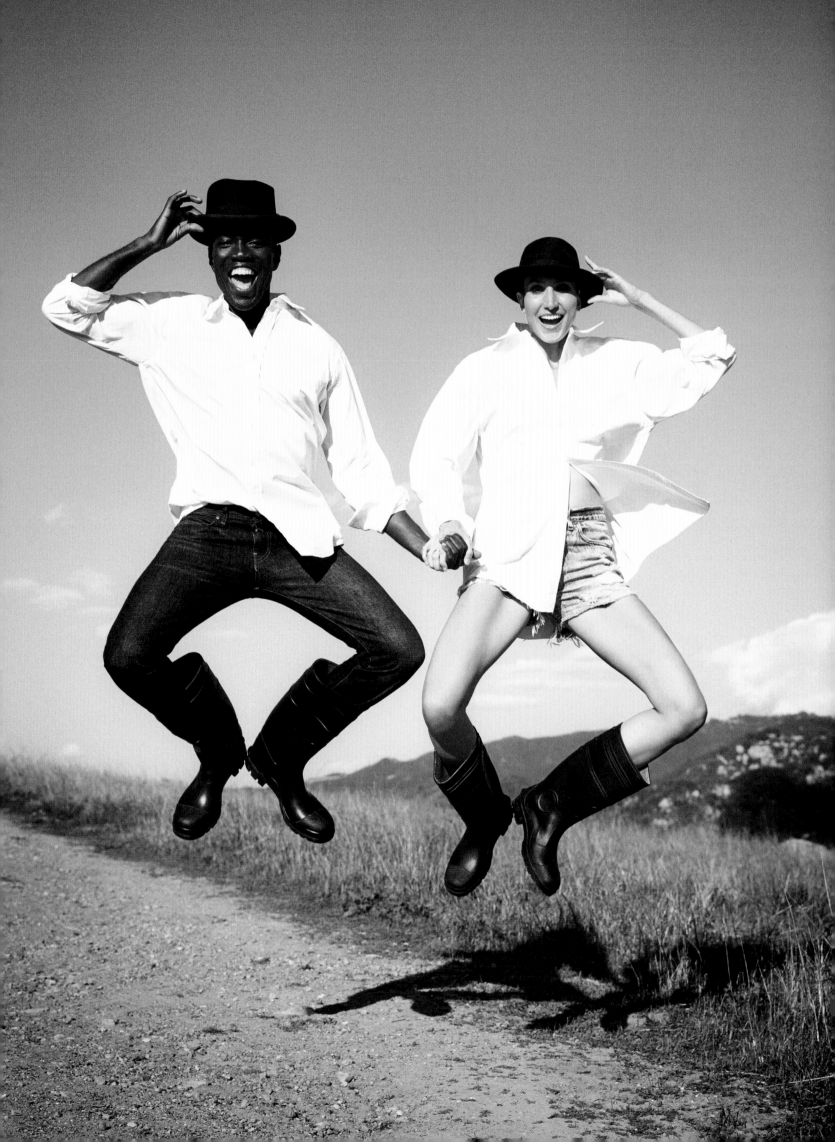

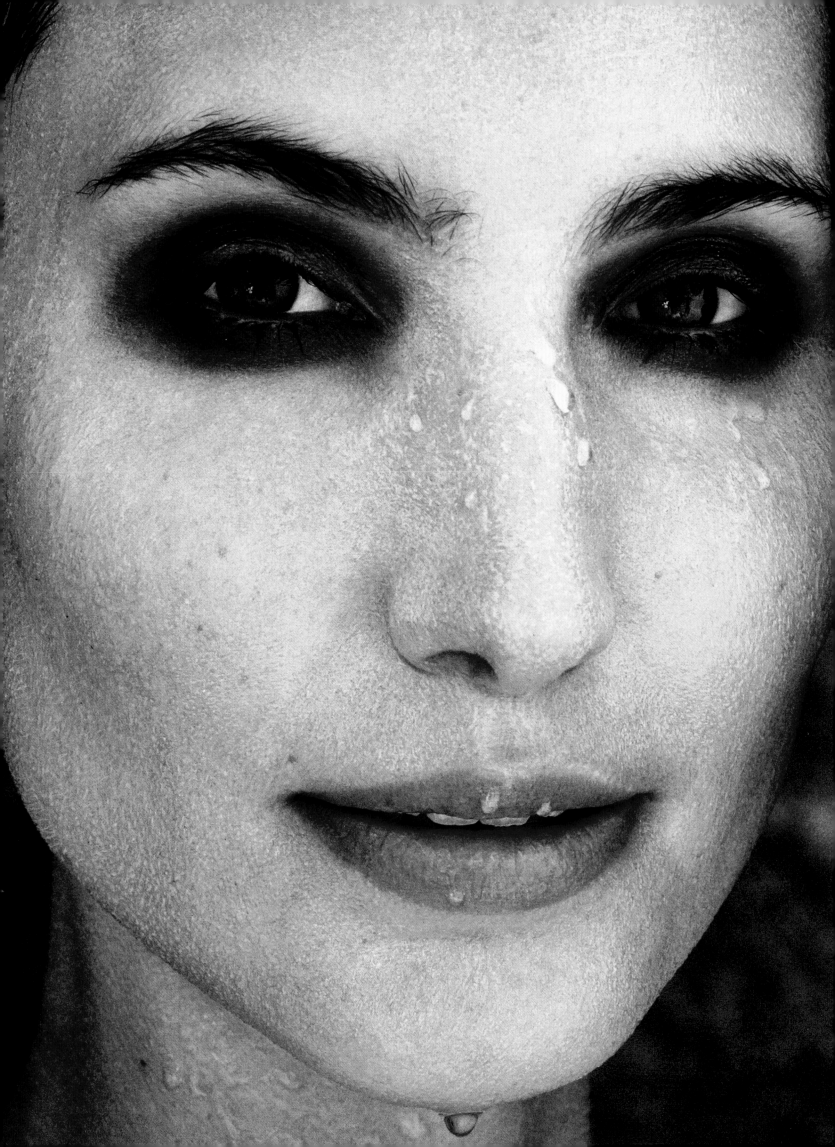

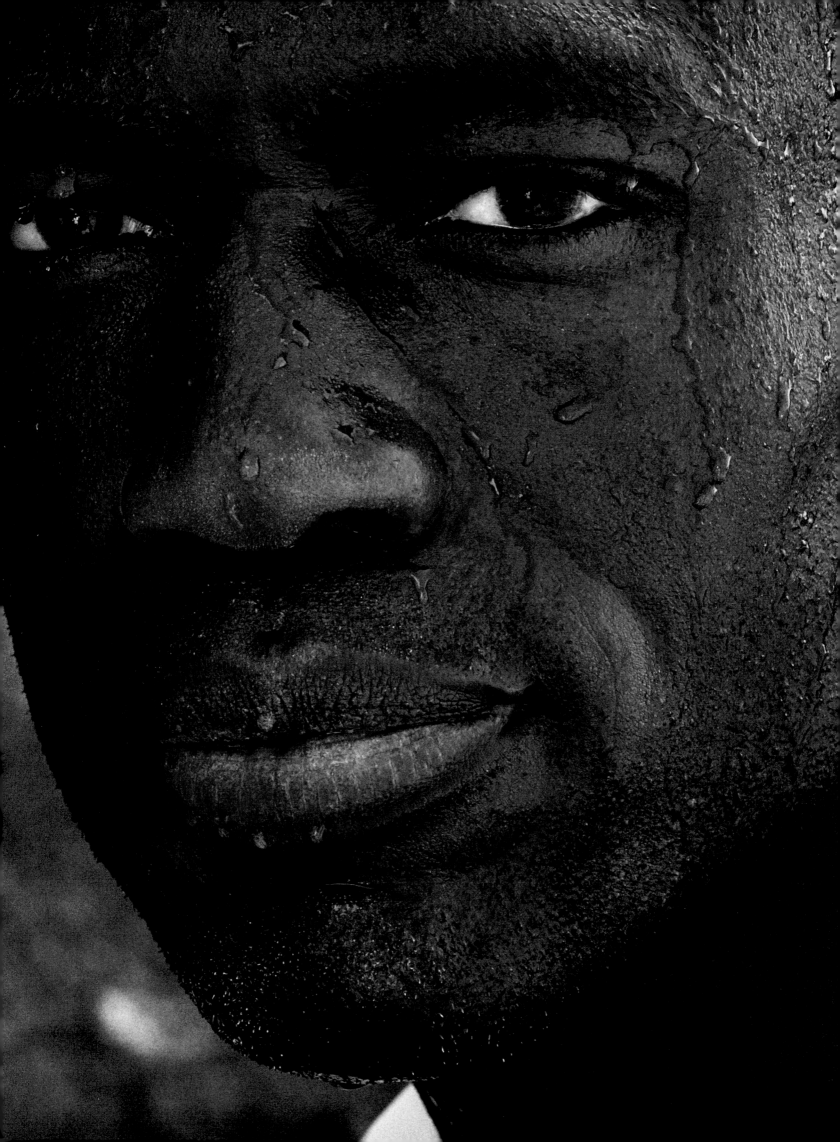

Eric Gabriel

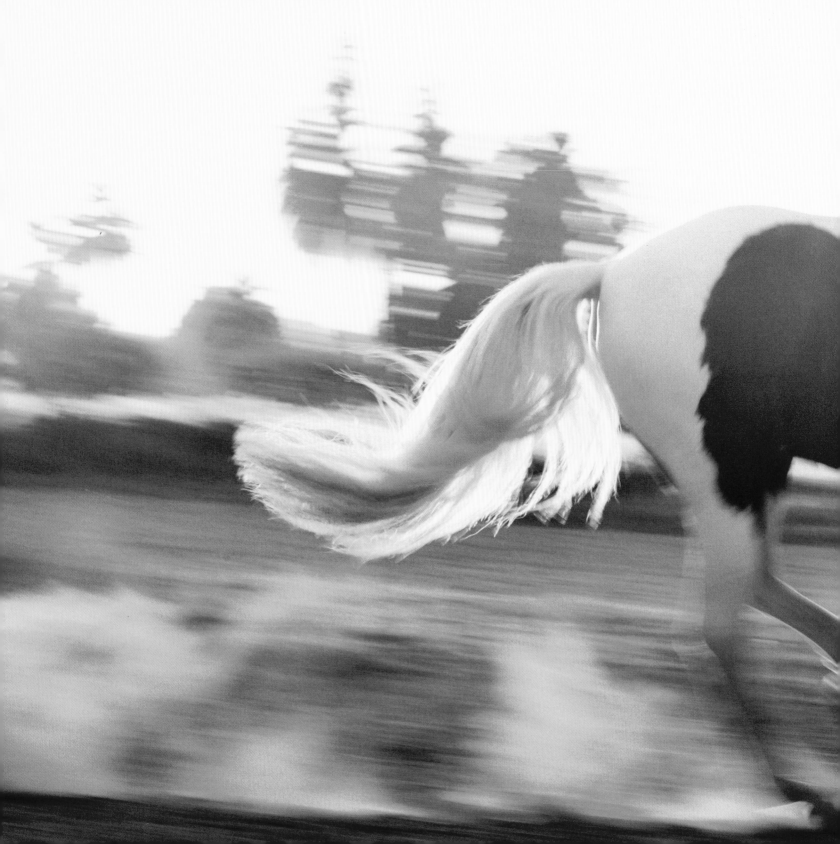

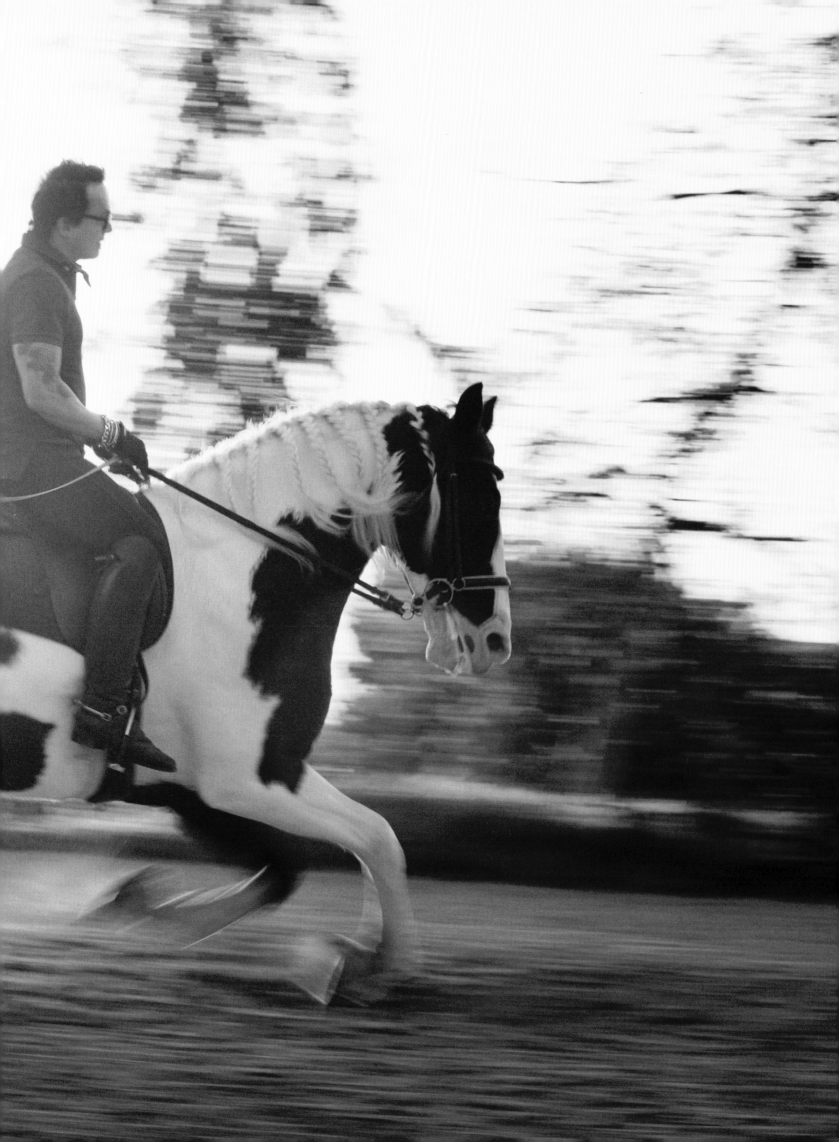

Eric is such a cool dude. Generally dressed in black, Eric's early career was as a musician in a band whilst simultaneously exploding onto the fashion scene as a top session hairdresser, working for all the *Vogue* magazines around the world. He oozes style and talent.

He arrived in New York from a small town in northern California, en route to Europe with a friend. New York City was meant to be just a stopover, but when he didn't have enough money for the fare to Europe he ended up staying, and threw himself into urban life. "I was seventeen, turning eighteen that year—the drinking age back then was eighteen. I was at the clubs and the parties and there was so much going on. The hip hop scene was really coming in big. There was a rock and roll scene at all these major clubs. I was a club boy, going out all the time. I come from a small town so you can imagine what a change that was."

By a chance meeting Eric ended up working for the legendary hairdresser Oribe. Eric had spent a lot of time at his mother's hairdressing salon when he was a child, but never thought he wanted to style hair himself. It wasn't until he realized that styling hair could be a ticket to traveling the globe for photoshoots, that he became interested in this work as an adult. Before long he was styling hair all over the world. At the same time he was fronting a band: "I orchestrated the whole thing, I wrote all the music. I got everyone together, I did auditions."

Eventually this led to some conflicts with his job. "I was with Art + Commerce at the time and they would tell me, 'We love that you're doing music because you're passionate and everything, but it's getting a little scary. You have to make a decision which direction you're going in.' I was actually canceling a lot of work just to do gigs and trying make things happen." Simultaneously another part of him was longing for the outdoors, for the time he spent out in nature as a kid. Eric's solution was to buy a motorcycle and get out of the city whenever he could. "That was my iron horse, basically, my freedom to go up to Woodstock or just venture out, go to Long Island, wherever."

After fifteen years in New York, Eric felt he needed to get even further out. So, at the height of his career, he decided to leave, as he felt that his work-life balance was off. He missed the activities he used to do a kid—surfing, snowboarding, horseback riding—the whole outdoor lifestyle. And then he did a chance job on the west coast: "I was always skeptical about L.A. because coming from Northern California, and from New York, people could be dismissive of it. But when I finally came here for a job, I just loved it immediately. I thought, this is perfect, you could live on the beach, you could live in the canyons, you could live in the desert, you could live in the mountains, you could be wherever and still work in this industry. So you can work hard and play hard."

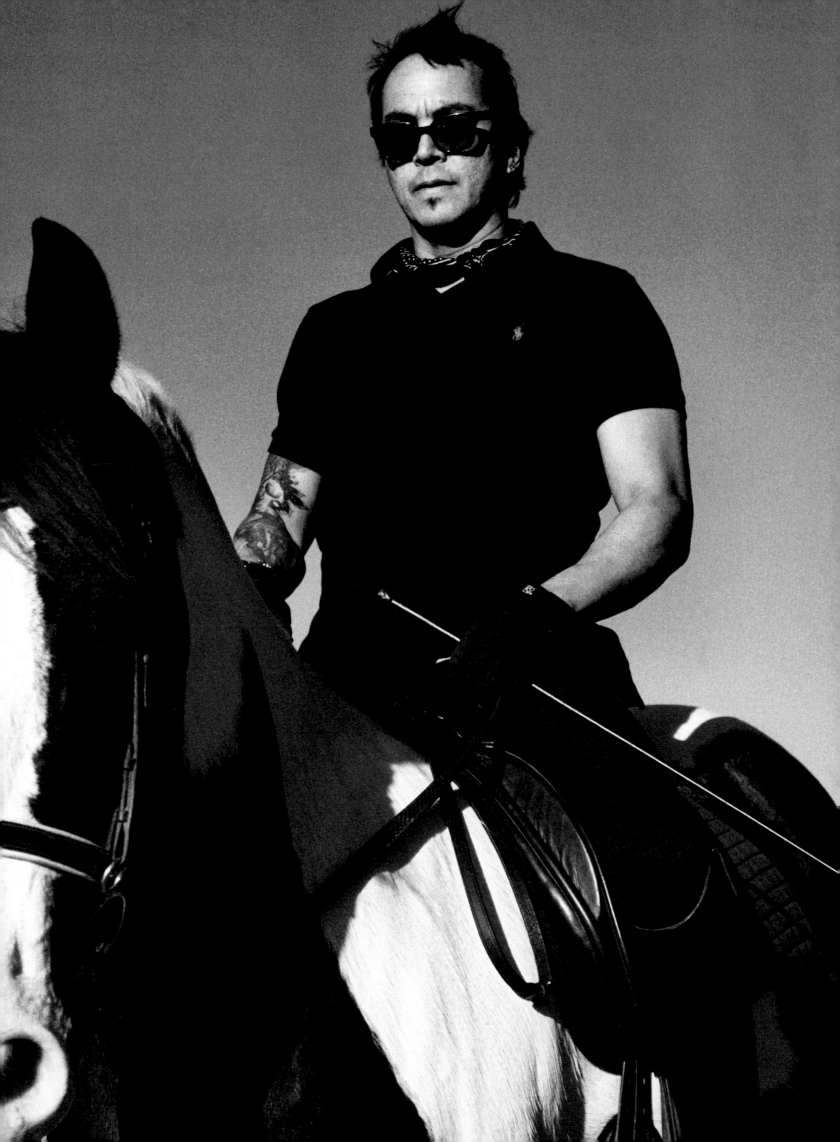

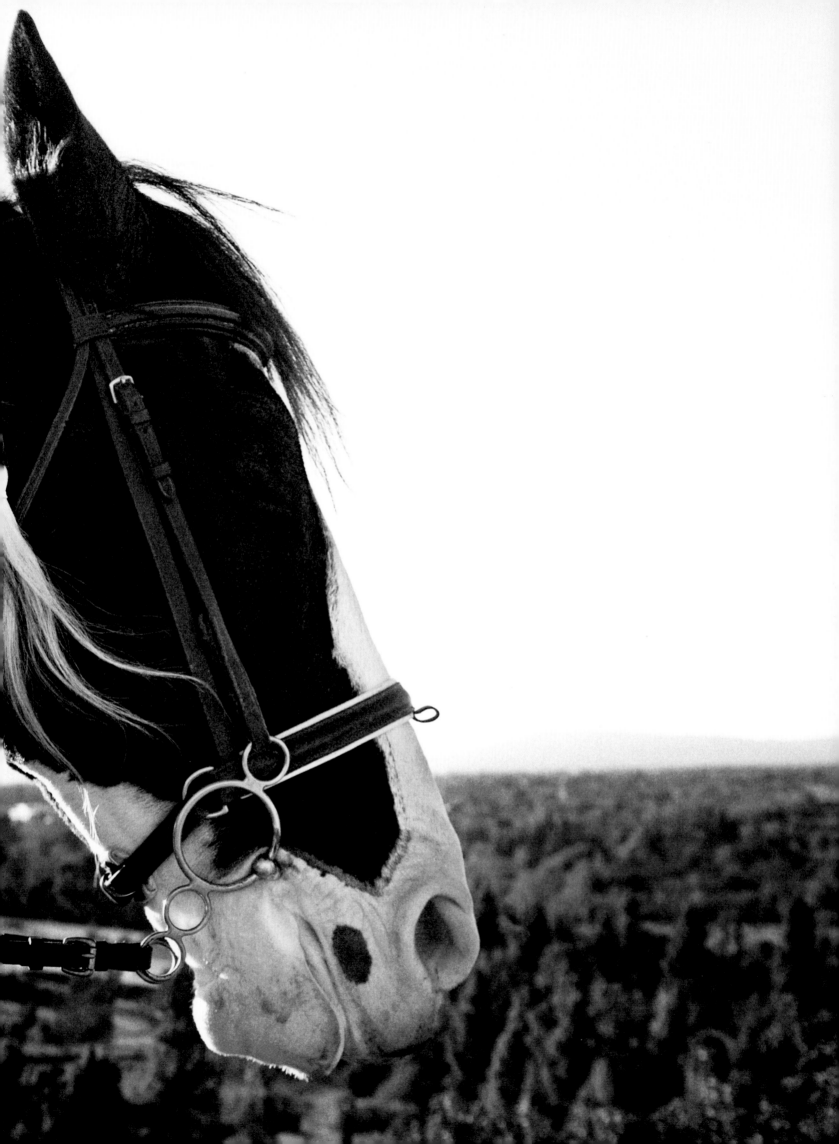

"When I came here for a job,
I loved it immediately.
I thought, this is perfect, you could
live on the beach,
you could live in the canyons,
you could live in the desert,
you could be wherever."

What Eric wanted most was a horse, and didn't settle down until he found a place where he could keep one in L.A. Now when he has time off, he celebrates it. "If I have two days off, I can go snowboarding, I can ride my horse, I can go for a motorcycle trip, I can go camping, I can go surfing, and because it's all pretty much L.A. weather, you can do it all year round."

In addition to all of these activities Eric is an amateur photographer (he learned how to take pictures from his father, who taught him how to develop film), has his own jewelry line, and is an aspiring perfumer. He is a person with boundless passions and interests who embraces all that life has to offer him.

As an admitted workaholic I almost feel Eric is speaking directly to me when he talks about the perils of taking one's job so very seriously. "I feel like everyone freaks out when they're not working, it's almost like a drug addiction. I'm not like that. My whole life has been a flow of energy. I appreciate everything." ♥

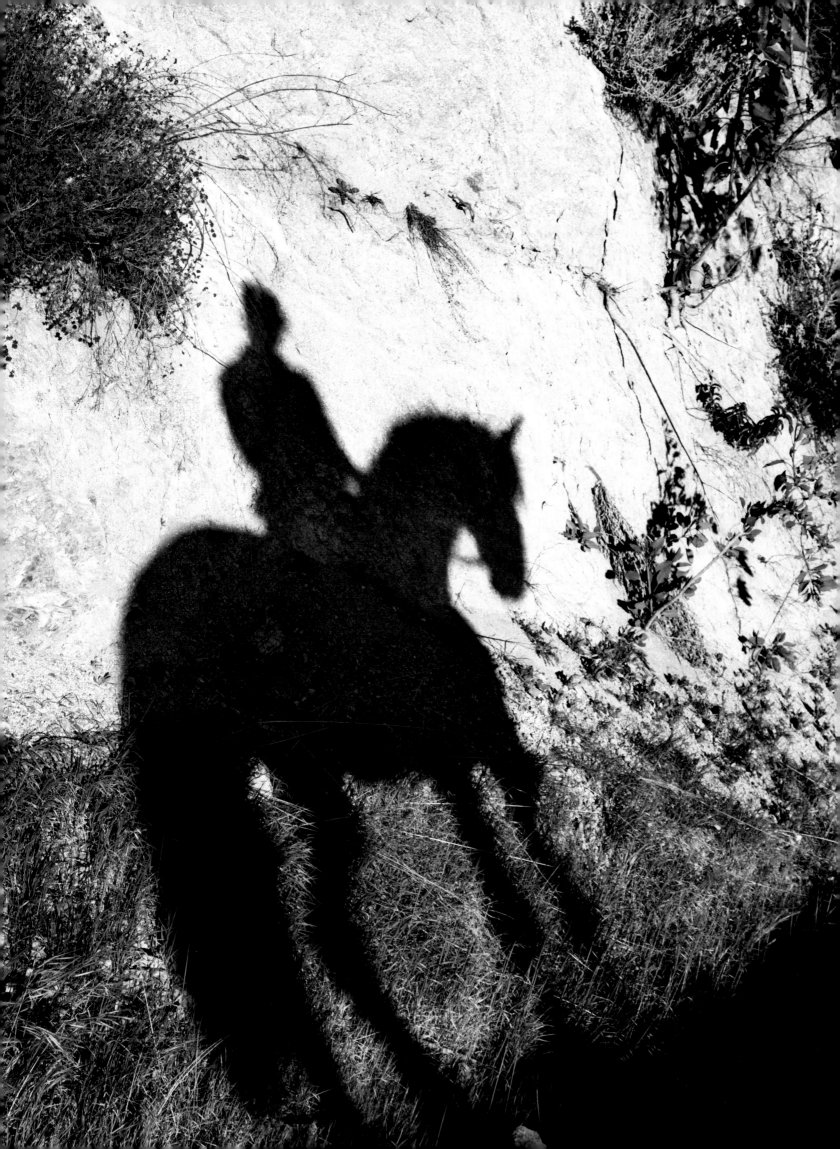

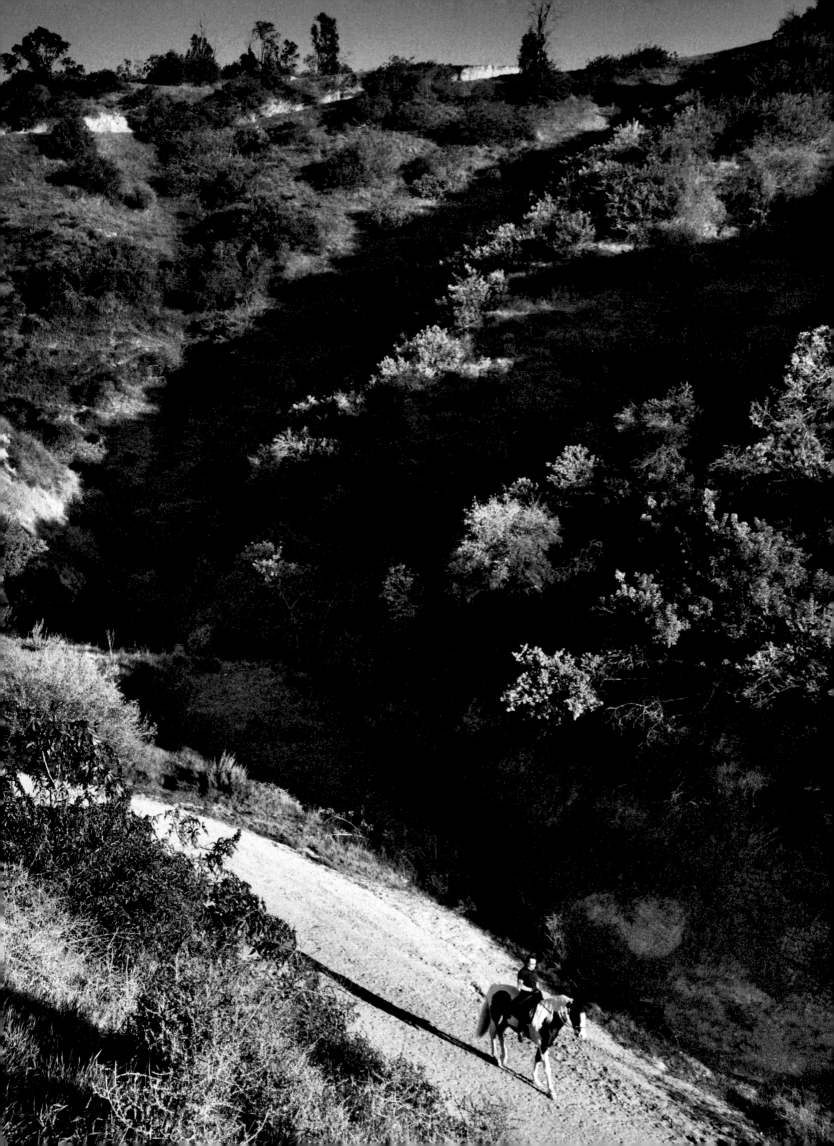

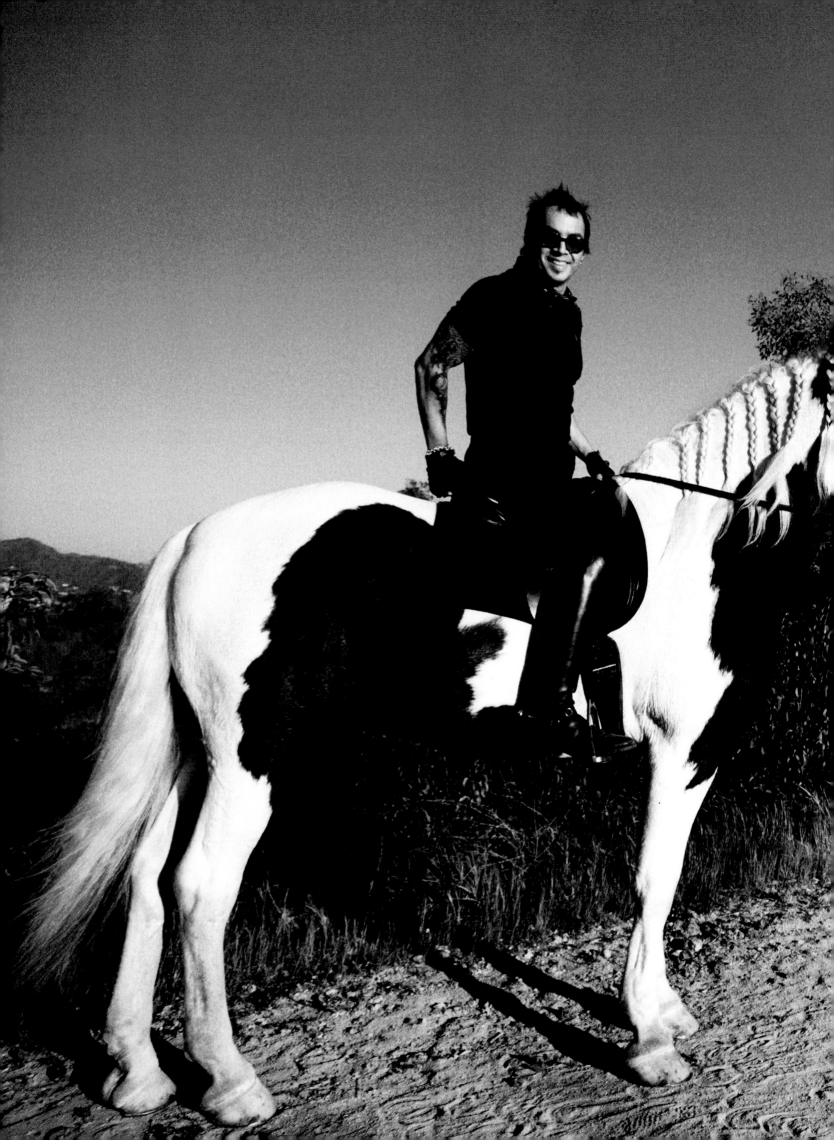

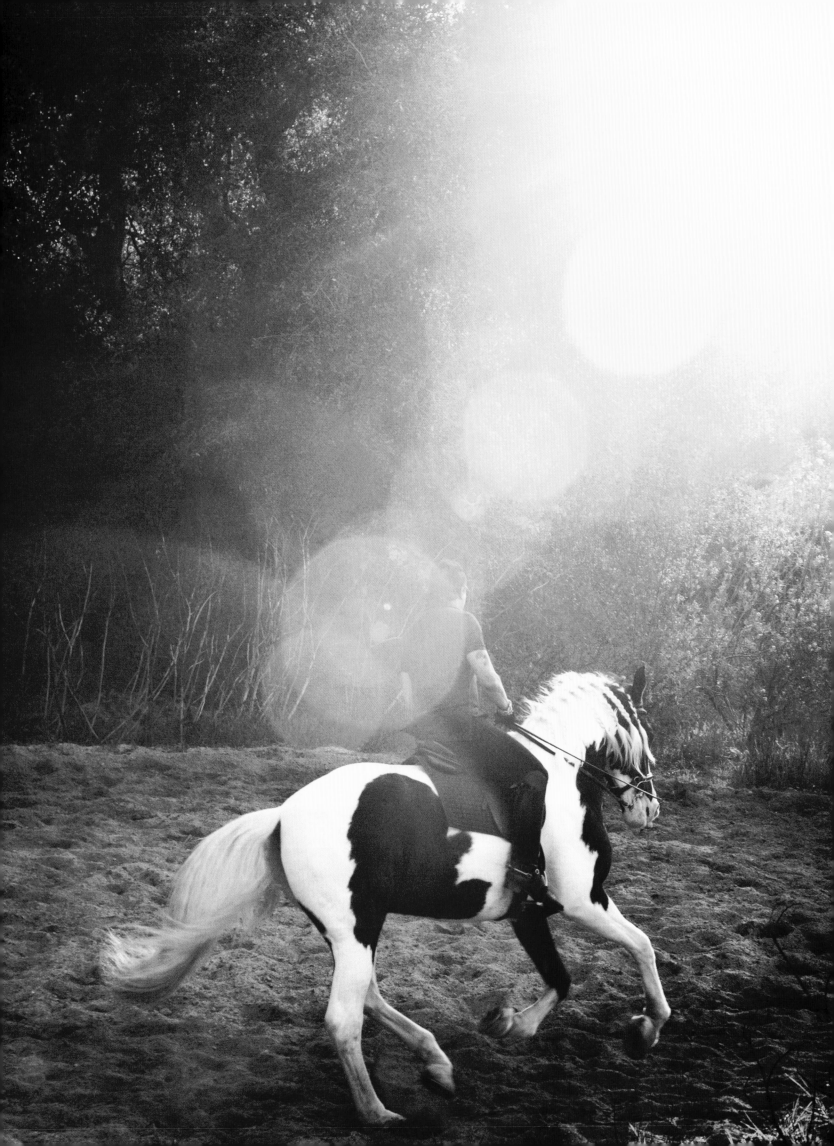

"I feel like everyone freaks out when they're not working, it's almost like a drug addiction.
I'm not like that.
My whole life has been a flow of energy.
I appreciate everything."

Barbara Fialho

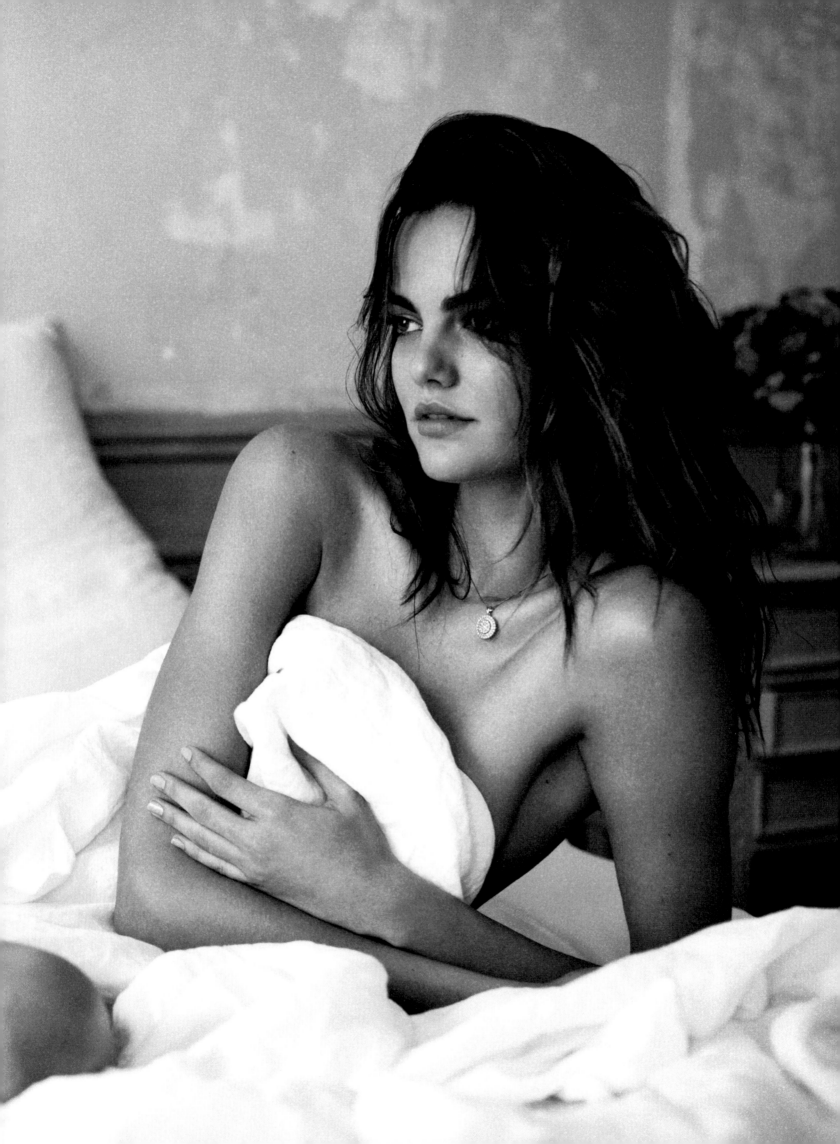

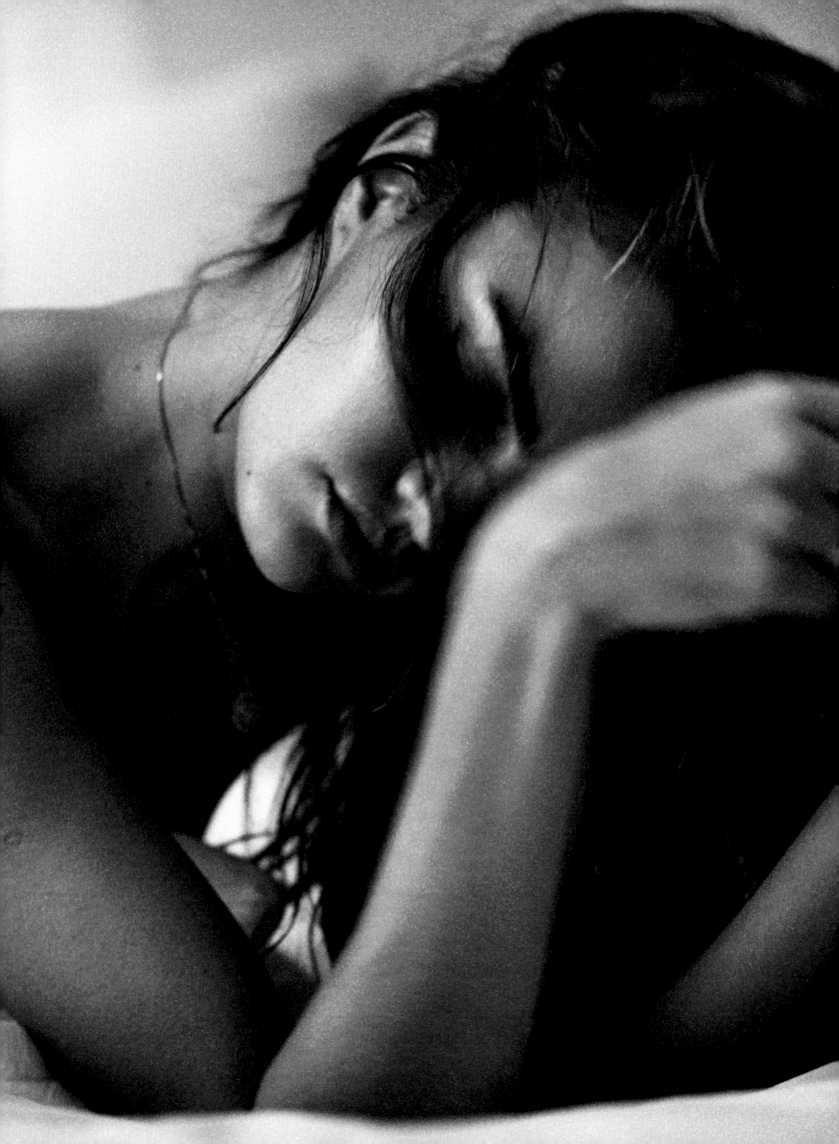

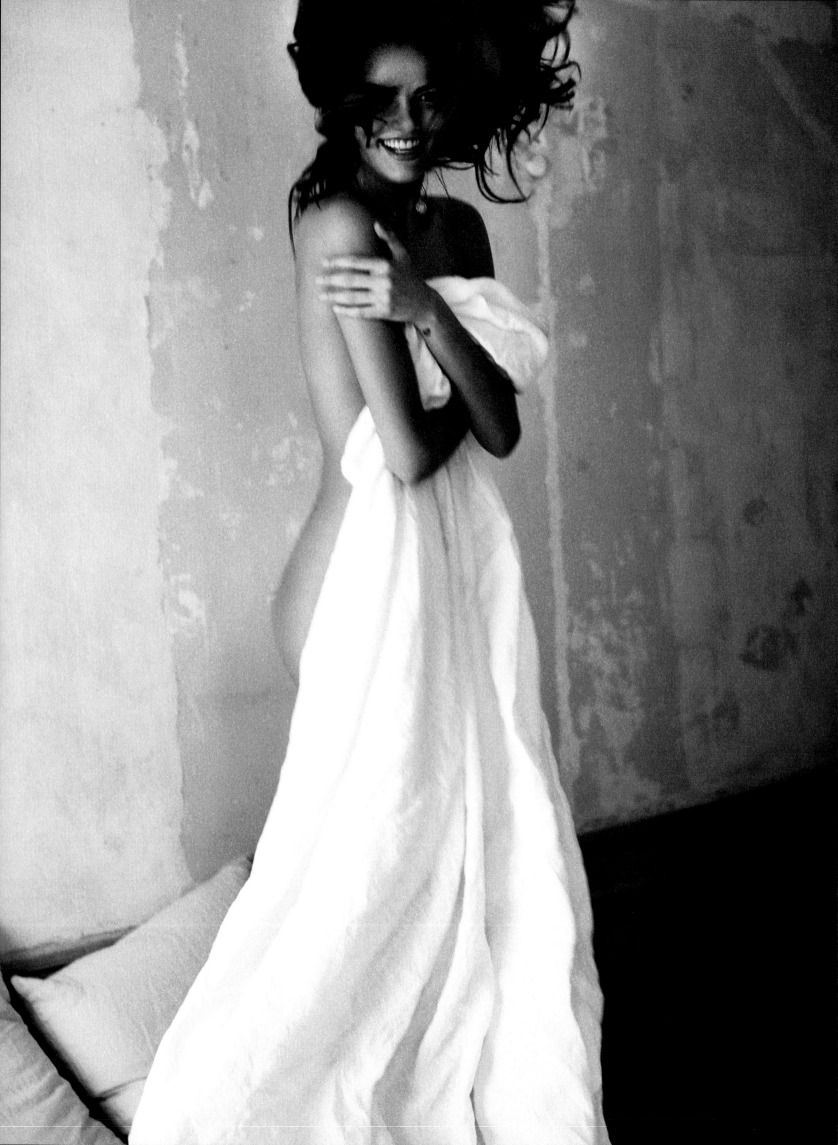

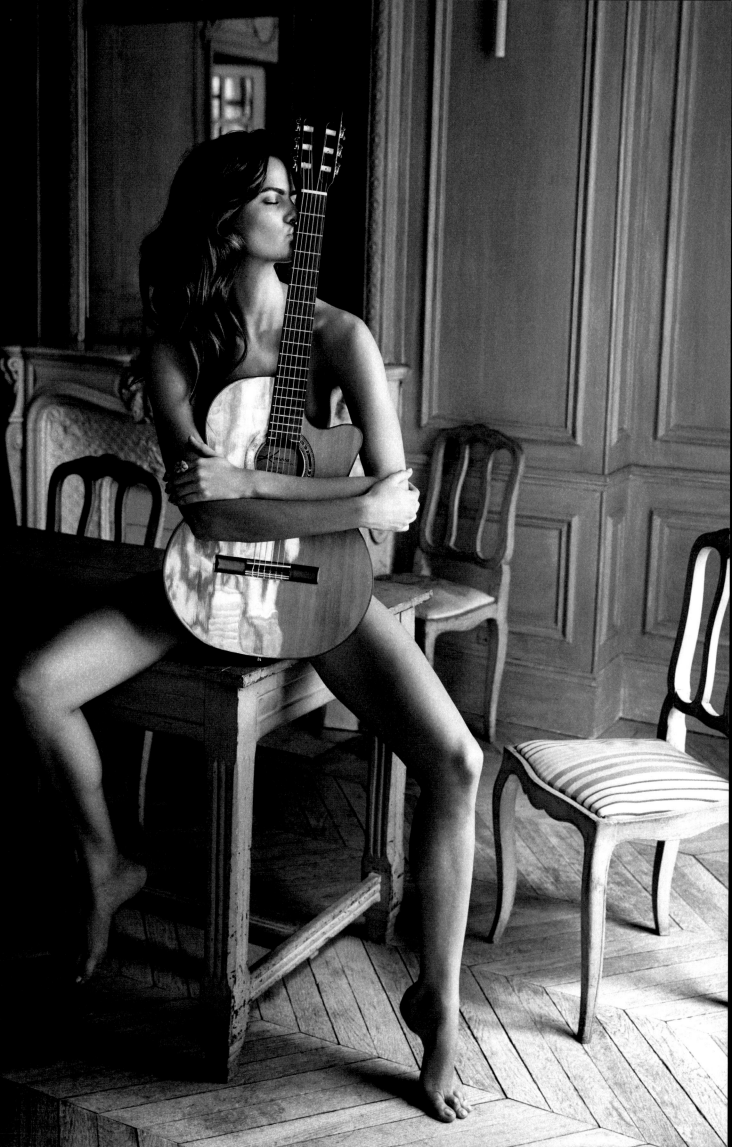

Barbara is a woman who radiates joy, sensuality, and determination. At only twenty-eight years of age she has had enormous success as a model, landing major campaigns for Victoria's Secret, Roberto Cavalli and many others, but what drives her is a dedication to music. She grew up in what she describes as "the middle of nowhere" in Brazil, and was scouted as a model when she was fourteen. She has travelled the world and studied at what she calls "the University of Life," but has never lost touch with the way music shaped her youth.

Because both her parents worked long hours to support the family Barbara spent a lot of time with her grandparents, listening to her grandfather play the guitar and sing. "He was a soul man," she says. "He loved to perform." All of her uncles played the guitar as well. "It's a Brazilian thing to have a guitar and play at the end of the day, on the weekends with your family, when you're doing barbecue. No one needs to play incredibly. You just have to sing and have fun with it."

Barbara started playing the guitar at age nine, in the bossa nova style her grandfather favored, and in the past five years has become serious about making music her career. She released a Latin jazz album of ten Brazilian standards from samba and bossa nova, on which she sings every song and personally invited all of the musicians who participated. One of her goals is to have younger girls learn more about the history and culture of Brazilian music, and she tells me that she added Afro-Cuban percussion to her record to make the music "fun and danceable and relevant" to a younger generation. When I ask her what is the thing that motivates her the most—is it a desire for fame or money or to perform for a living—she knows the answer immediately. "My motivation is to work with music. It's something I can do for fourteen hours straight in a studio with no air conditioning in a tiny little booth and I am so happy. It feeds your soul."

Barbara knows that this commitment to her art may eventually come to a crossroads with her modeling career, which for now pays the bills. "I don't dream of stardom when it comes to music because that can never be your motivation. Especially if you're doing jazz. I never did anything with music that has earned me any money. Very much the opposite." But she says she will take this as it comes, doing everything she can to make music a priority. "My feelings guide me a lot. I had opportunities to record and in the same day, I had a job and I said no to the job and I went to record because I knew that I needed that studio for the project and it had to be at that time because otherwise I would lose a player."

Barbara inspires me to be true to one's passions as an artist. When I look at her I see someone who knows it is easy to fill the days with work that comes naturally and can be well-rewarded, but is not the work that most fully challenges and transforms. "Music has always been in my heart, always," she tells me. "My heart beats for it. I love it." ♥

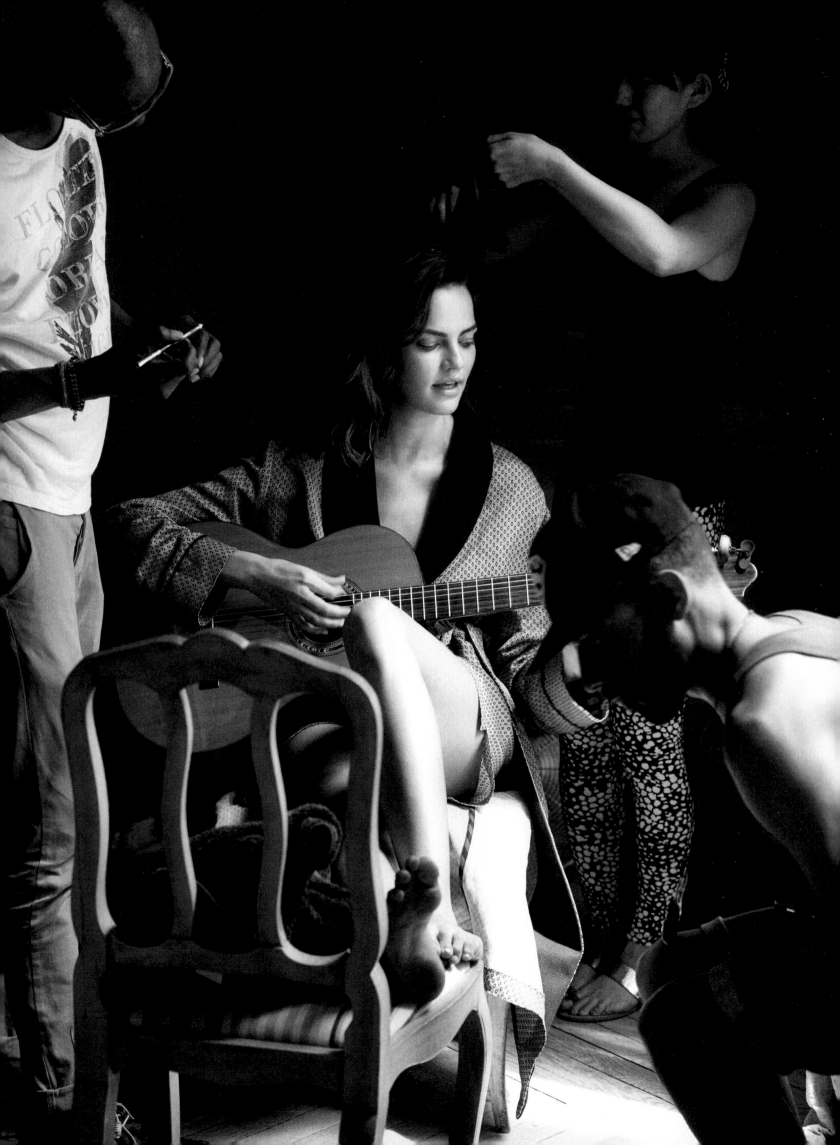

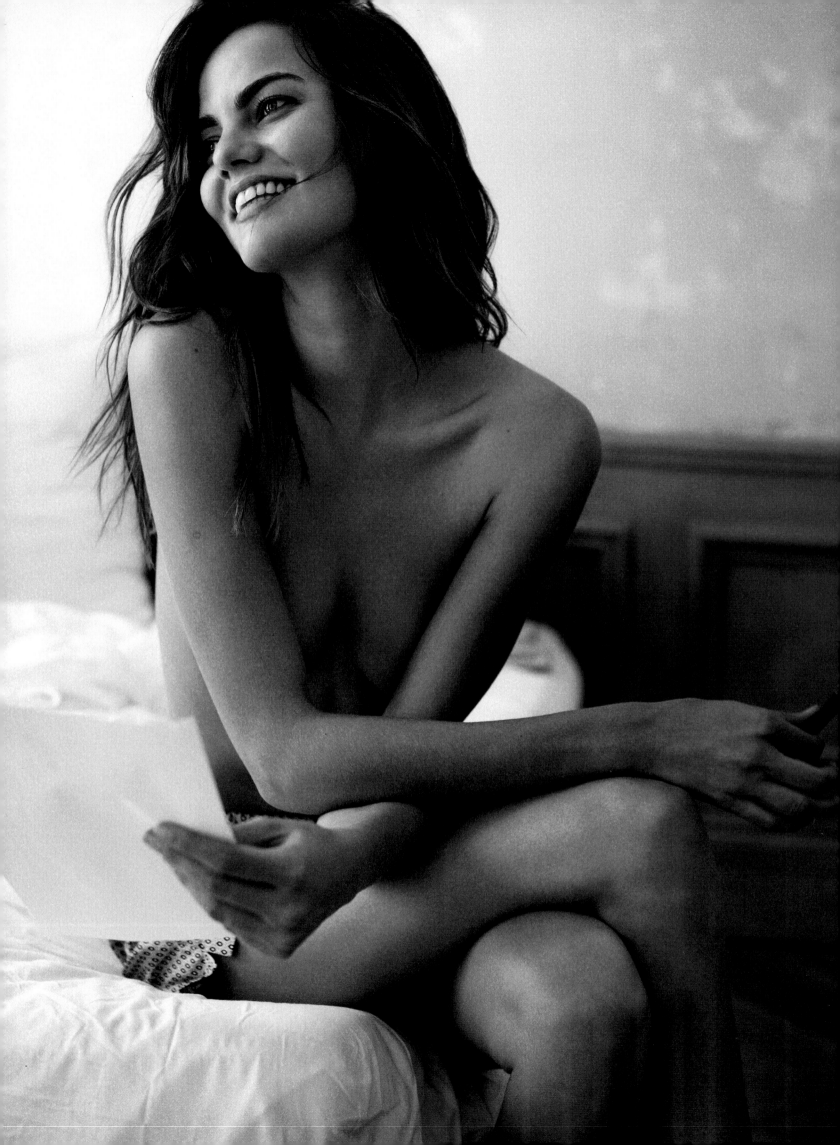

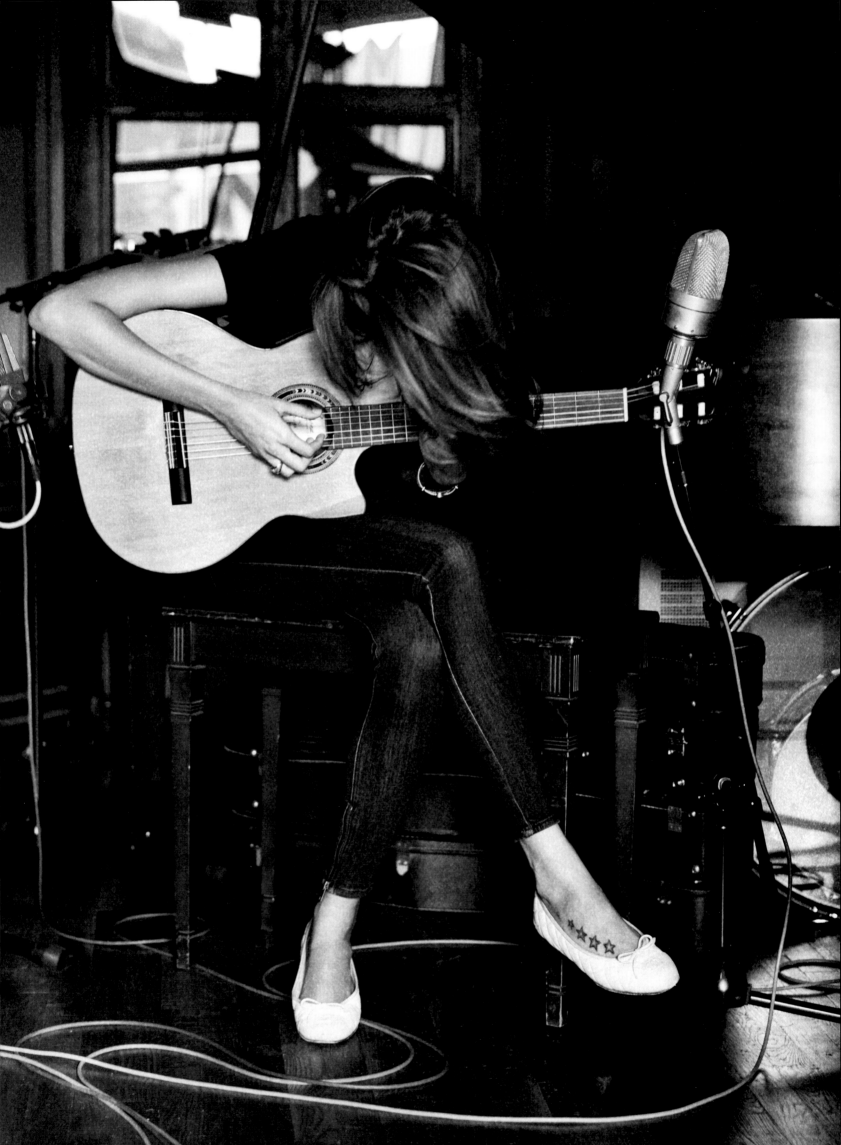

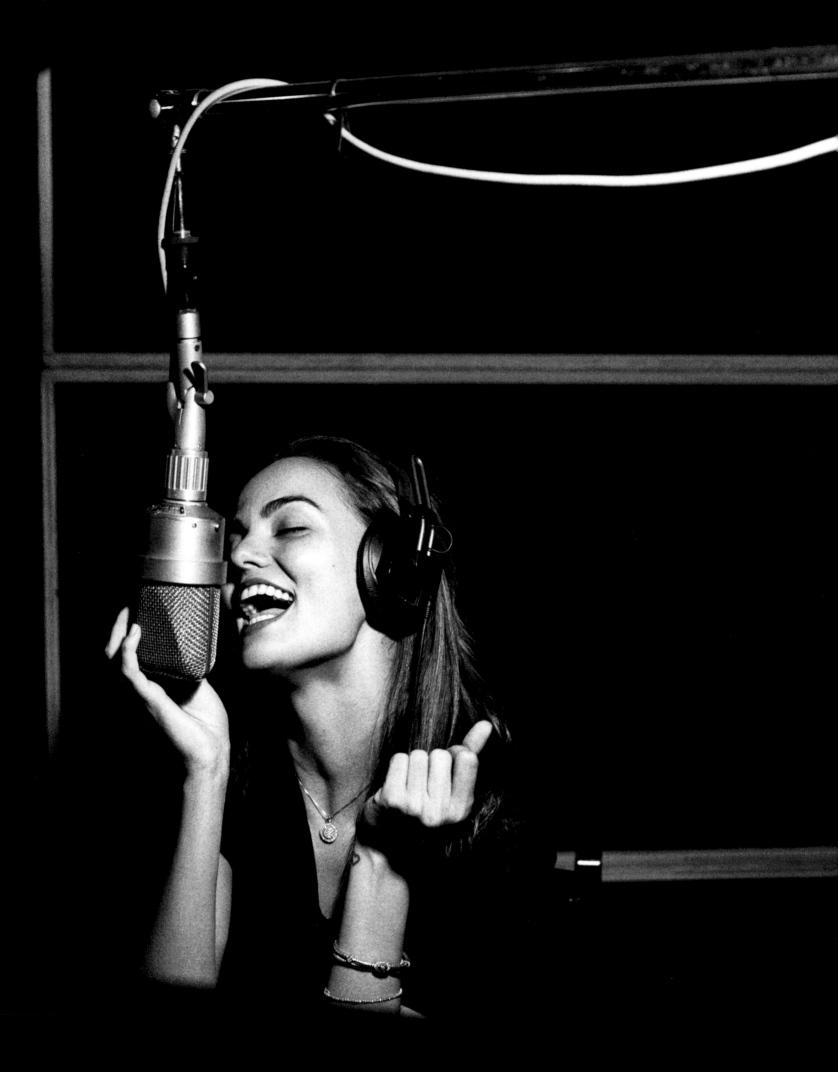

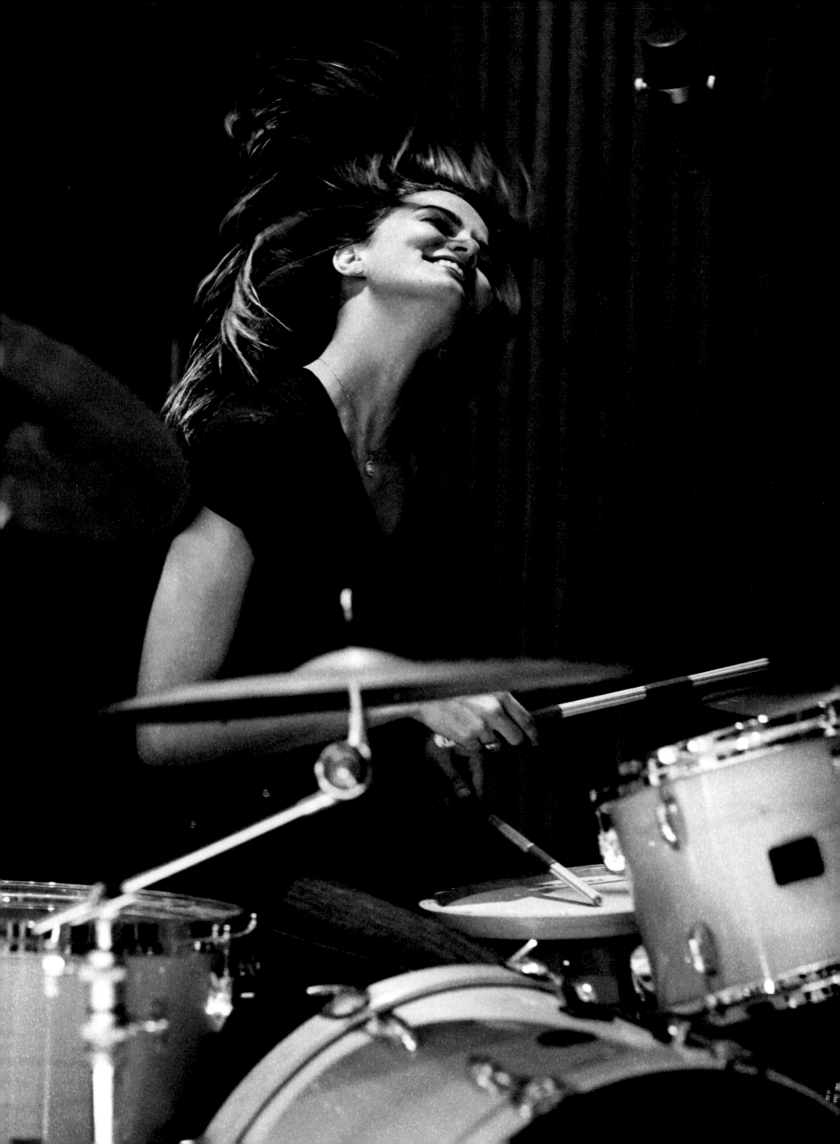

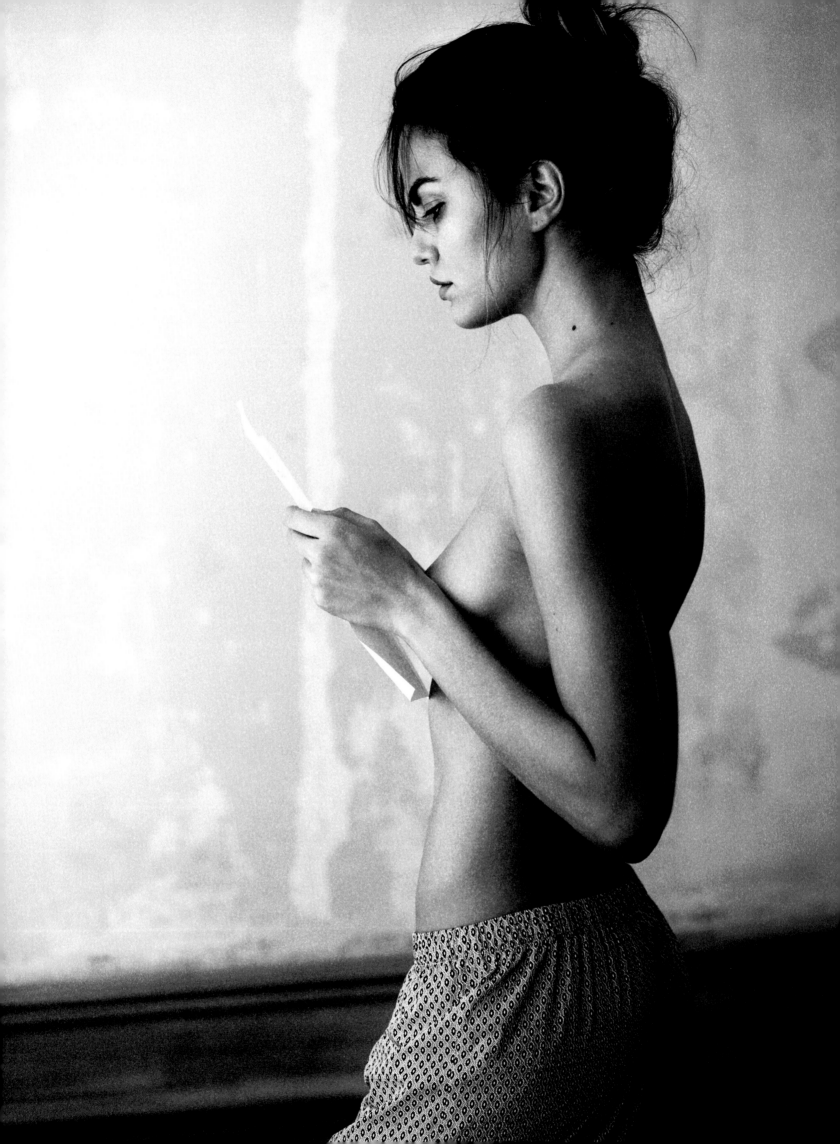

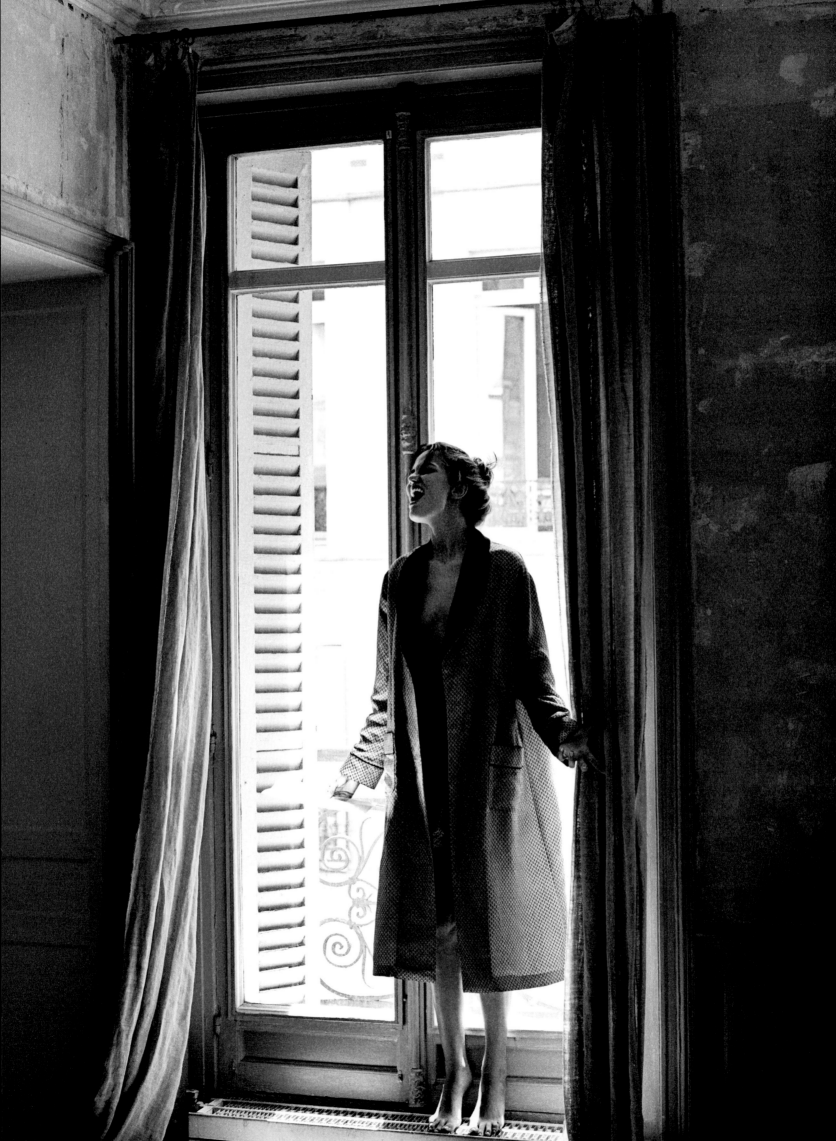

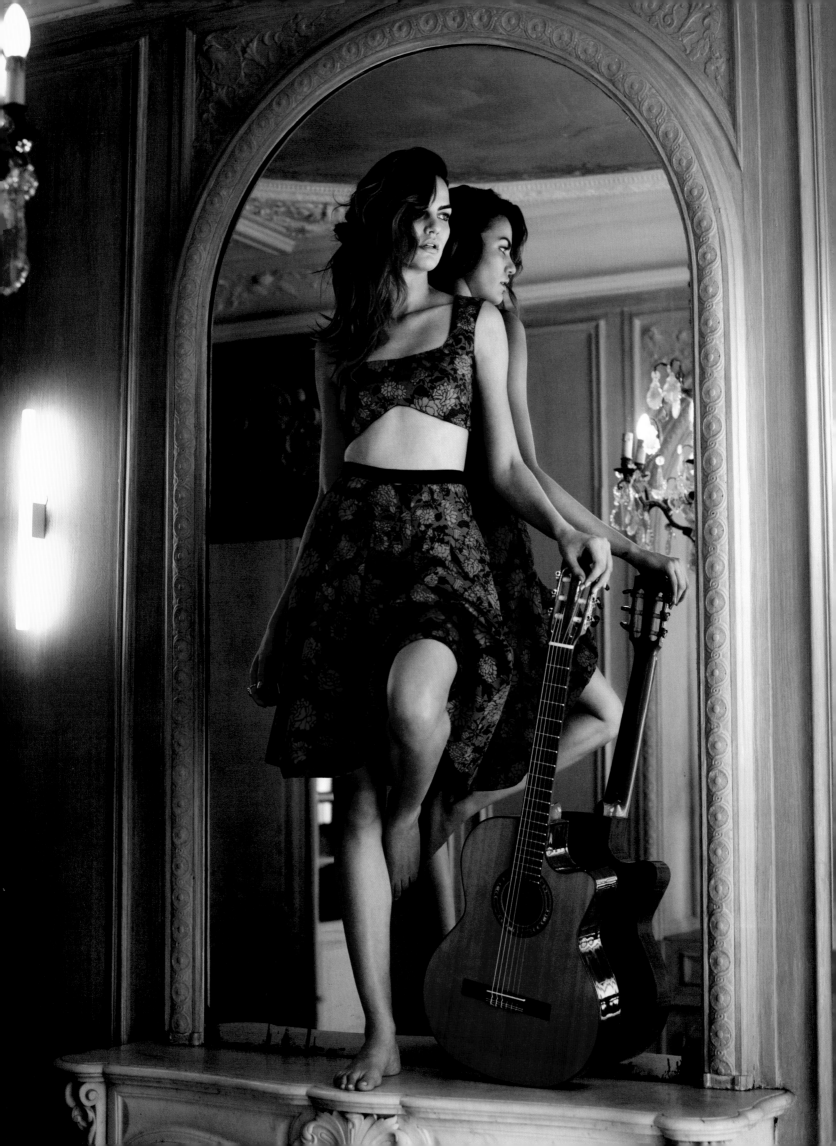

"Music has always
been in my heart, always.
My heart beats for it.
I love it."

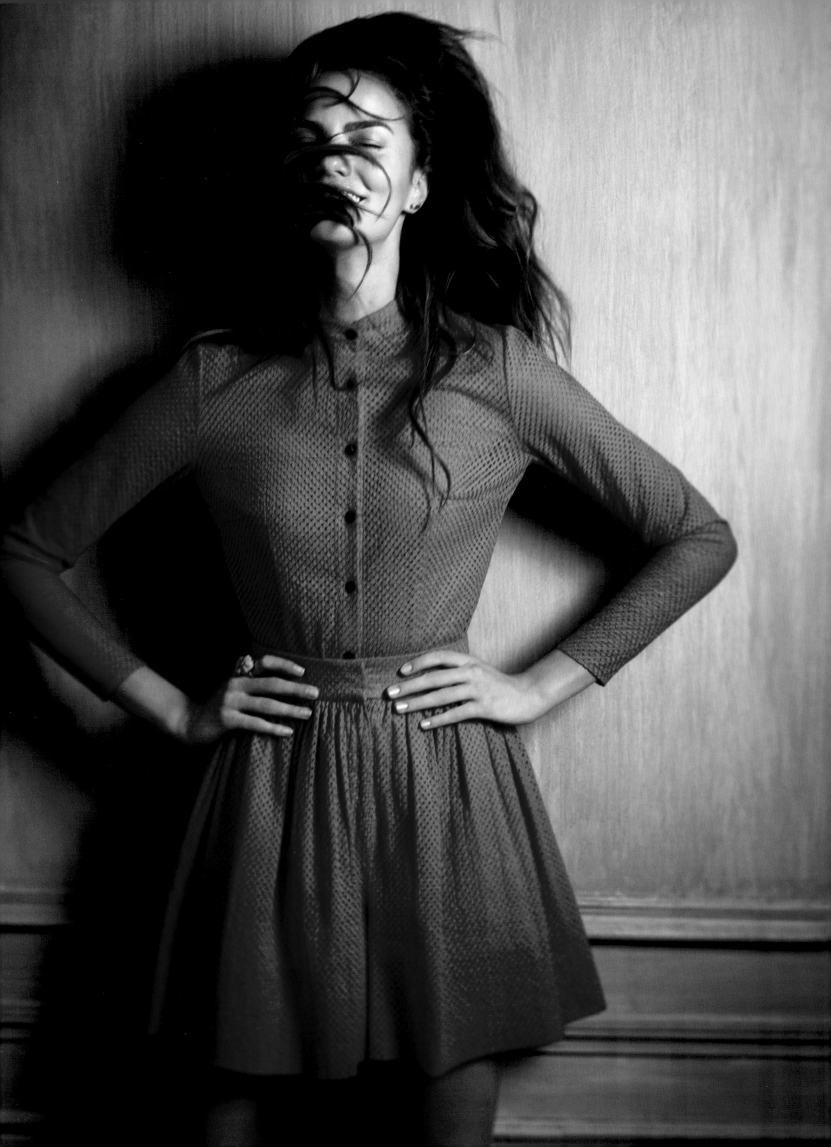

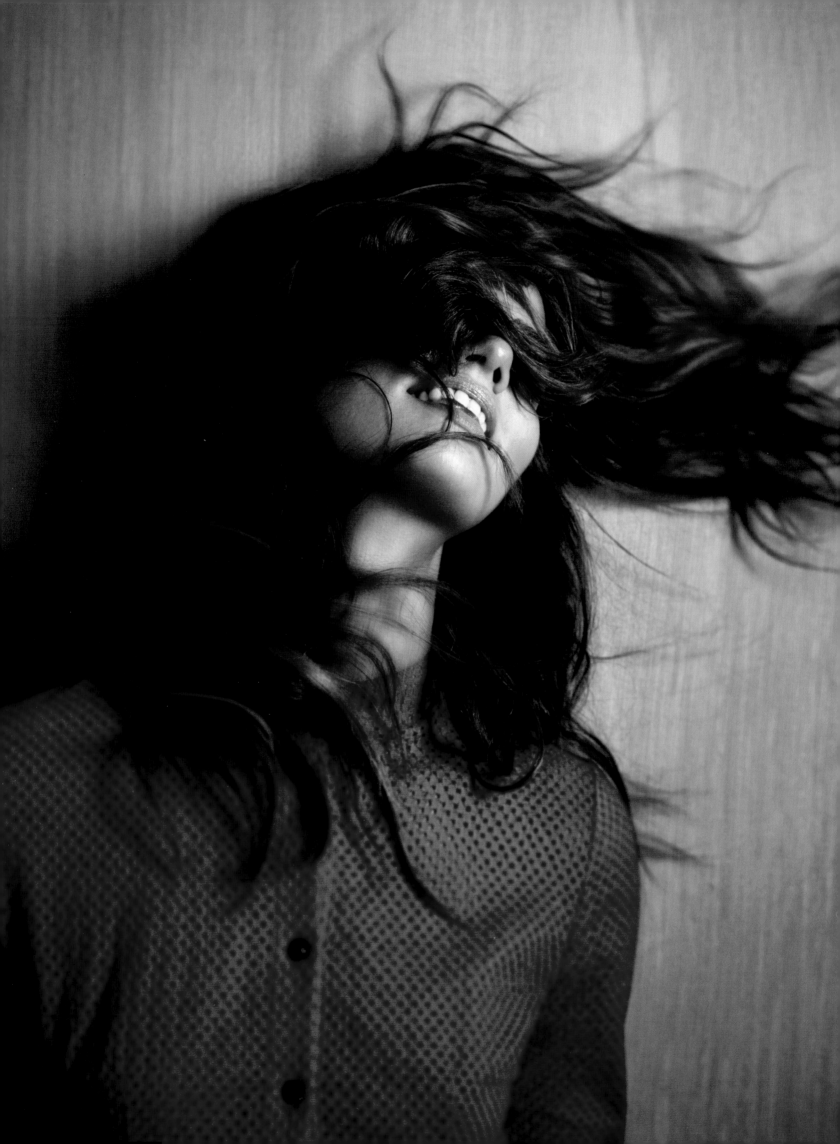

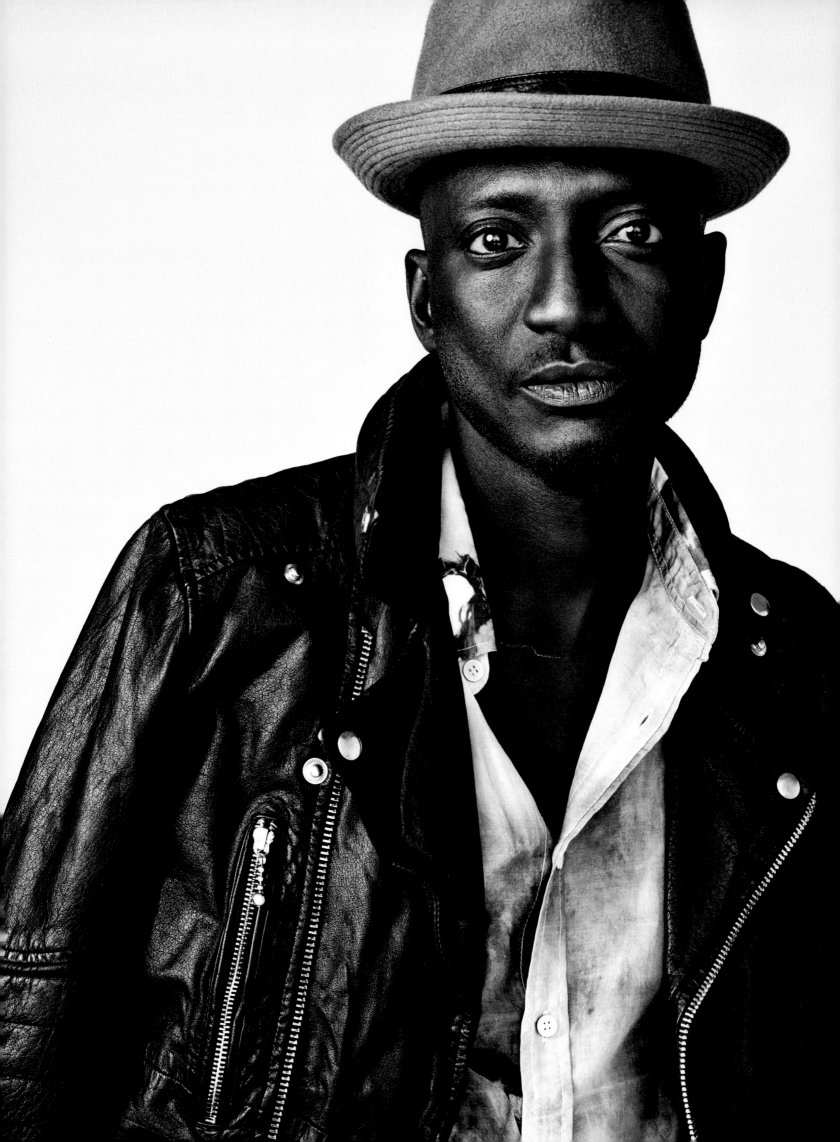

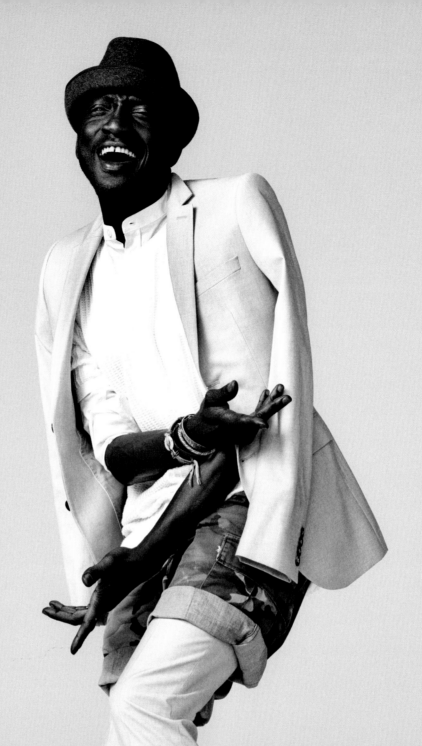

Jenke Ahmed Tailly

Jenke Ahmed Tailly is a true polymath. He hails from the Ivory Coast and now lives and works in Paris and New York City. He works as a stylist, creative director, and producer, for mega-celebrities like Beyoncé and Kim Kardashian, but also for artists just starting out, who are virtual unknowns. When I talk with him I always feel that his imagination is exploding with ideas and influences, drawing from his love of film, music, art, and fashion. I am inspired by the depth and range of his cultural references.

When I ask Jenke to talk about how Africa has influenced his work, he is quick to point out that Africa is a place of so many countries, and so many diverse cultures, that it is impossible to specify. "Africa is Morocco, Egypt, Libya, and they're all different from sub-Saharan Africa. The climate is different. The vegetation is different. The populations are composed of different components and the religions are different." It is the vastness and diversity which motivates him, the refusal of a place and people to be categorized by one label. Jenke can be a man who is hard to pin down. He draws widely and freely from the various customs and styles he has been exposed to in his life. He tells me about his grandfather, who could move effortlessly from participating in traditional village rituals where he grew up in the Ivory Coast, to wearing a made-to-measure three piece suit and talking high philosophy.

Jenke has inherited this ability to link the old with the new; the indigenous with the exotic and foreign. He sees his role as being that of a connector—bringing the right people together in the right moment, and putting them "in the right state of mind to let go of everything and create." He is drawn to performers because they are people who are always looking for that connection with an audience, and admits that "deep inside of me I really wish I was a performer." His job as a creative director is "like the job of an actor. You're able to play all these different characters." He is fascinated by people who can use their bodies to produce compelling sounds, or visual beauty, or a piece of art—"things that stimulate all our senses."

As an artist Jenke reminds me how important it is to always be learning, always deepening one's awareness of the world around them. In the end, Jenke says his work is "all about beauty. We are all trying to sell this universal connection we have." It is also about knowing oneself profoundly, embracing both our origins and the journeys away from them that have so much to teach us. Jenke's parting words to me are full of the wisdom and complexity that define him: "You make new steps when coming closer to home, to who you really are." ♥

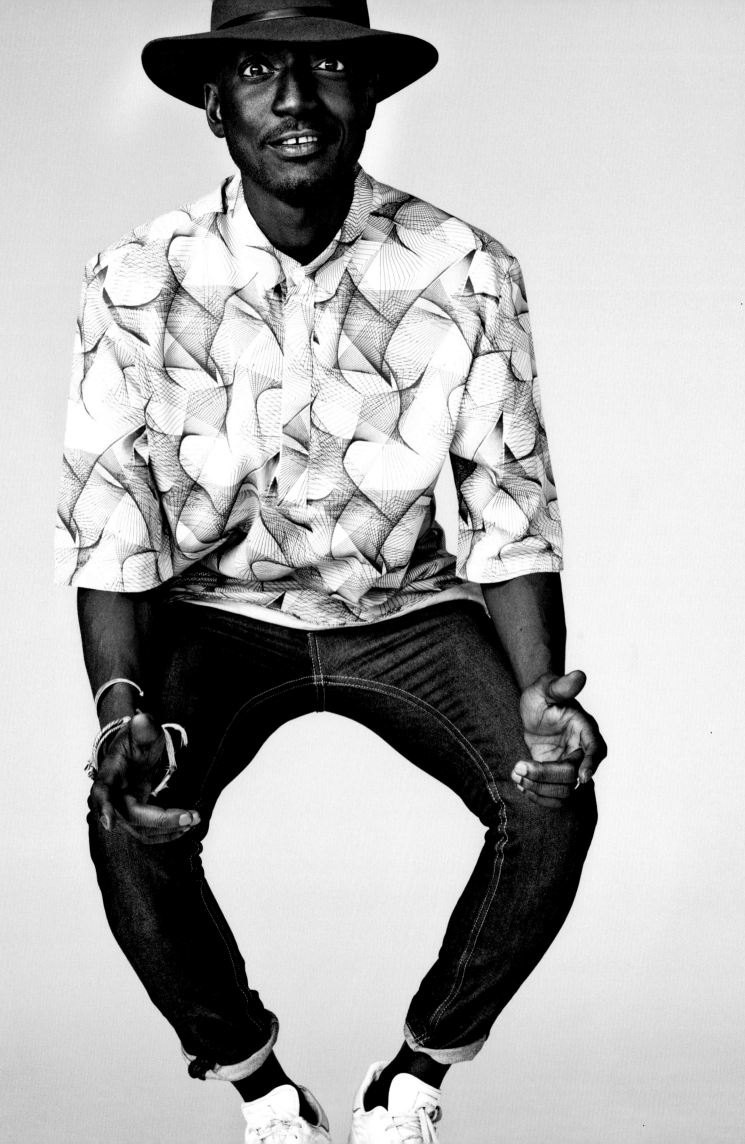

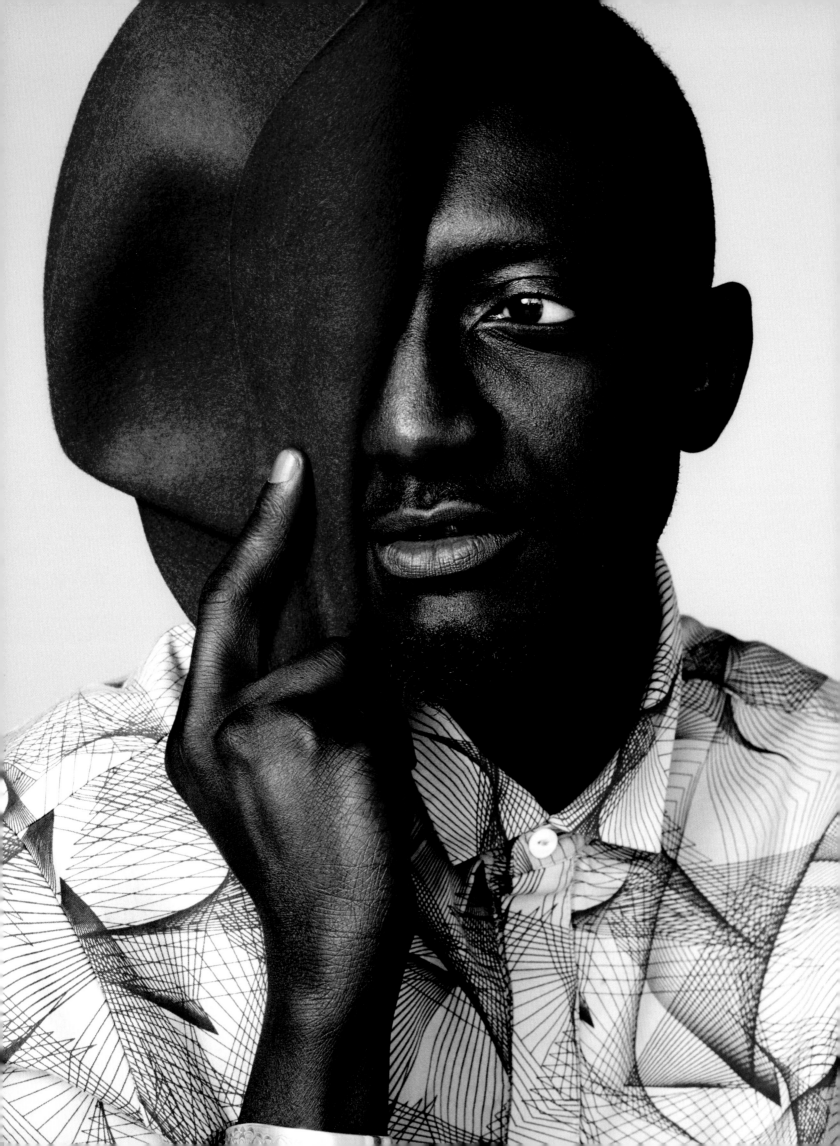

"You make new steps
when coming closer to home,
to who you really are."

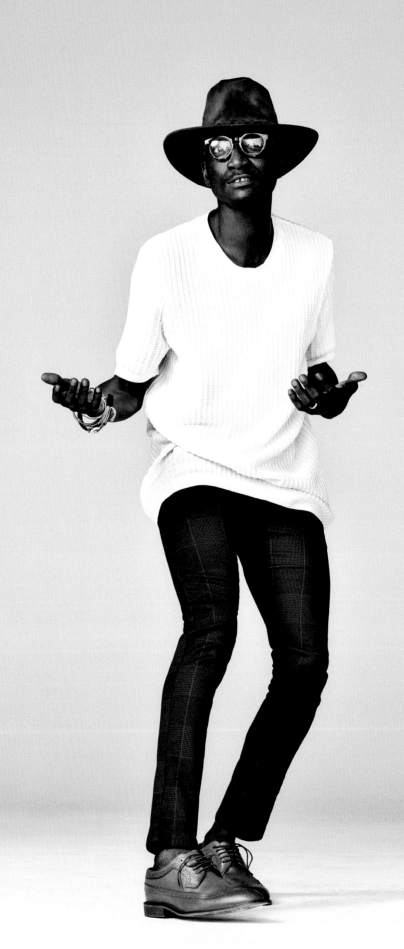

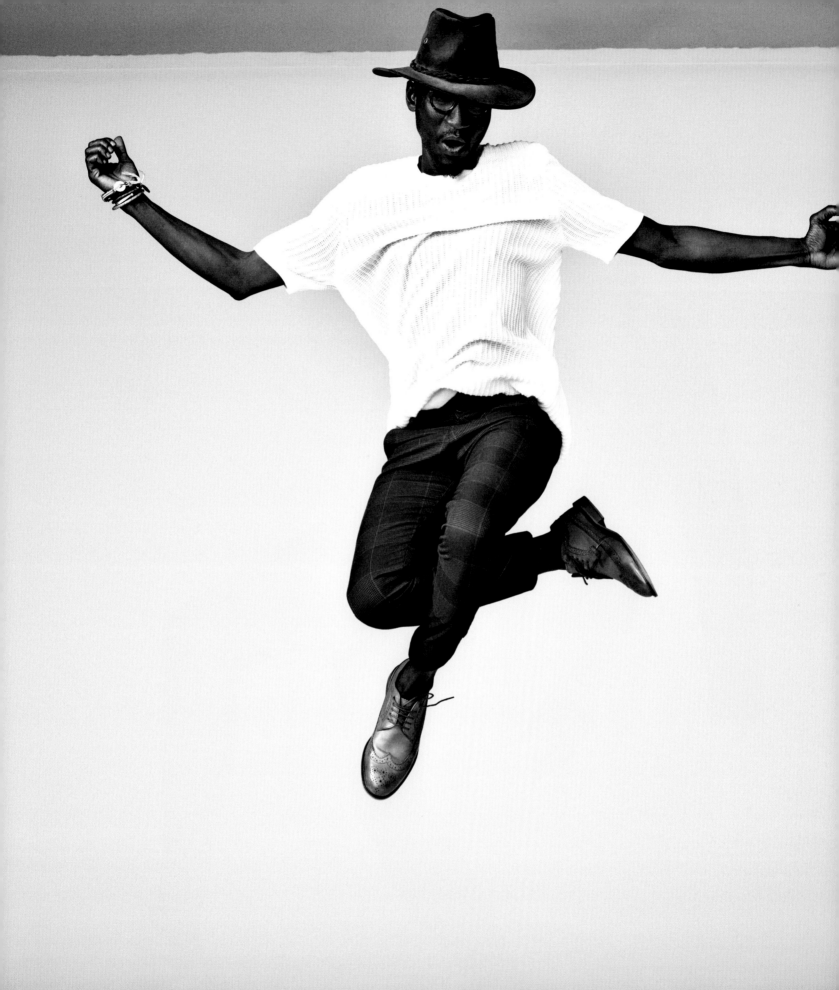

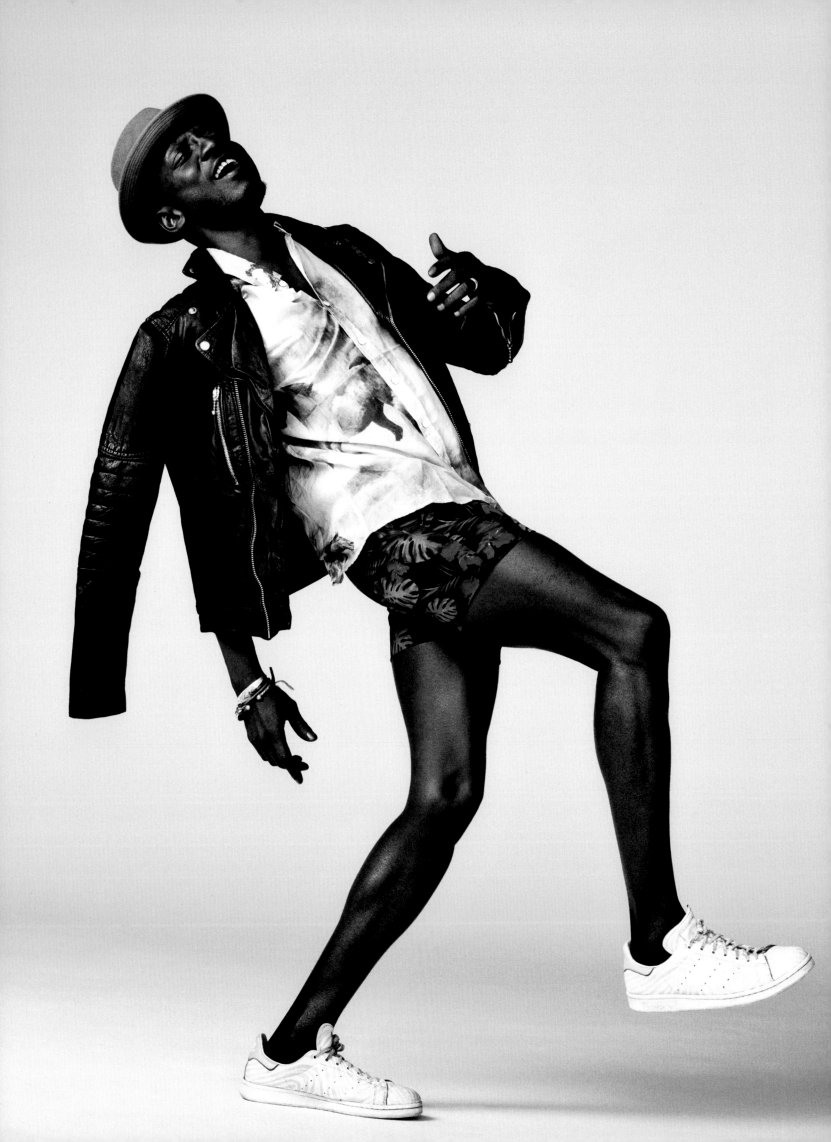

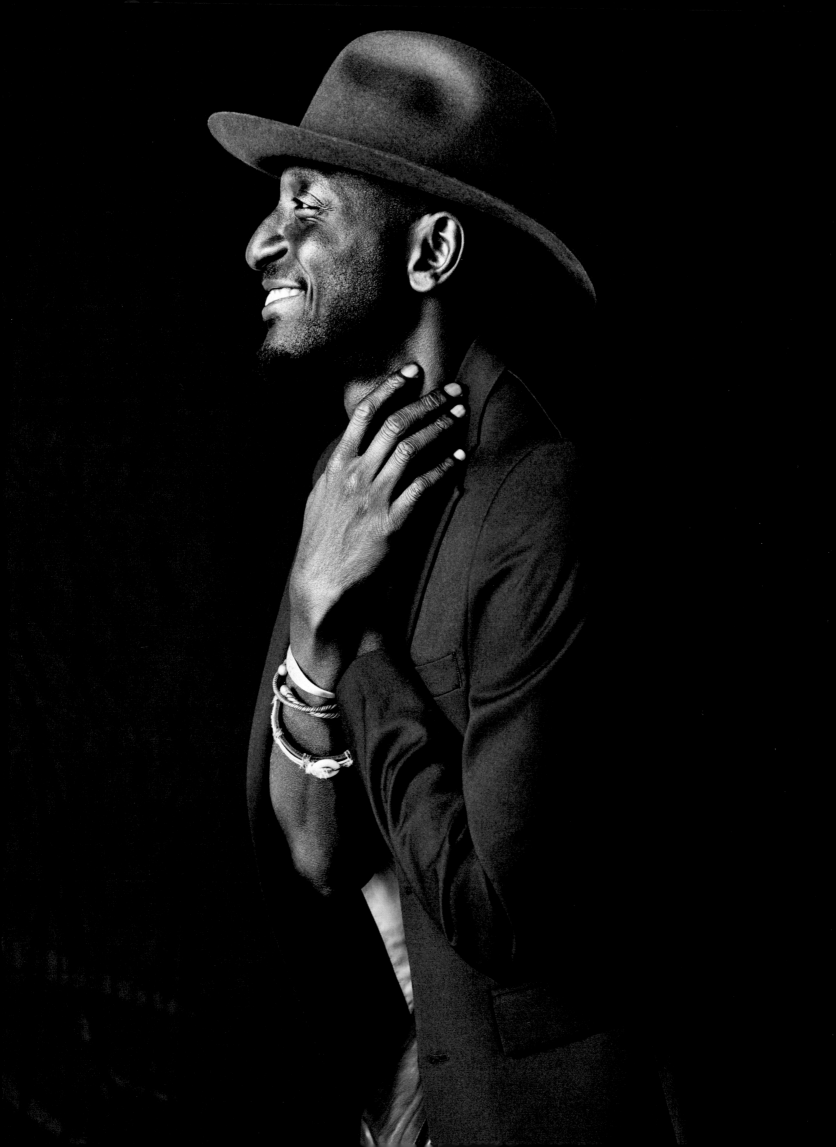

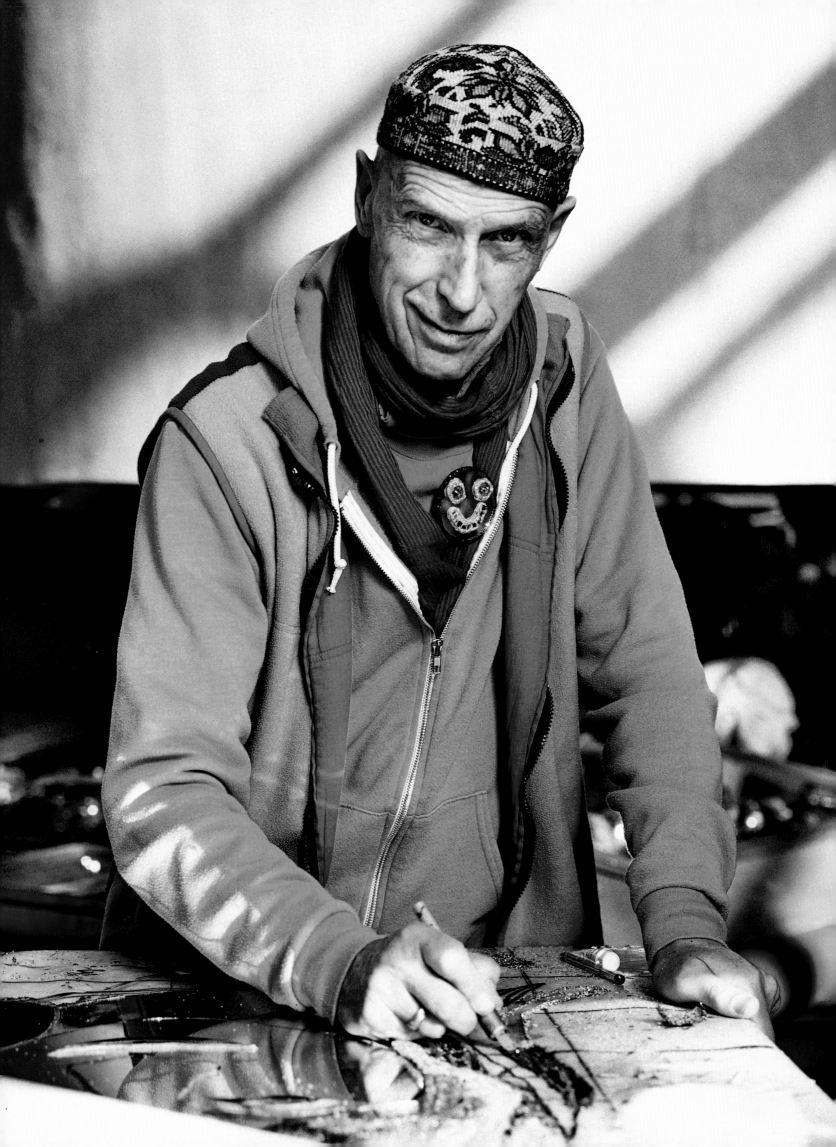

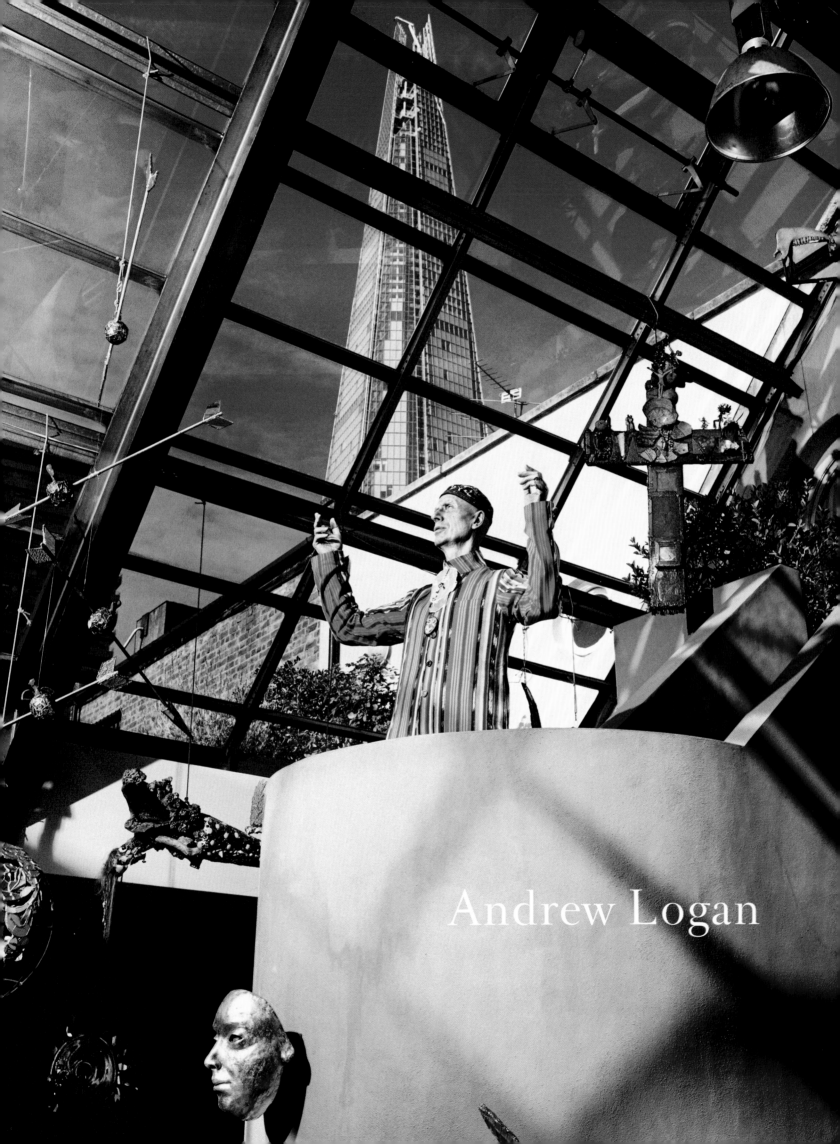

Andrew Logan

Andrew is a delightful English eccentric, acclaimed sculpture artist, and also a yoga instructor. I love his idiosyncratic and colorful studio (where we shot this series). It's like a magical grotto populated with his friends, fellow artists and collaborators. Andrew is an unconventional person who says he wants to bring a little joy into the world, and who loves to make people smile when they see his work, so full of wit and charm. "My message to the world is a celebration of life, and joy. I want, in my lifetime, which isn't very long, to make as much as possible for everyone to enjoy. I can make beautiful things that bring smiles to people's faces, whether it's for two seconds or two minutes."

I love this: this goal of making people smile. It is one that I share with him although the styles and mediums of our work are totally different. I have always loved this idea that people have some kind of emotional response when they see my pictures, so you can imagine how good it feels to find out that an artist of Andrew's stature has a similar objective. Andrew is incredibly prolific and this is another attribute of his that I greatly admire. When I started out as a photographer I wanted a long and prolific career and this is what Andrew represents to me: an artist who is still working in his late sixties and shows no sign of slowing down. He is doing what he loves after all. "For me," he says, "art is a total dedication. I've dedicated my life to it."

I photographed Andrew in his phenomenally colorful and quirky London studio and home. He has named it the "Glasshouse," a name that befits the wonderful light that floods into the space, even on a dull London day. Glass is also his chosen medium for creating his astonishing and wondrous sculptures. He describes the glass he works with in spiritual terms—as something "almost cosmic… mirror is light and glass is light, so you are playing with light … it's a physical thing, it's solid, but actually it's light and I get more and more fascinated with that."

Andrew's sense of fun and love of ritual can be found in his work but also in a decadent event he hosts called "The Alternative Miss World." He describes it as "a big sculpture, even though it includes quite a lot of people. I call it an art event for all-round family entertainment. It's inspired by Crufts Dog show, because it's all based on poise, personality, and originality—it's nothing to do with beauty. It's organized chaos!" When the Alternative Miss World is named Andrew places a specially sculpted crown on the winner's head.

>

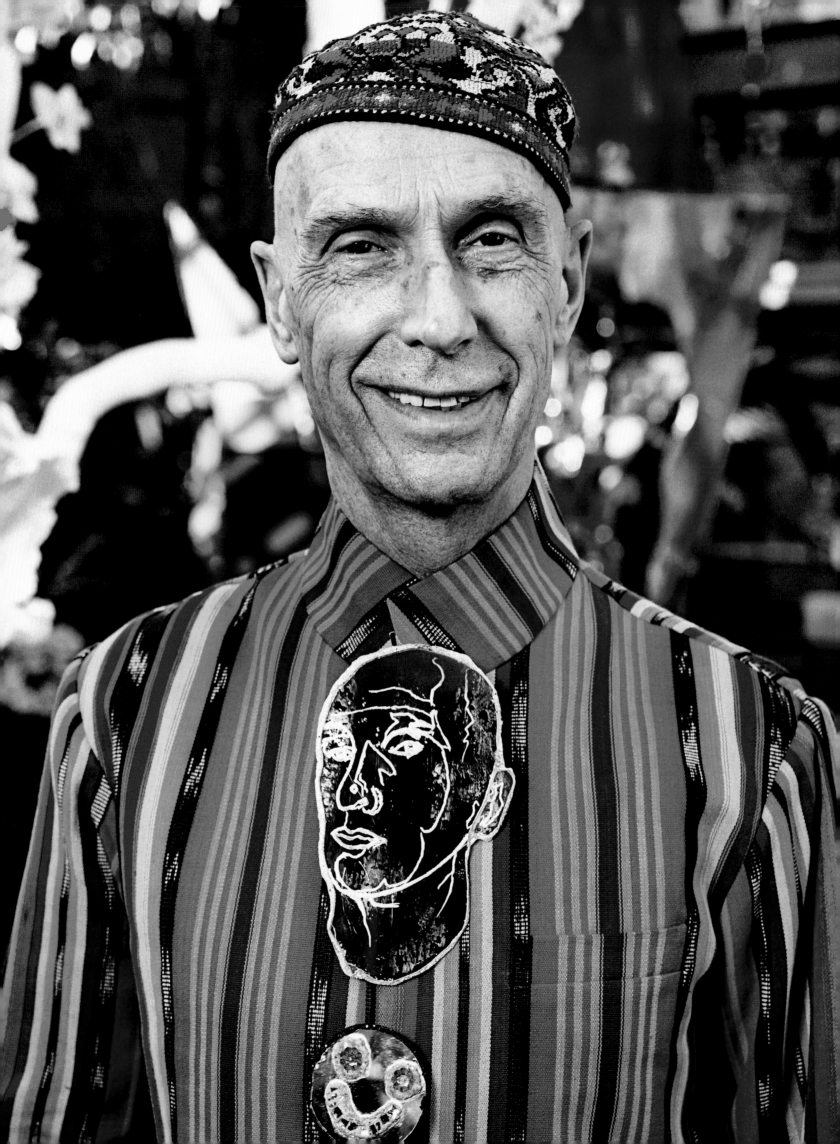

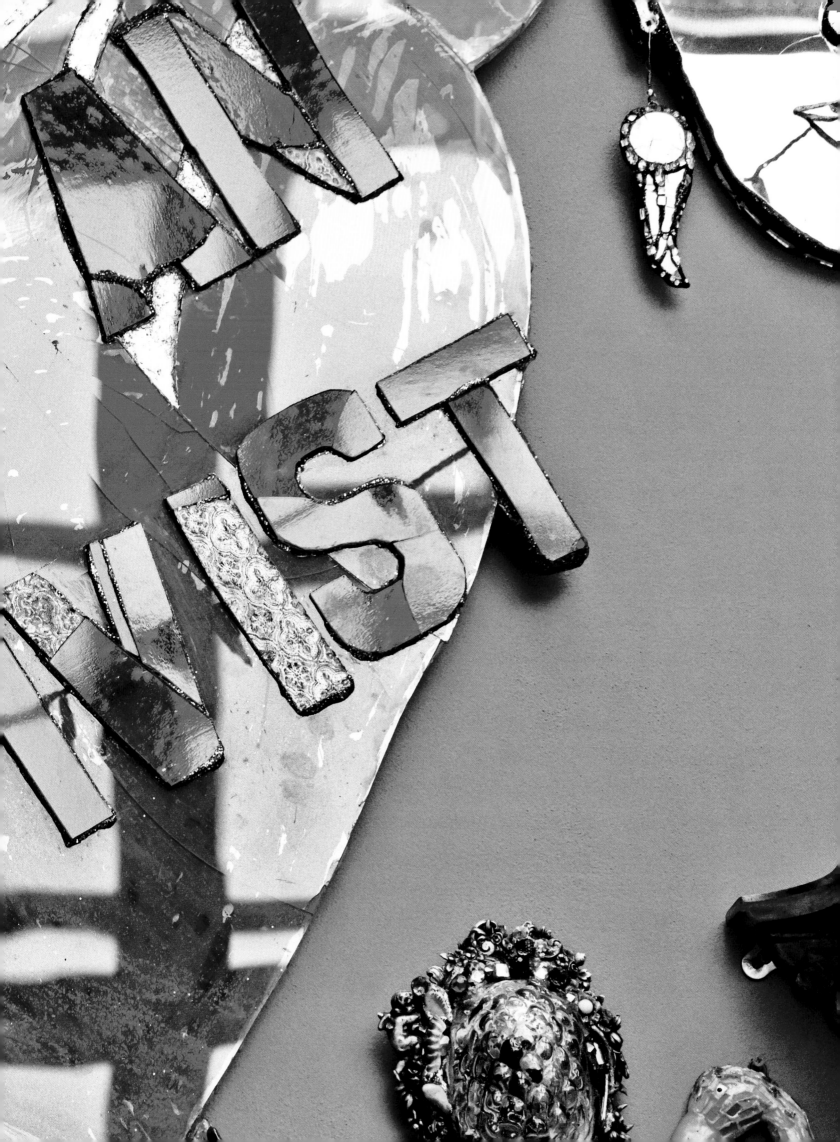

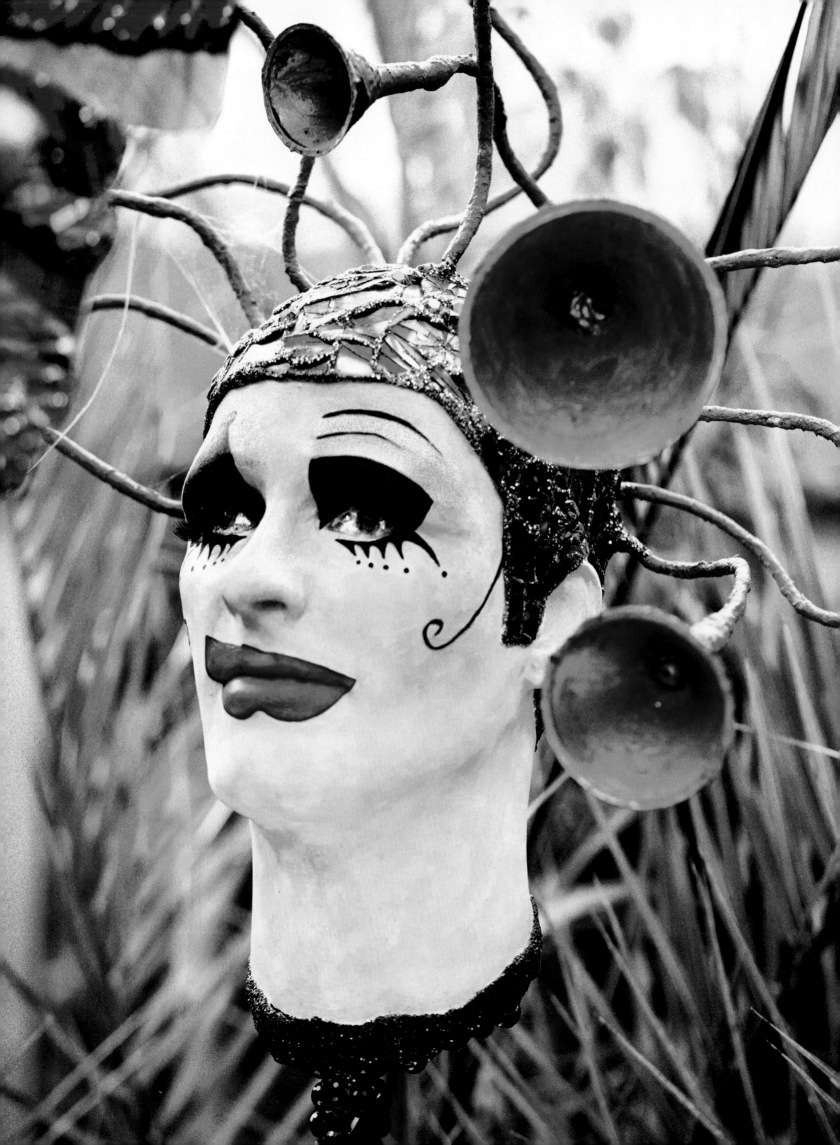

"For me, art is a total dedication. I've dedicated my life to it."

Andrew describes himself as "very spiritual" but not particularly religious, and describes his work as "very much the physical embodiment of the spiritual." Andrew has had a long and affectionate relationship with India, where he spends three months of the year. He first went there in 1982 with his long time friend the designer Zandra Rhodes. He describes how it felt like he was coming home when he first arrived there because all the colors and imagery mirrored his own. He is currently negotiating a huge installation at the new Mumbai airport.

Andrew is memorable for his flamboyant outfits. His first Nehru suit was designed for him out of pure silk by Barbara Hulanicki from Biba. Since then he has had numerous copies made in India. The addition of his huge brooches turns him into a kind of walking gallery for his own work.

Finally, Andrew is a yoga disciple and teacher. In this I am sadly a mere lifelong yoga novice, in that I keep starting and then stopping and lack the willpower to adhere to sustained practice. However, I love yoga and greatly admire those who make it part of their way of life. So Andrew represents what could be rather than what is for me in this area of life. ♥

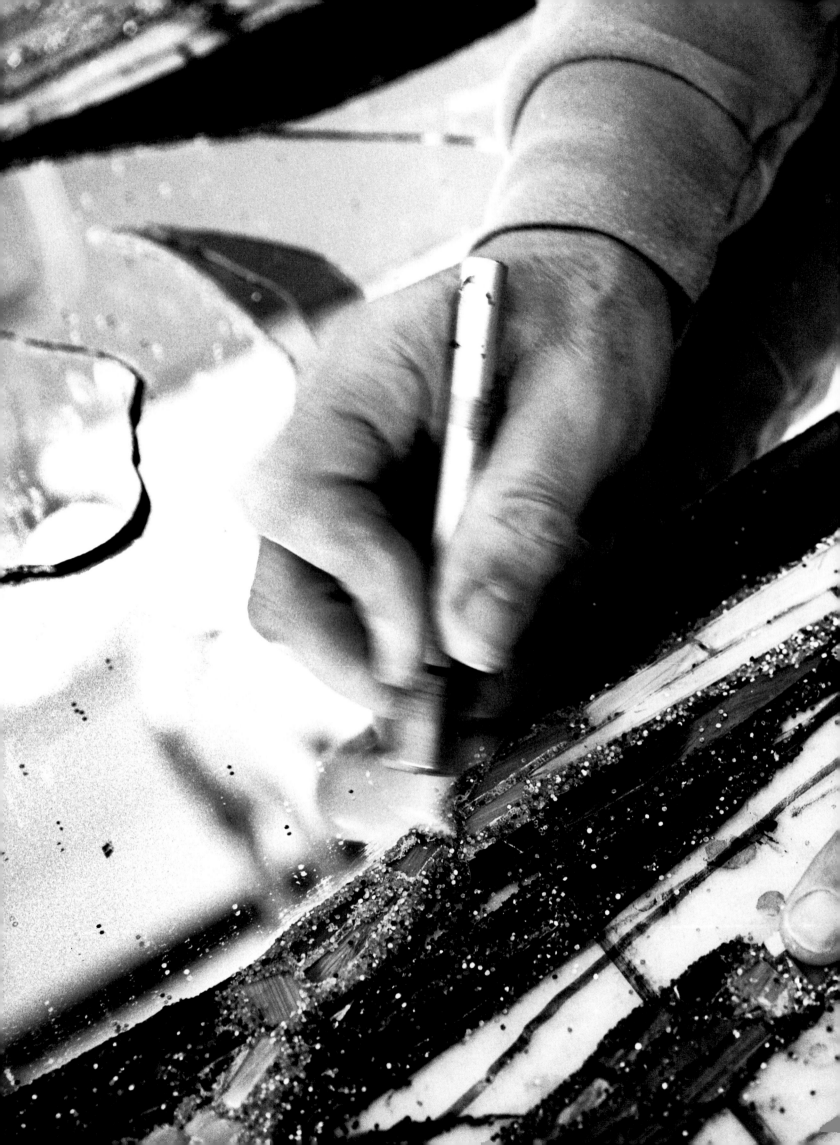

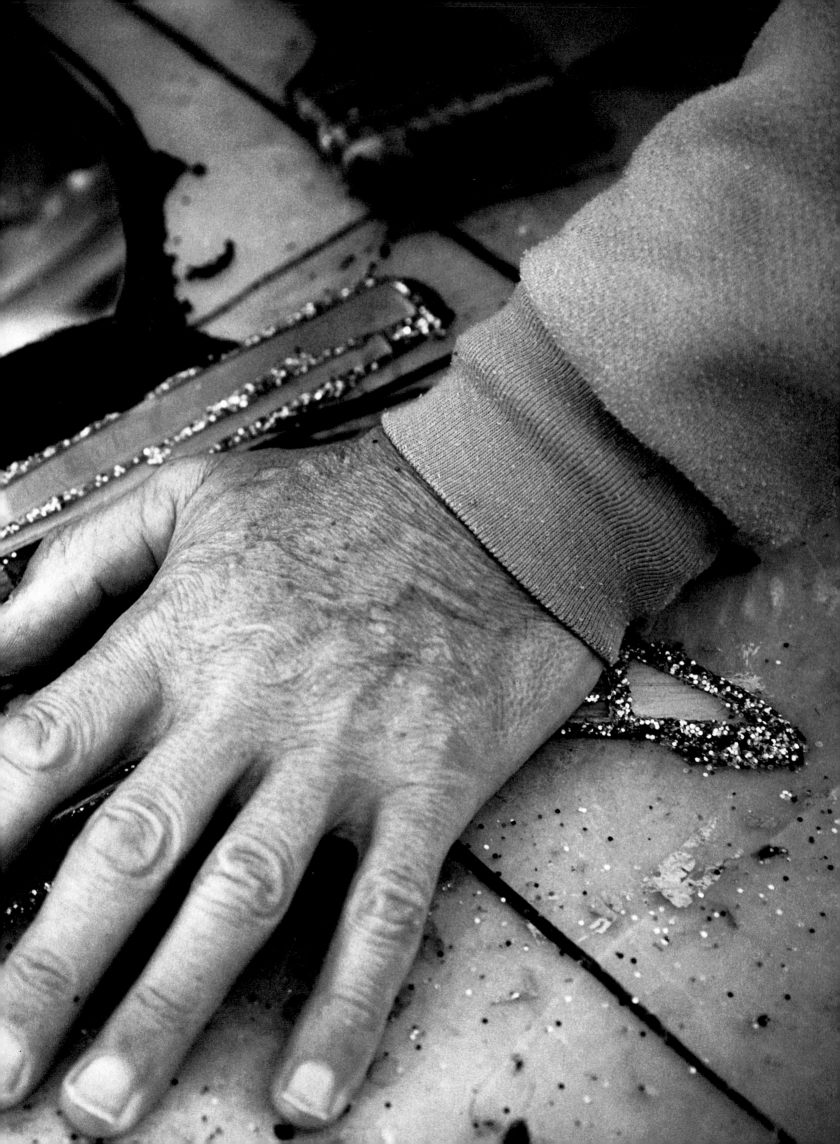

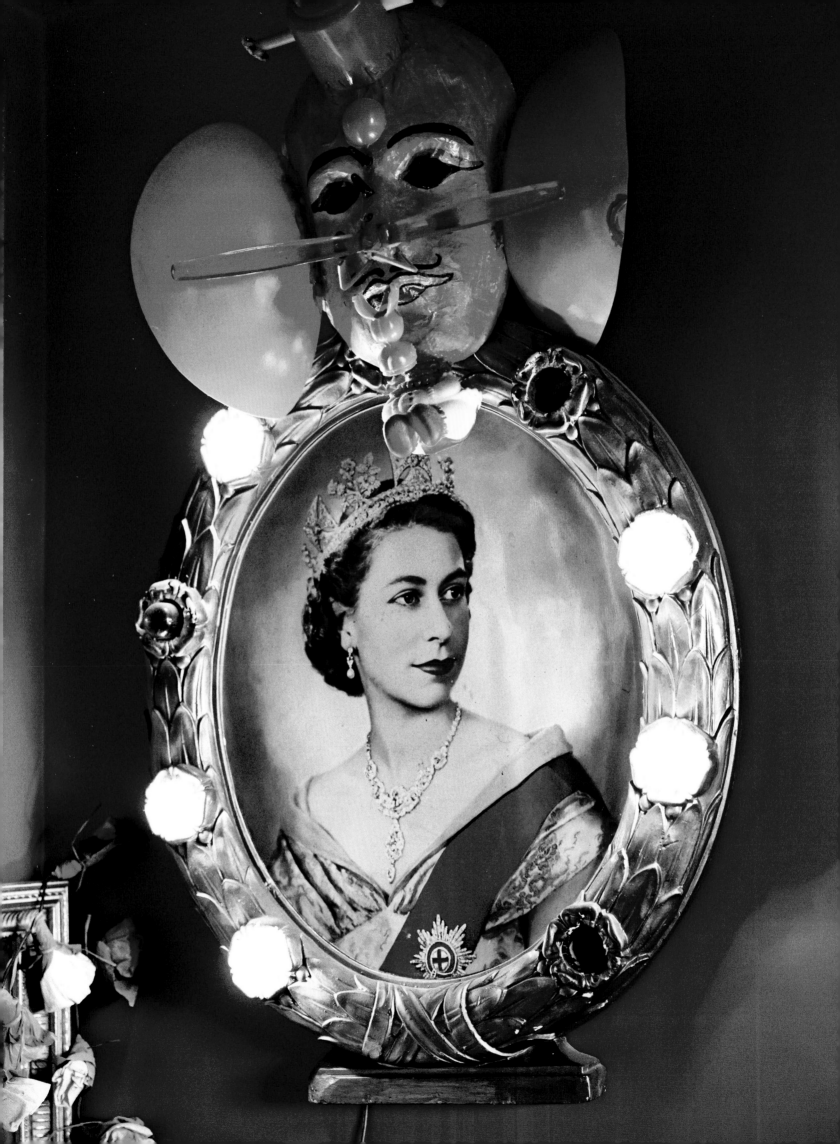

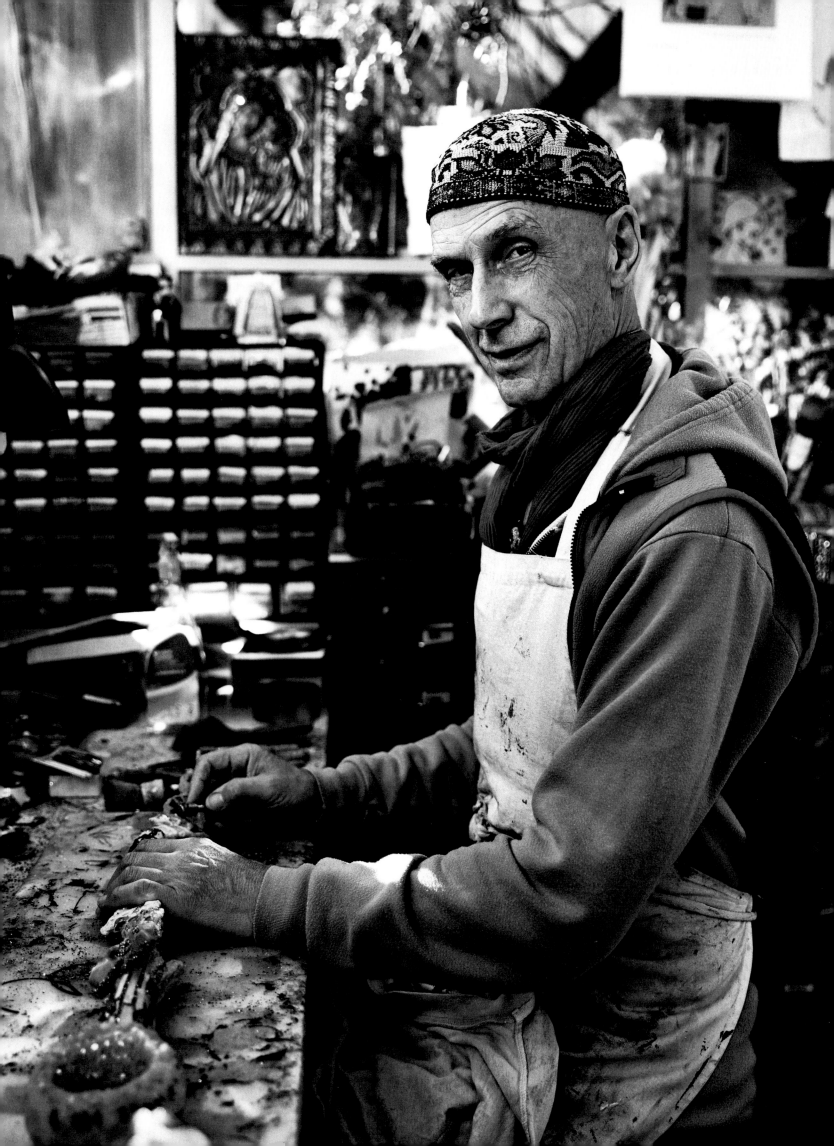

"My message to the world
is a celebration of life, and joy.
I want to make as much
as possible
for everyone to enjoy.
I can make beautiful things
that bring smiles
to people's faces, whether it's
for two seconds or
two minutes."

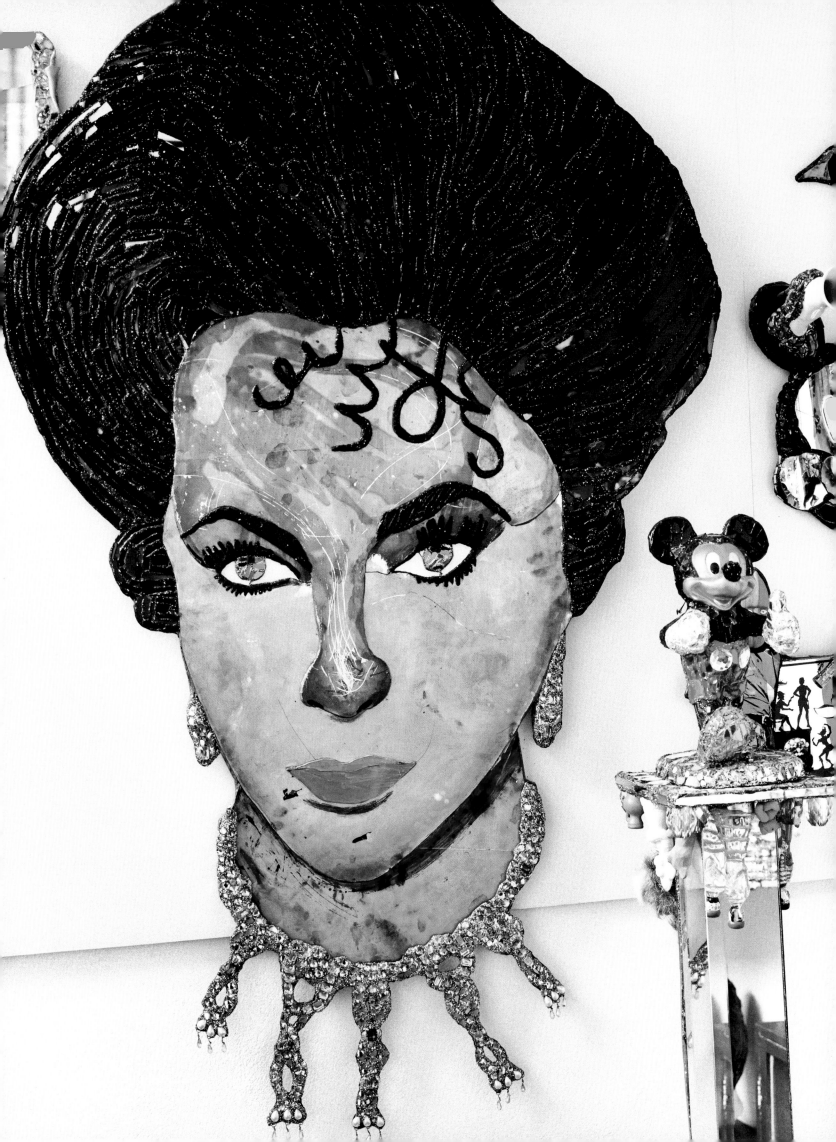

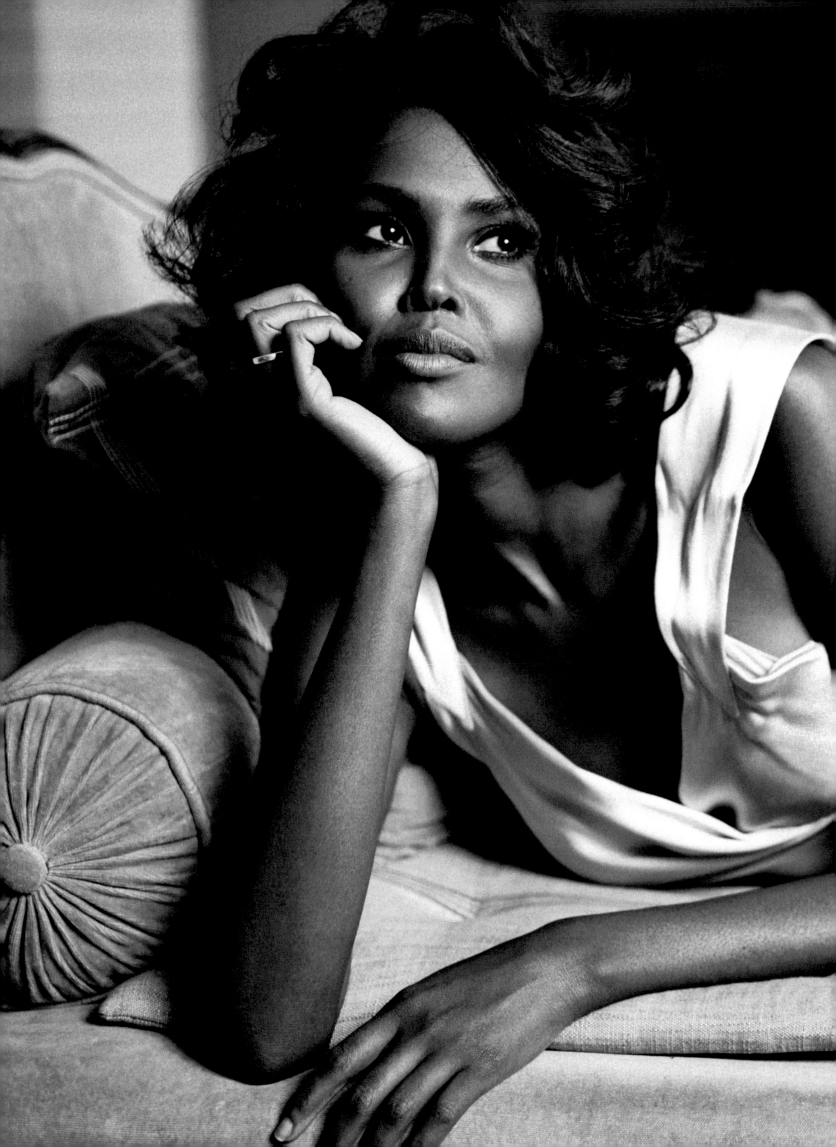

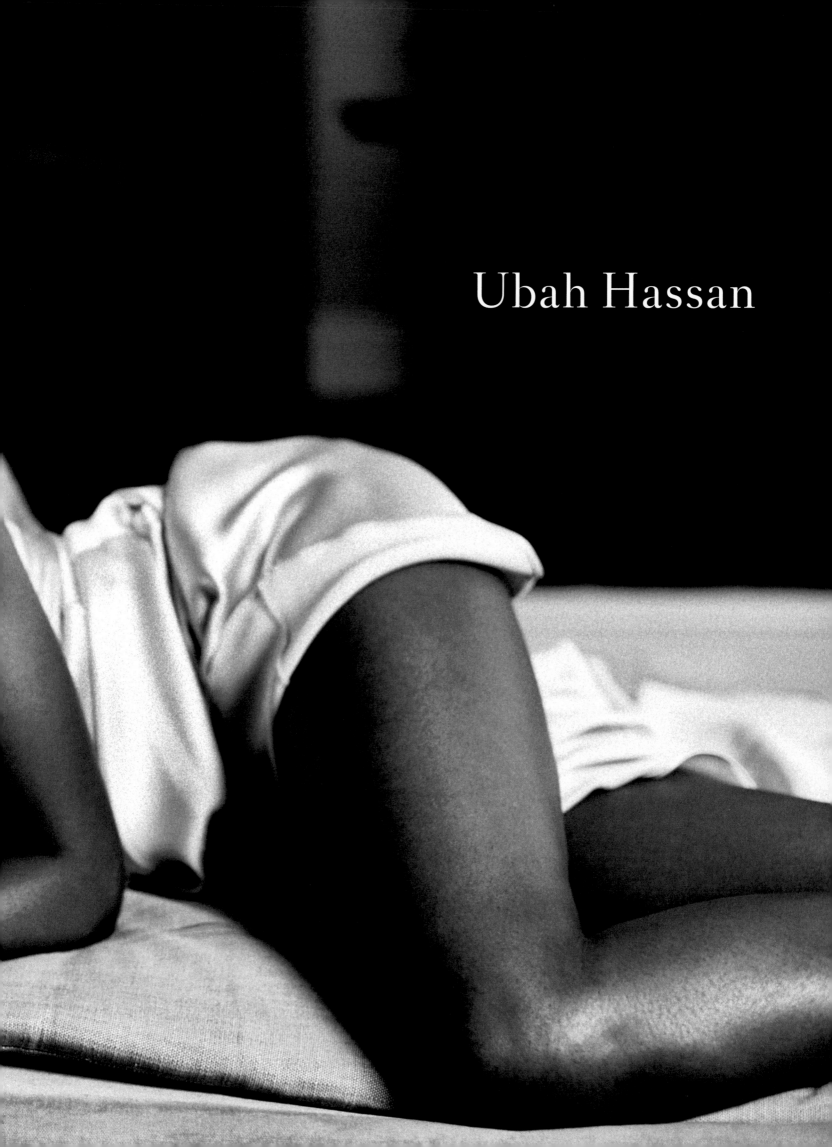

Ubah Hassan

Ubah is a one off! Her beauty is astounding, and at six feet tall she instantly changes the energy of a room when she walks into it. Her effervescent personality reflects her zest for life and her enthusiasm for those around her. She has a striking elegance coupled with a smile that is broad and authentic—the Platonic ideal of a fashion model and a photographer's dream.

But there is much more to Ubah than meets the eye. She grew up in Somalia, a country torn apart by civil war and tribal conflicts. Although she had a happy childhood there, her family emigrated when she was ten to escape the war—first traveling to an uncle's house in Kenya, and eventually to Toronto, where the family lived in a shelter initially. I was inspired to photograph Ubah after seeing an extraordinary CNN film about her, made by director Joe Berlinger, in which she describes herself as both a Somalian and a "citizen of the world."

Ubah is a Muslim who does not dress in traditional Islamic clothing, but her faith is one of the pillars of her life. She is inspired by her mother in this regard, who taught her the importance of compassion for others, kindness and respect, and above all the importance of charity, which Ubah defines in the broadest sense of "making other people's lives better." She says that charity for her is not just about giving money but giving of your time and spirit—checking in on a neighbor who you know is lonely or needs help; offering your seat to a pregnant woman on the subway. She is horrified by the practice of female circumcision that still takes place in Somalia, which she herself was a victim of, but says in the CNN film that it has "nothing to do with Islam" and that it doesn't make her, or any of the other girls who have suffered it "less of a woman." She says she prays for the girls who are suffering it in the name of religion and social pressure. Much of her philanthropic work lately has been devoted to the CCF, or Cambodian Children's Fund. She was inspired to support this organization when she traveled to Cambodia and was struck by the dire poverty of the children's lives there—children who did not even have families to support them, the way she did growing up in Africa.

Ubah is a person who is truly gorgeous inside and out. When I ask her about being beautiful she says she knows it is something she is blessed with, but that physical beauty always fades, and that "you should not aspire to let it be part of your identity. You need to strive for the things that you can have forever. Which is your character—who you are, how you treat others. Those are the things that you are going to have when you are eighty or ninety." She is a person who seems to draw her greatest joy in bringing joy to others, and does so with grace and humility. She tells me an expression her mother used to say, that "every human being has a nose facing down, and it's to remind you of where you are going back to eventually." She elaborates on what this means by saying, "the rich, the poor, the super-rich, if they were better than you they would breathe a different oxygen, but God made us equal. No matter what the circumstances are in your life, it does not change how special you are as a human being."

Ubah has the ability to make every person she comes in contact with feel special; she tries to live her life by the principle of "what opportunity do I have to make someone else happy?" For me, she is an inspiration for women who have ever been oppressed or endured hardship and displacement because she is so generous and positive about her life. She believes that everyone has something to give to the world, and that when you do so "it comes back to you, like a circle." ♥

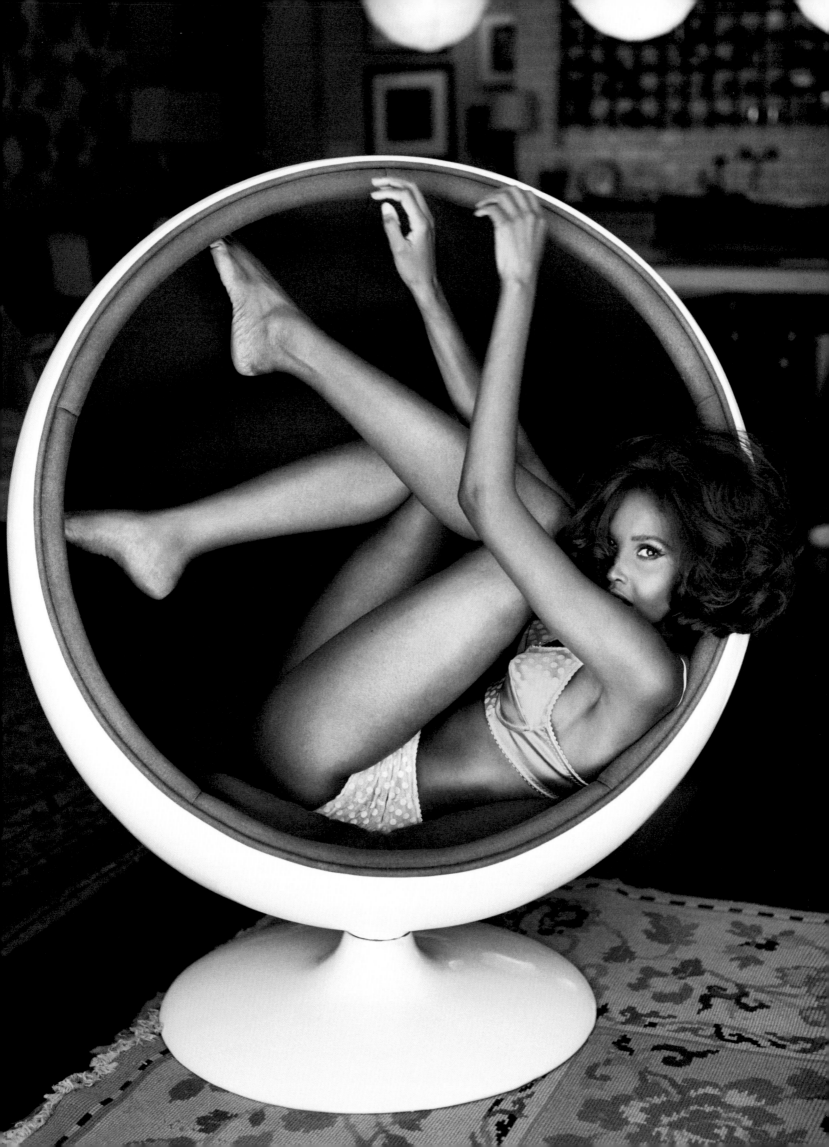

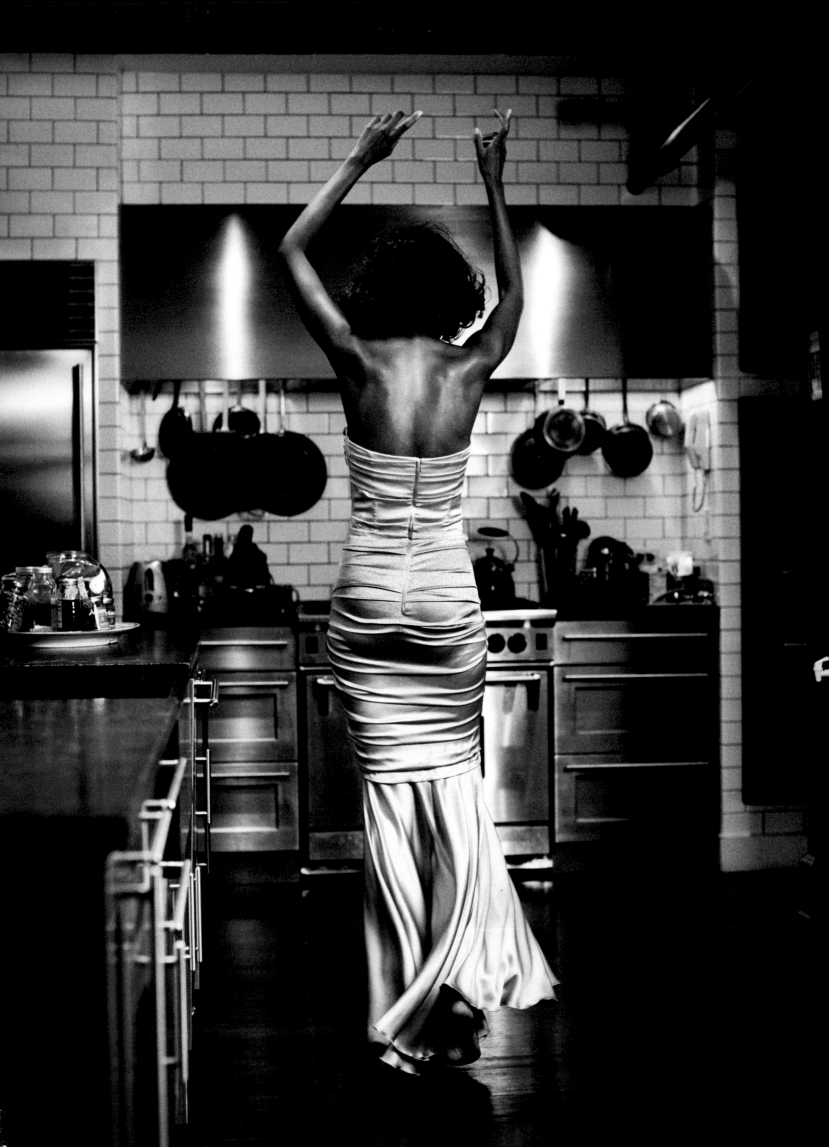

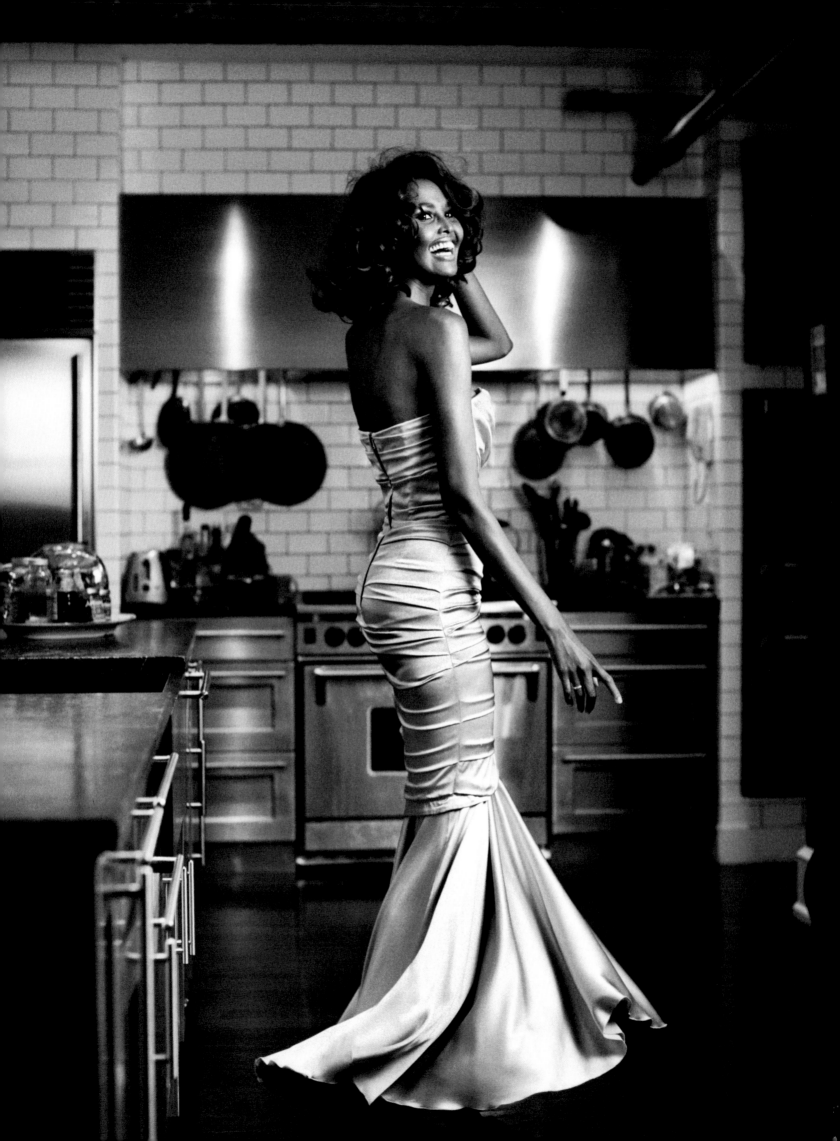

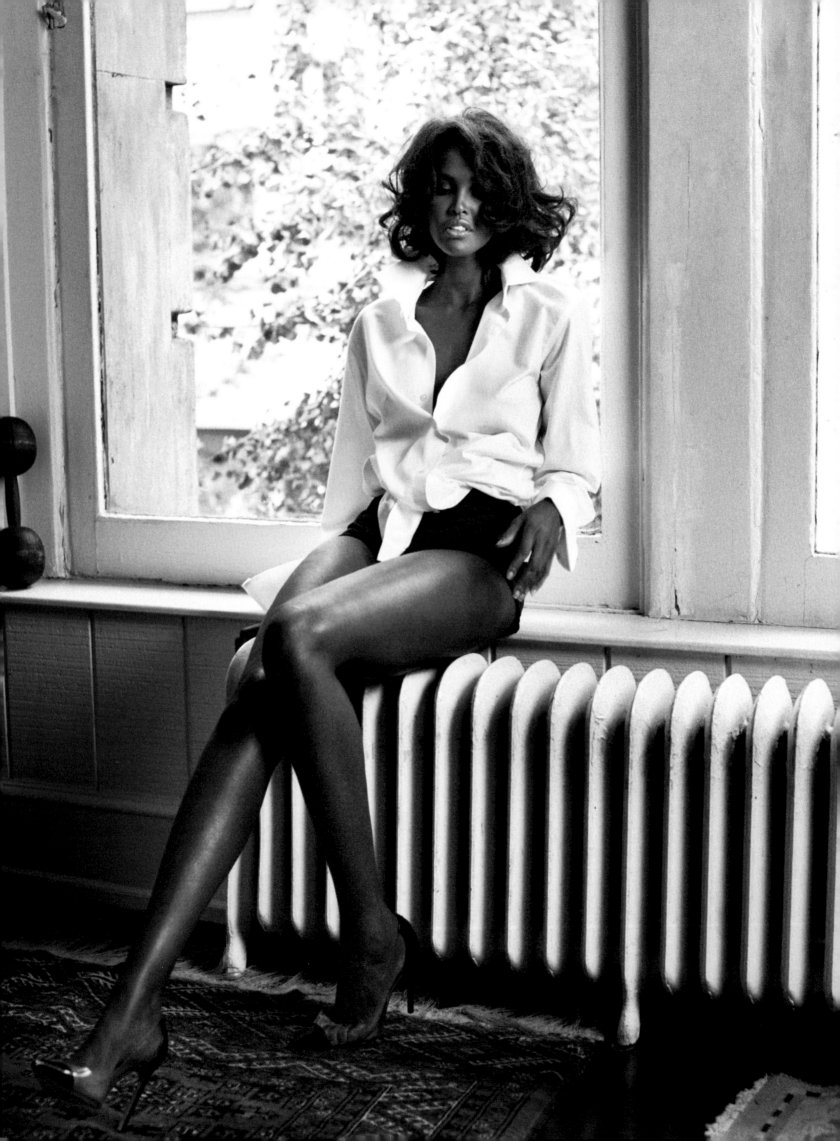

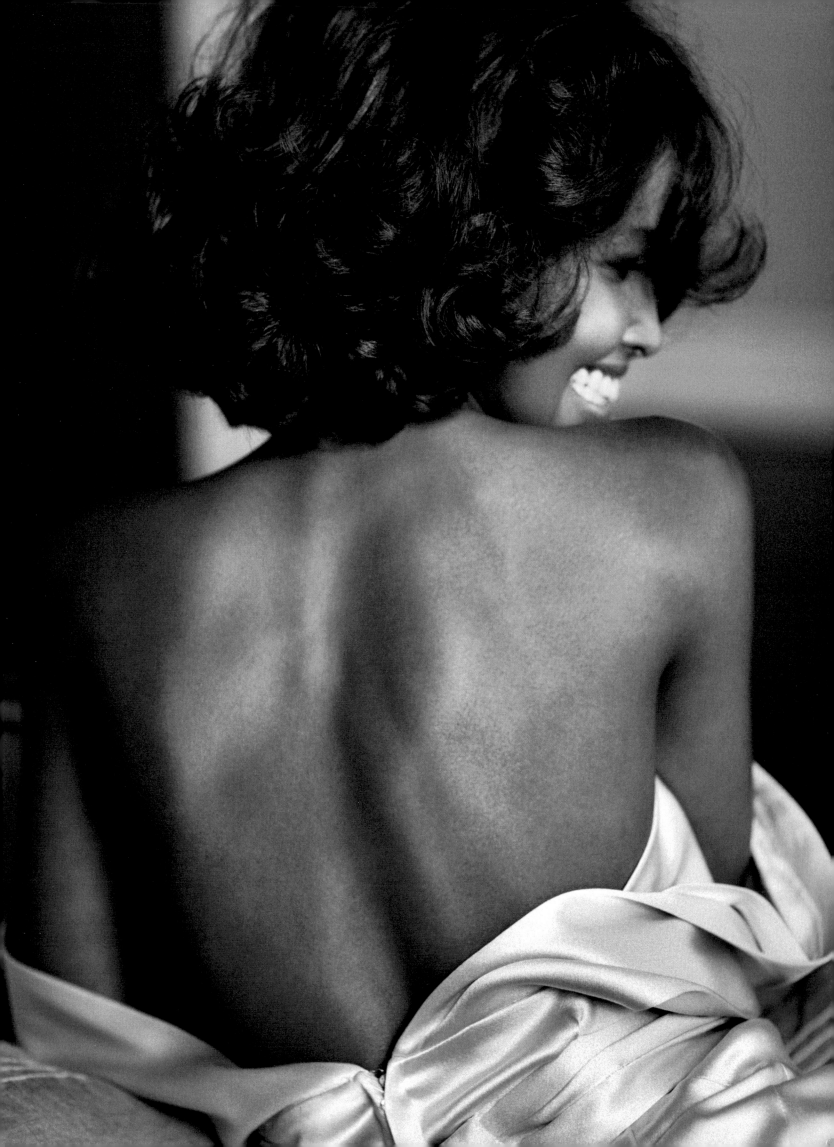

"You need to strive for the things that you can have forever. Which is your character—who you are, how you treat others. Those are the things that you are going to have when you are eighty or ninety."

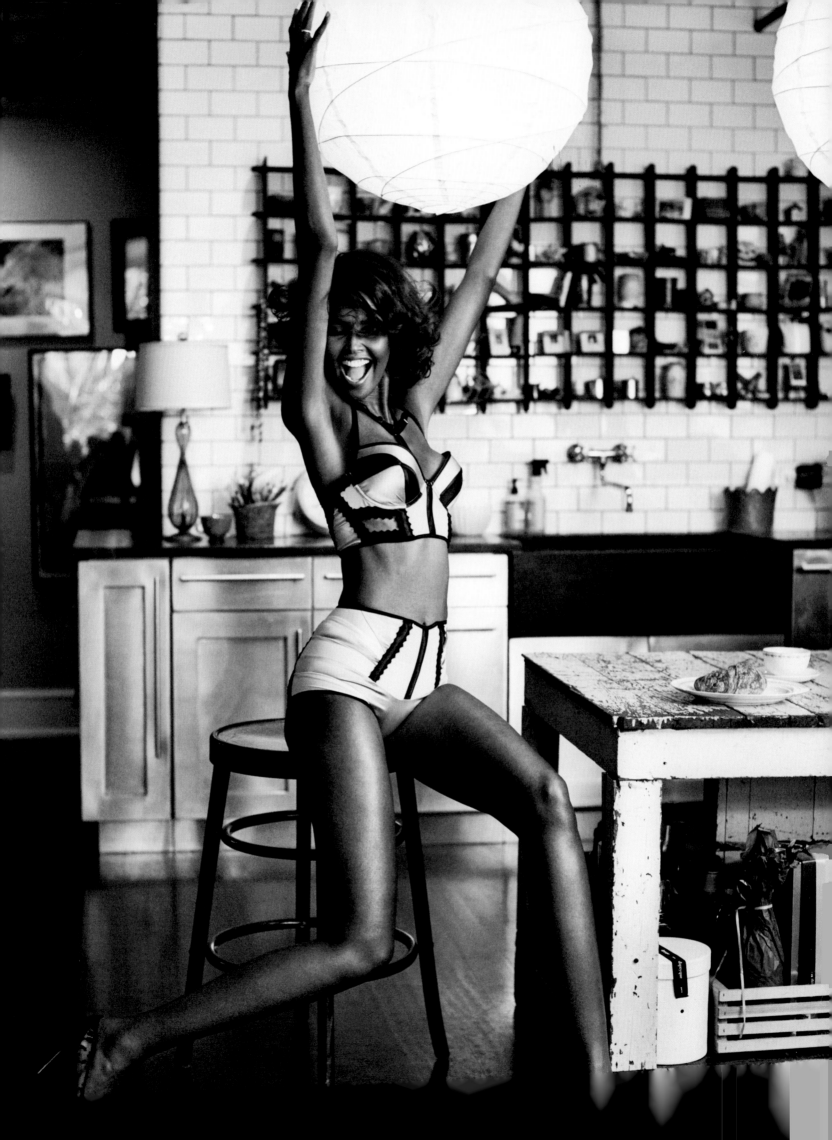

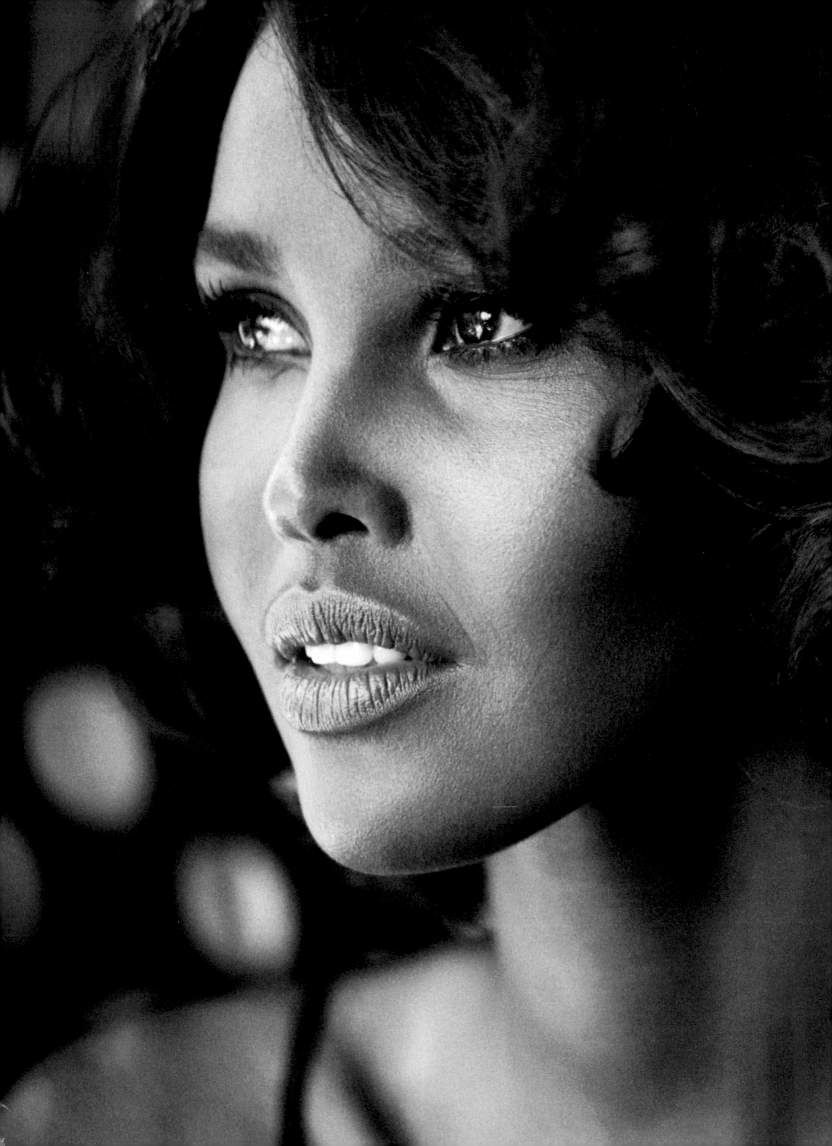

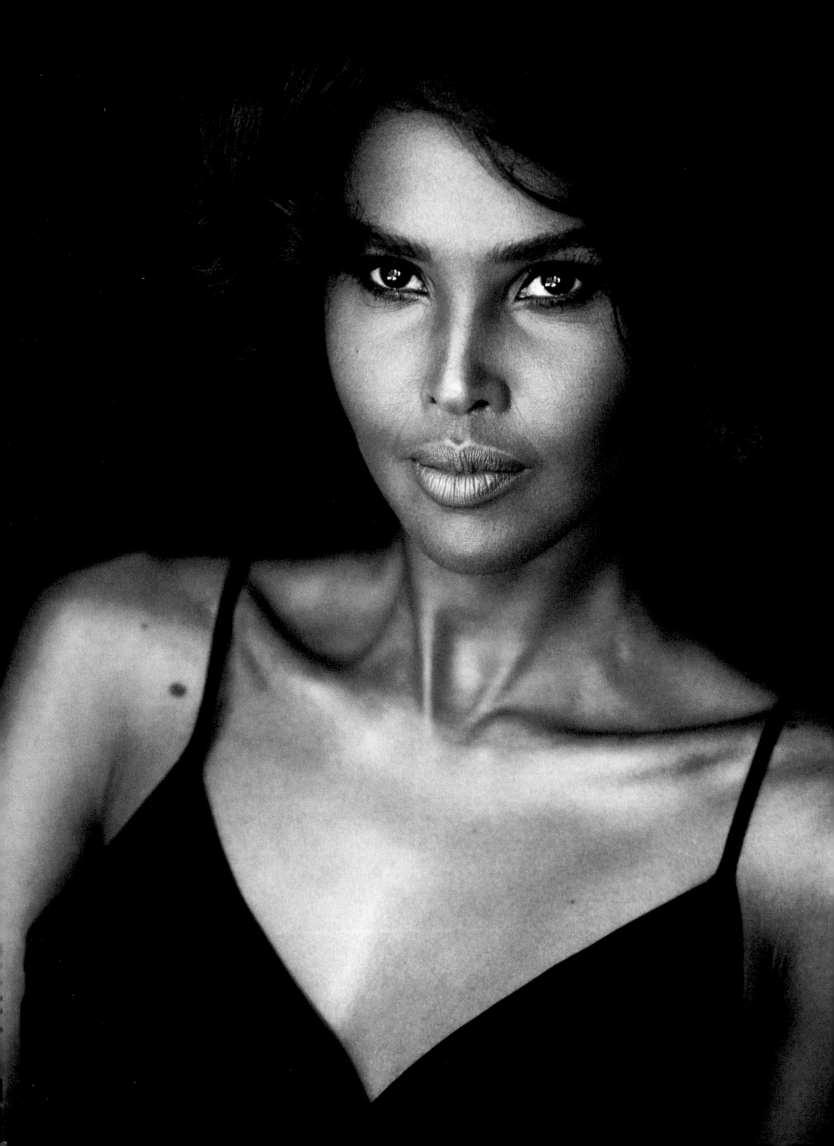

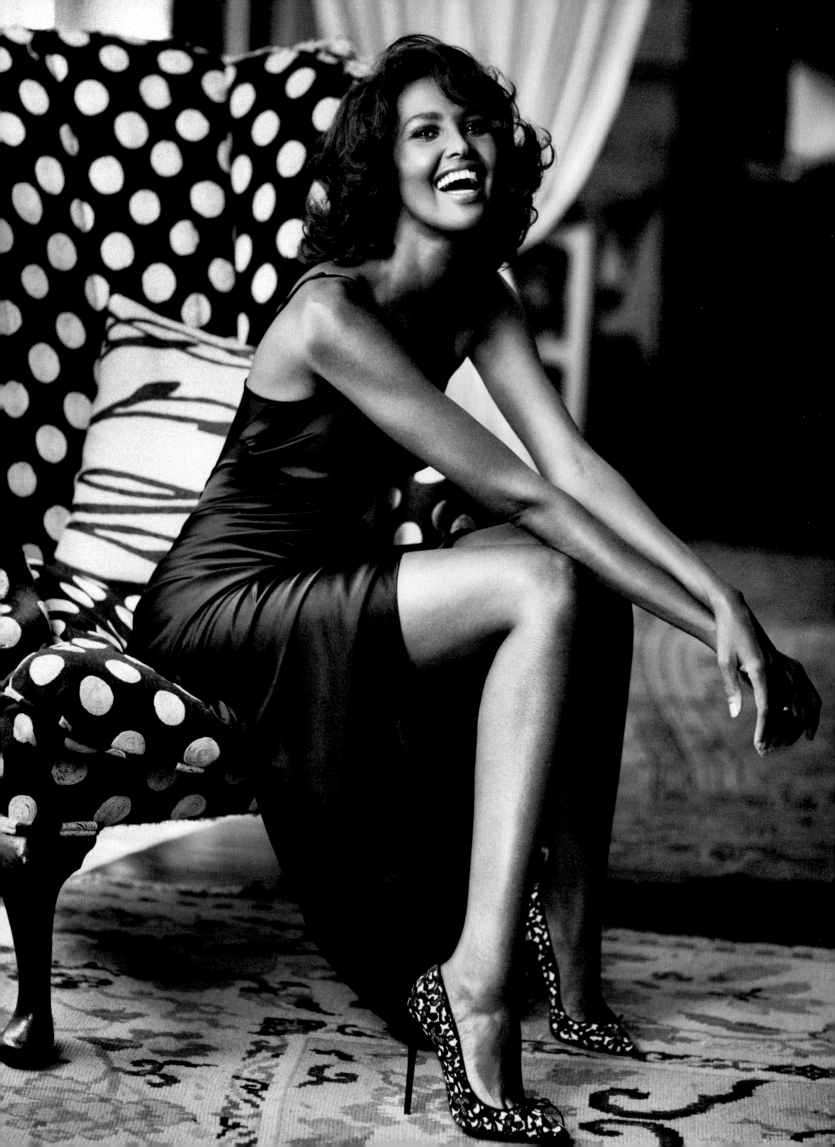

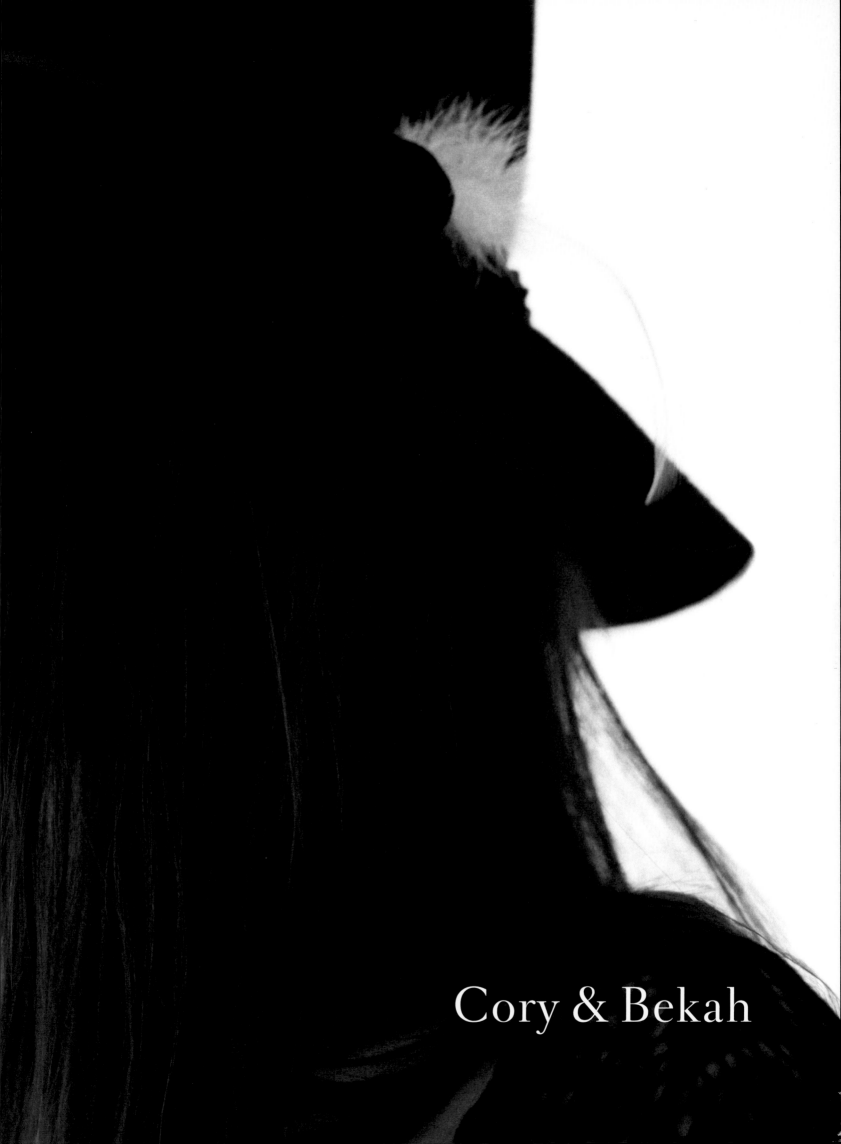

Cory & Bekah

Cory and Bekah are special for me. I work with loads of couples and always feel humbled when I find two people who have a deep relationship. There is a calmness and profound friendship between the two of them. They both delight in each other's company and like many successful couples, one cannot ever imagine them being apart. They are both supremely proud of each other, unquestioningly loyal and devoted. They both hail from different parts of the country. Bekah is from upstate New York and Cory from Tennessee. Both were persuaded to enter modeling competitions in their small towns, and both were unconvinced about their chances of success.

Bekah Jenkins still remembers how her father took her to a modeling competition when she was twelve. "I am from upstate New York from a very small, very charming town that has one blinking stoplight and maybe six hundred people. My mom's a nurse, my dad's a computer programmer, and he had taken me to 'Bring your daughter to work day' and everybody there was like, 'Oh, she should model, she should model.' Then he heard on the radio that there was a scouting agency coming to town, and he dragged me kicking and screaming to this scouting event. I thought the pretty girls would get it, and I just didn't feel like going. I was twelve, and I was 5'8" and like maybe 110 pounds, they were like, 'whoa!' I was just lucky, I mean, I had an immediate response and was doing incredible things and was just so fortunate." So Bekah came to New York when she was only thirteen years old, with her mother as her chaperone.

Cory Bond has a similar story in that he also won a modeling competition. As Cory tells it, "I'm from Tennessee. We didn't have a lot of money when I grew up either. I grew up in a small trailer on a tobacco field in the middle of the woods. I got scouted kind of in a similar way Bekah did, except I had an ex-girlfriend when I was eighteen, she had heard on the radio one of those announcements that they were searching for models and I didn't think it was going to be much. I thought it was a scam. I got picked up by an agent, though, and I got flown to New York, and it was a night and day experience from where I grew up." Cory recalls that the change between his home life and New York was dramatic. "I was further isolated by the fact that I was a Jehovah's Witness growing up and that religion kind of isolates itself in a way. That led to my outgoing personality, I think; I really wanted attention, and to see everything. I wanted to go everywhere and see the world, basically".

So here we have these two modest people arriving in New York City. Bekah was thirteen and had her mother in tow, and Cory was eighteen when they first met. They had to wait nearly four years for their first date. They have been inseparable ever since. Cory, who is just about to turn thirty-four, remembers that "It was pretty quick, I'd say within the first six months of actually dating, we were talking about getting married." Bekah then chimes in, "It was pretty immediate, he came up to visit my family and me, and he wrote the most lovely poem on the train, as he was pulling out of the station and showed it to me later and it was just such a special thing and I knew that this doesn't happen every day." ♥

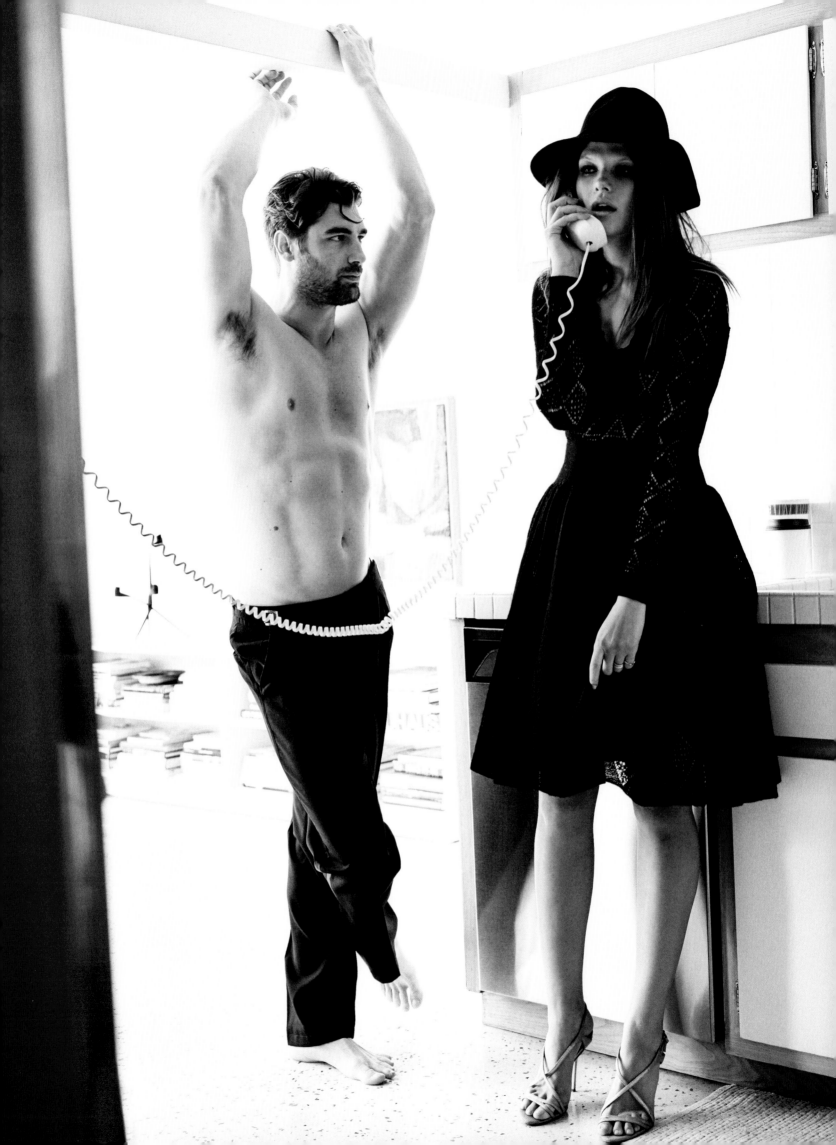

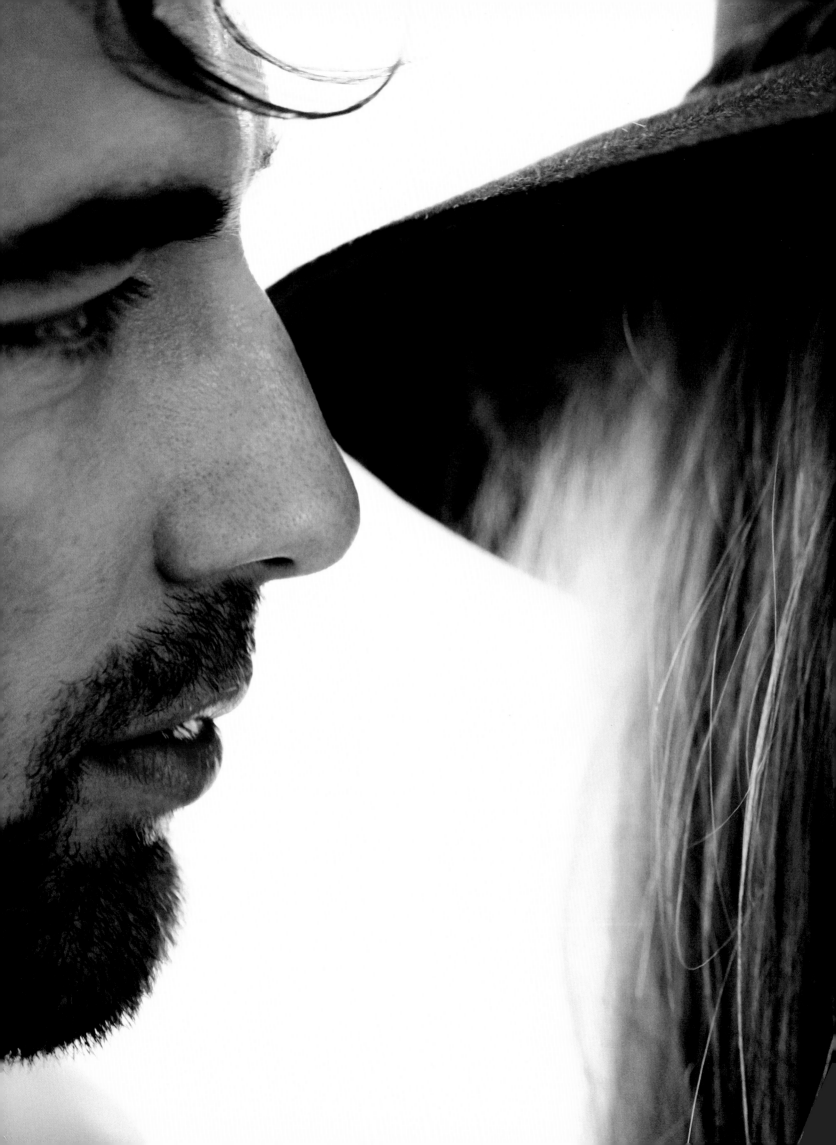

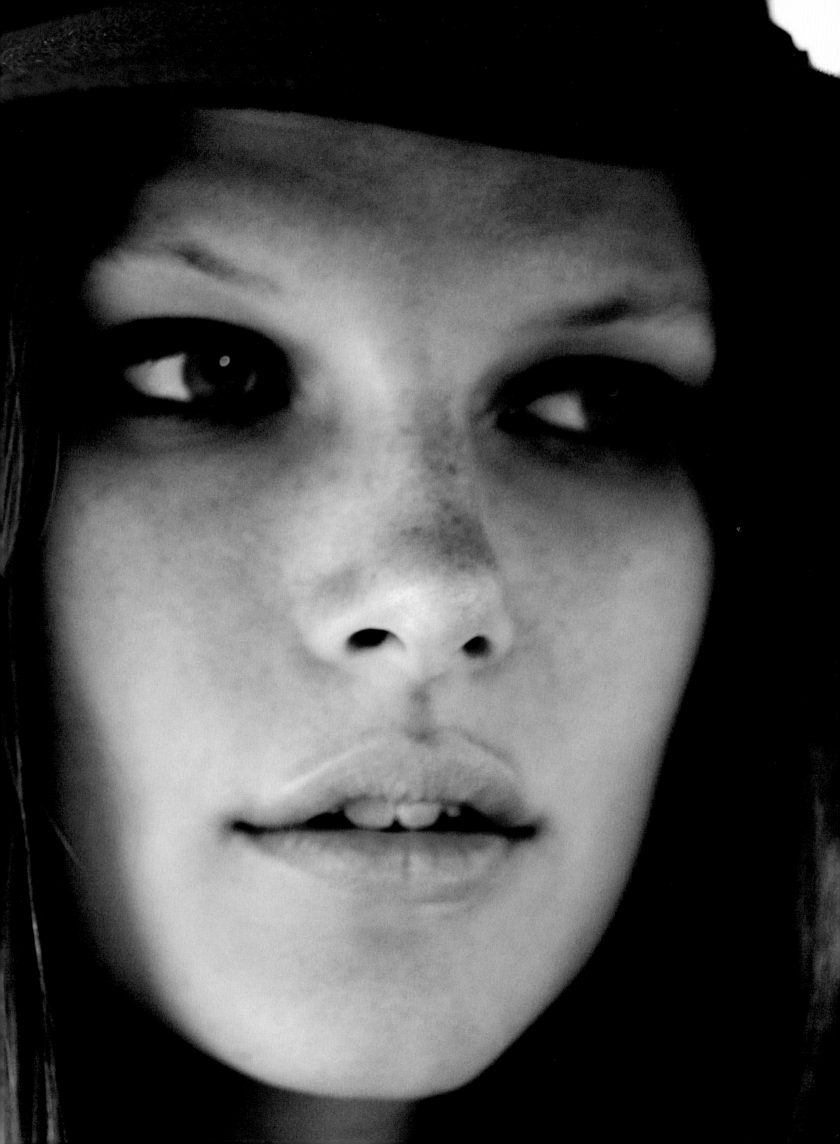

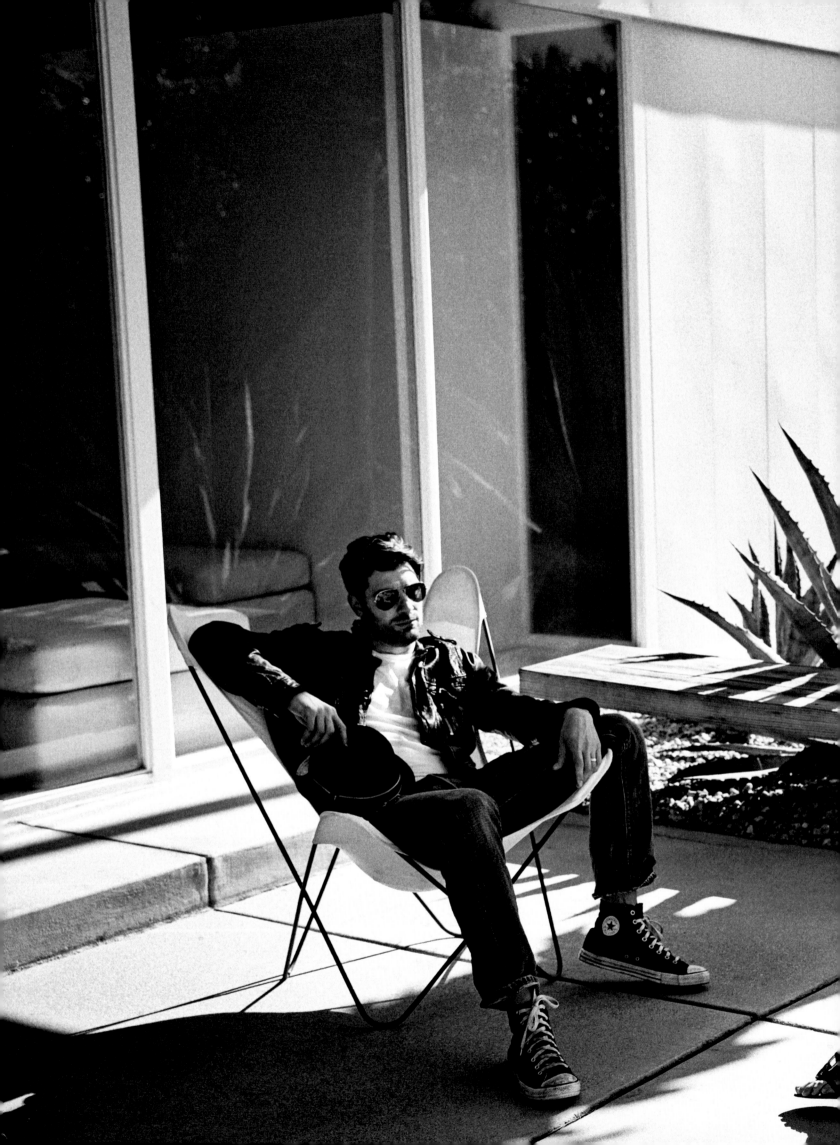

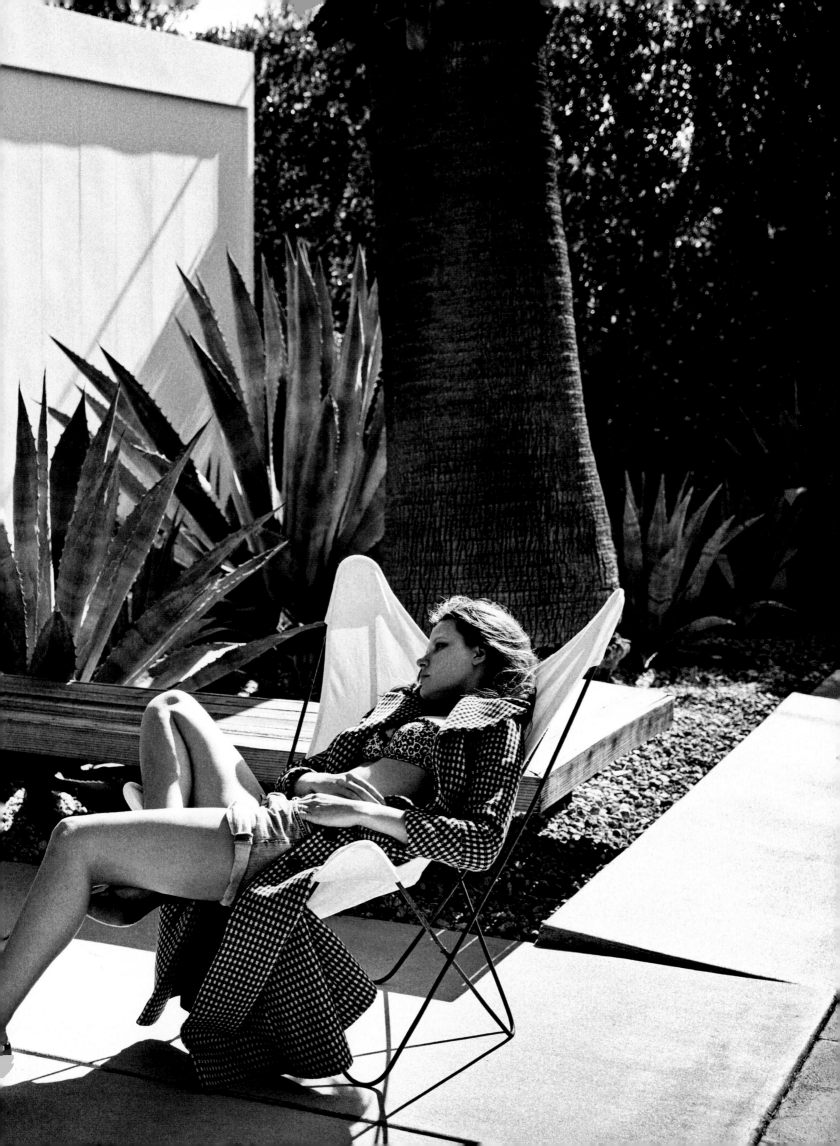

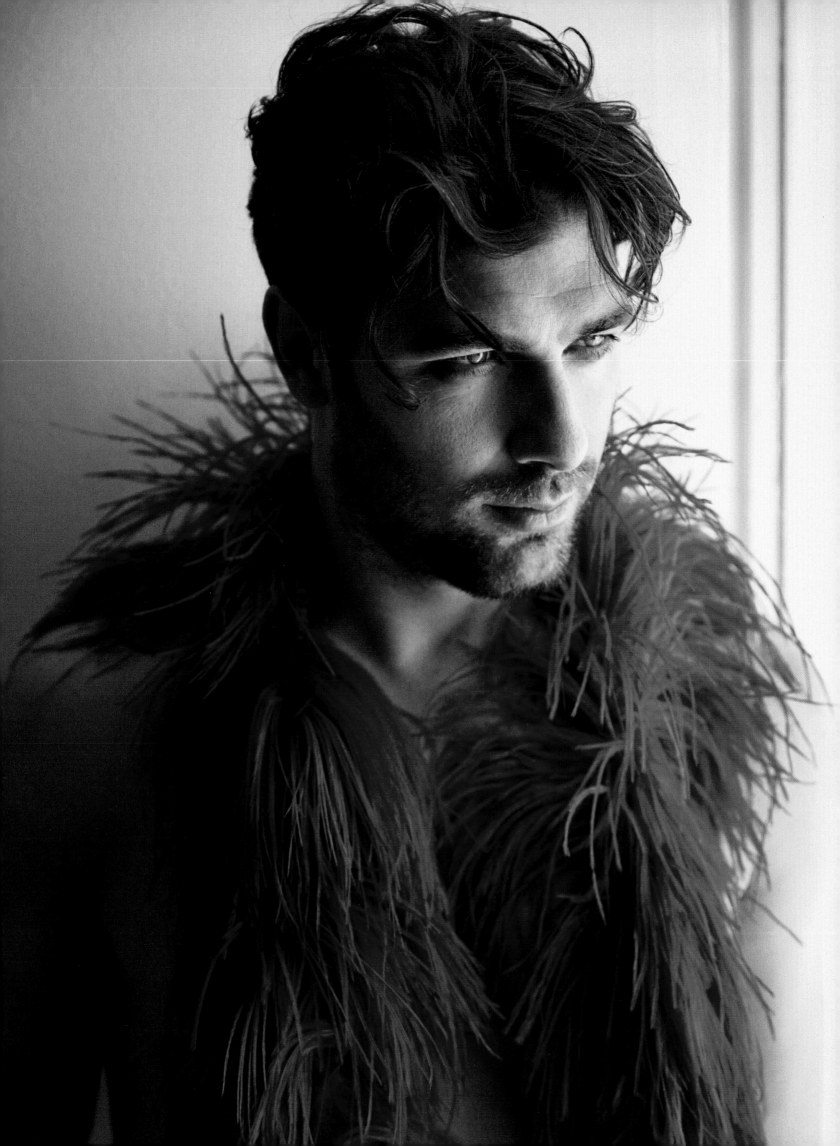

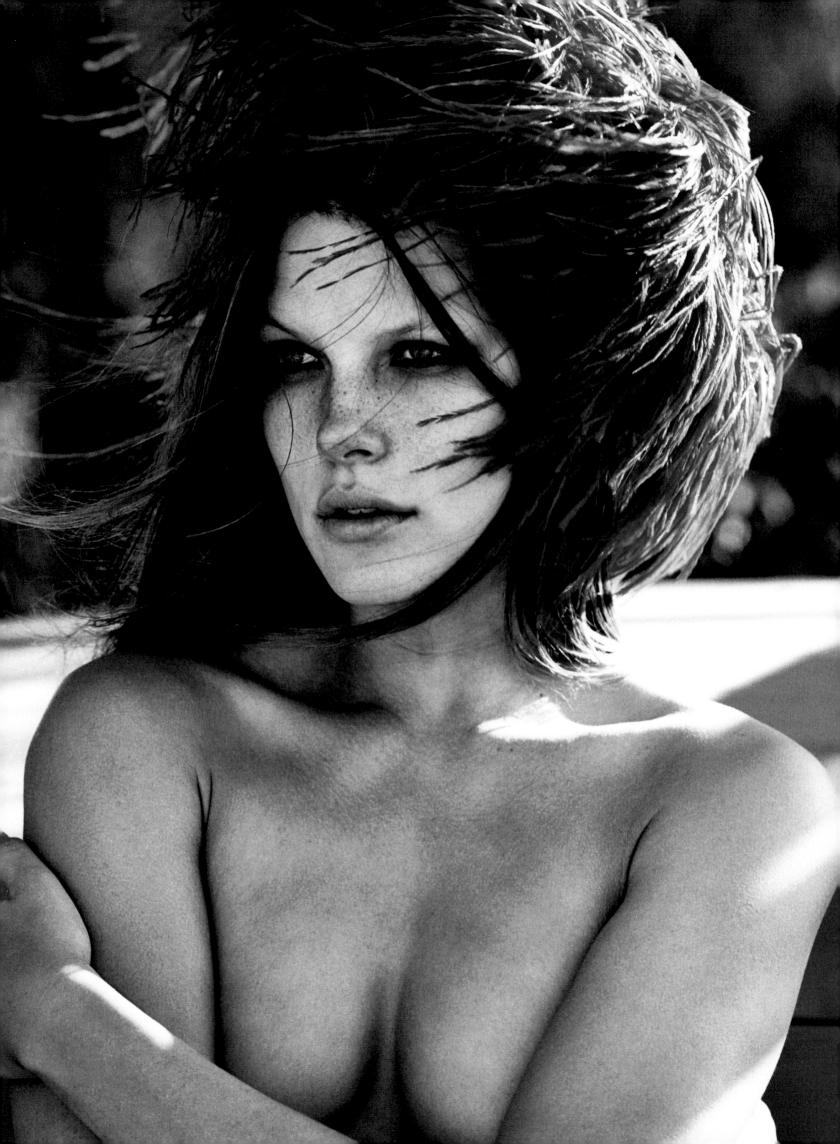

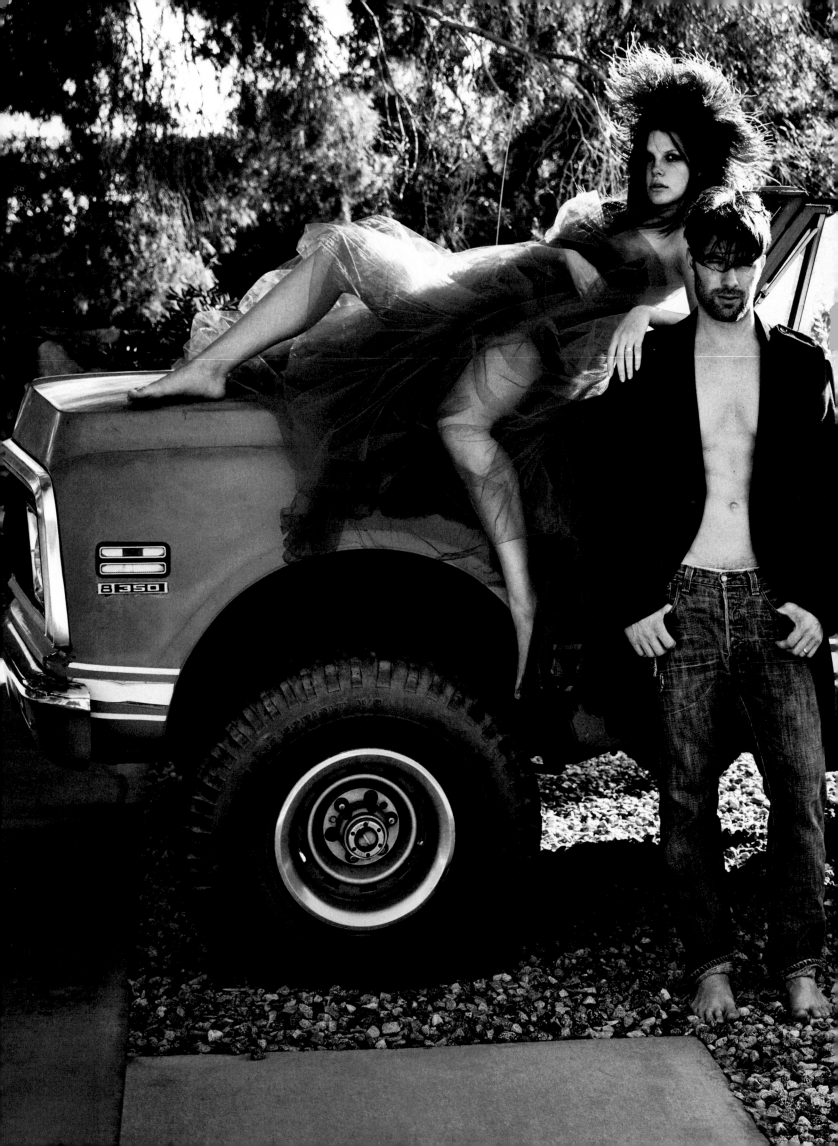

"It was pretty quick, I'd say within the first six months of actually dating, we were talking about getting married."

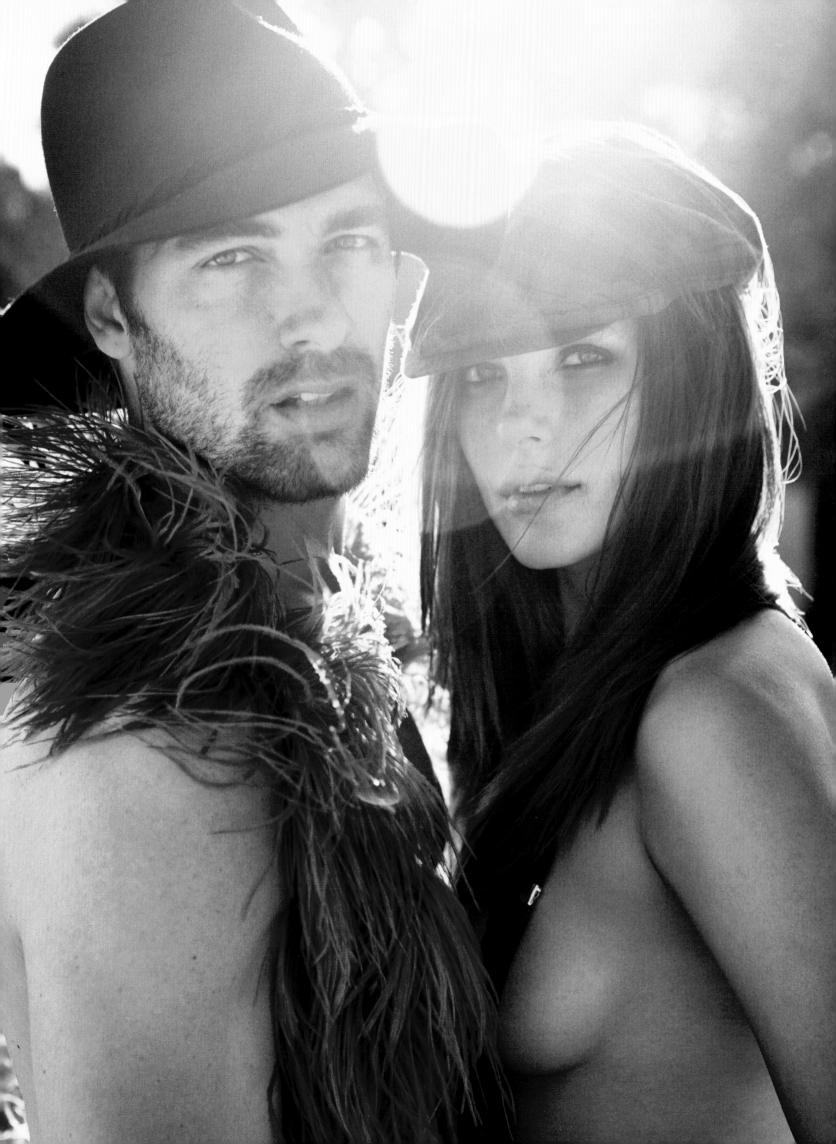

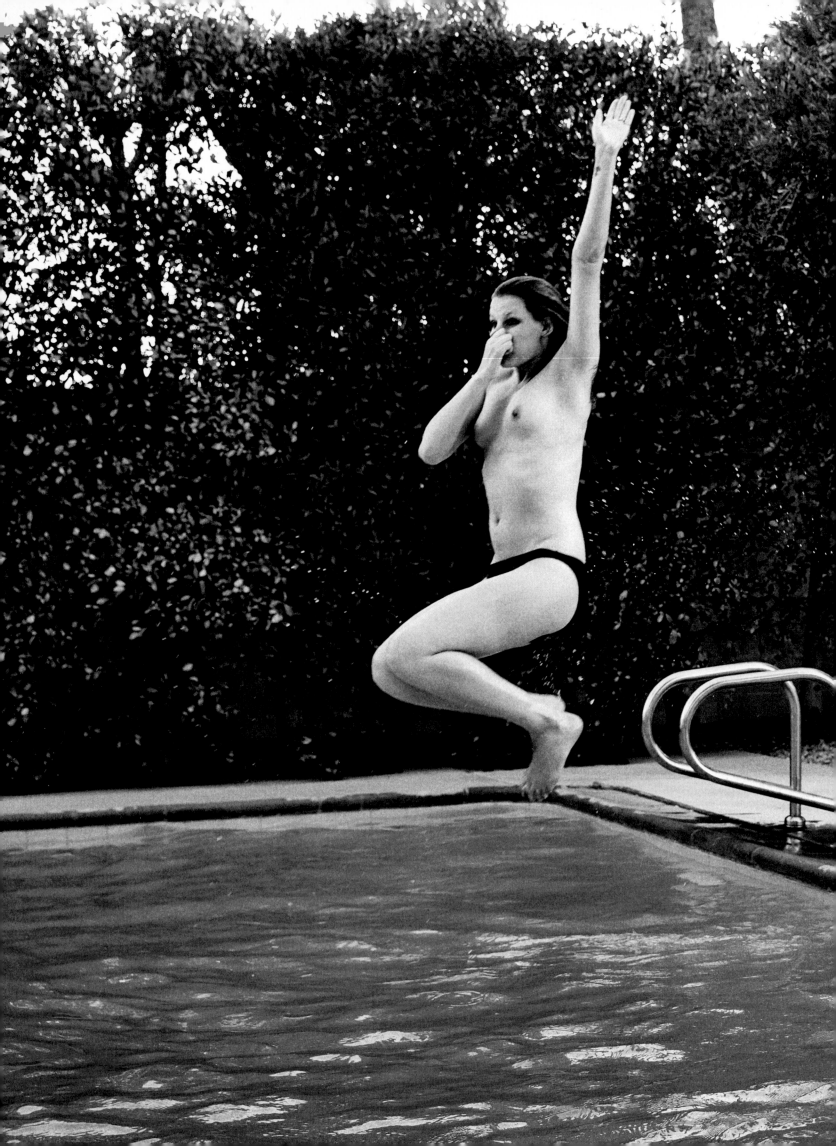

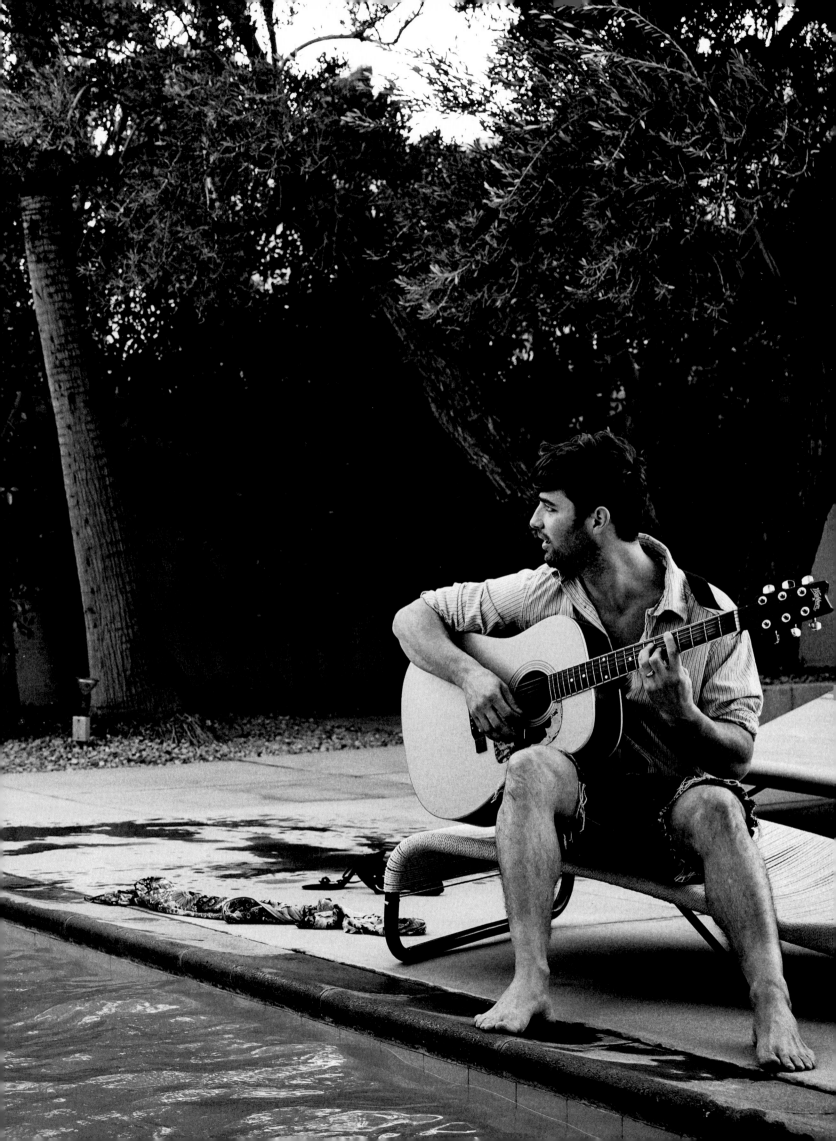

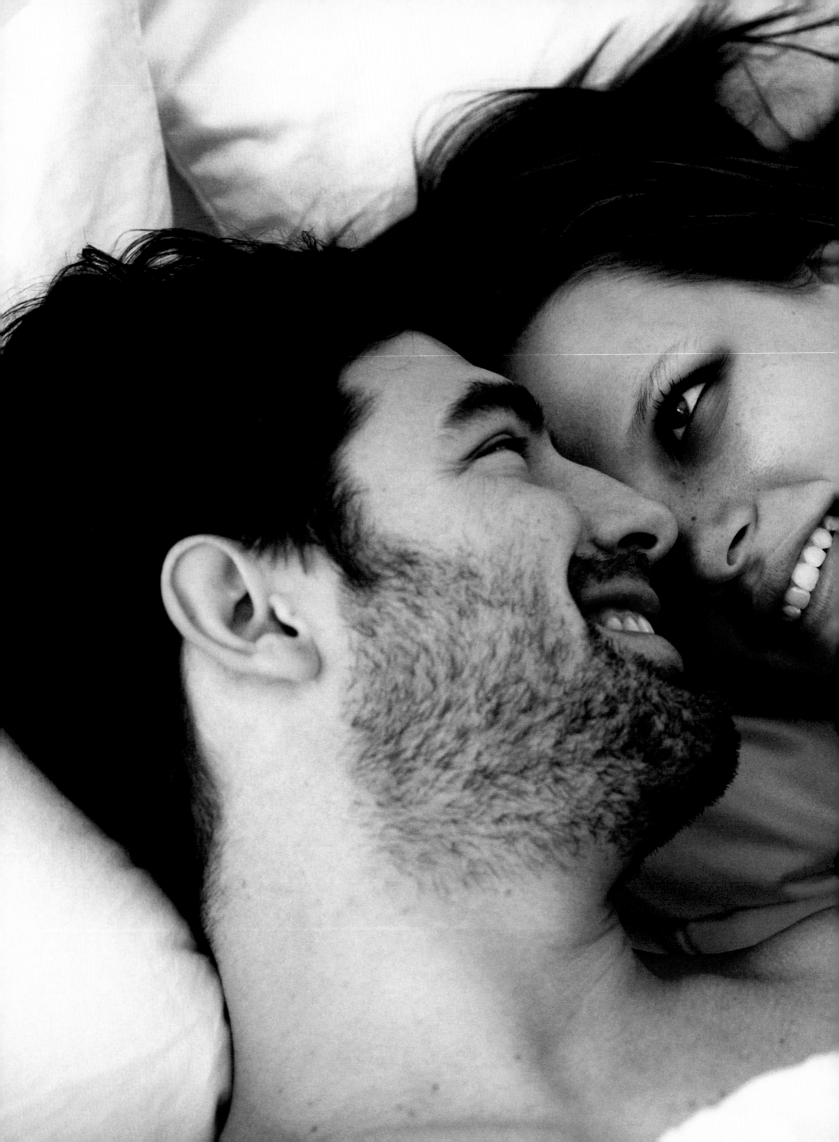

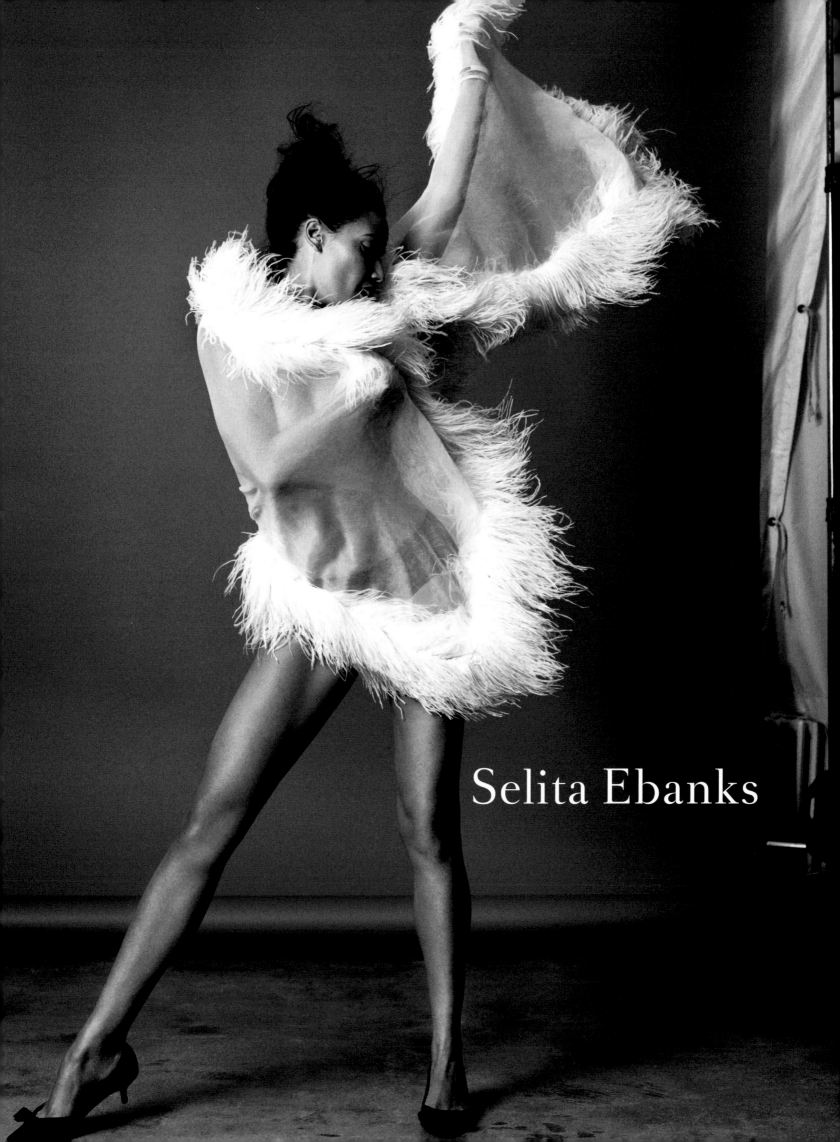

Selita Ebanks

Selita is an exuberant performer. She is funny, sexy and beautiful. A former Victoria's Secret model who has now launched herself as an actress, she is glamorous and highly intelligent. But life wasn't always like this for Selita.

Selita's mother was homeless when Selita was born in New York City. Selita had an unpredictable youth, with periods spent in the United States and then back in the Cayman Islands, where her mother was born. By the time Selita was five she had been in and out of foster care with three different families. She remembers what life was like at that time: "We were living in the projects. My mother had little to no money. One time when we had to move we ran out of gas three times. We even had to stop at the truck stop, and one of the truckers helped us suck gas out of their tank for our car. Then we would take food stamps into the grocery store and buy a twenty-five cent bag of chips so that we could get gas money. We used the seventy-five cents back for gas. Mind you, gas was much cheaper back then."

The family relied on charities, churches, and government organizations. But Selita appreciates that her mother, who only ever had a third-grade education and relied on Selita to manage her bank balance and help raise her younger brothers, "never made us feel that we were needy. She never made us feel like we were different than anyone else. She just let us be kids. We just saw it as this big adventure." Despite all the hardships she had to endure Selita always maintained a 3.8 GPA in school, and had dreams of being an entertainment lawyer, until she was scouted as a model. What I really admire about Selita is that she has come from such a challenging background but there is no bitterness, just a deep gratitude for where she now finds herself and a deep understanding of what it is to be underprivileged and struggling.

Selita now spends sixty percent of her time working for the numerous charities she has either set up or supports, in the U.S. and abroad. "I know the magnitude of the effects that being poor can have on someone's life," she tells me. She works with the New York Food Bank, which helps feed hungry families, and the New Yorkers for Children organization, which helps foster children get scholarships. When she traveled to Sierra Leone for a shoot on non-conflict diamonds, she was inspired to help the women and children there by creating an organization which helps fund local hospitals and improve the quality of medical care. And of course she has not forgotten her roots in the Cayman Islands, where she has set up an after school charity called the Stardom Advance Program, which she says gives children there the permission to dream.

She clearly enjoys the interaction that volunteer work brings her. "People don't understand how one smile can change someone's whole day. Especially when they're in that environment. They want to feel human like everyone else." Selita has a joy for life that is infectious. There is a sense of fun in her, and certainly a fearless quality. She is full of stories that seem enough to fill several lifetimes, let alone her thirty-one years. As she says, "When I do crazy things like jump off the side of a boat even though I can't swim, that's because that's the little girl Selita in me. I just want to say that I did it. Life is too short. I don't want to walk away from an opportunity and say, 'Oh, well. I coulda, shoulda, woulda.' No. I like to have these stories." ♥

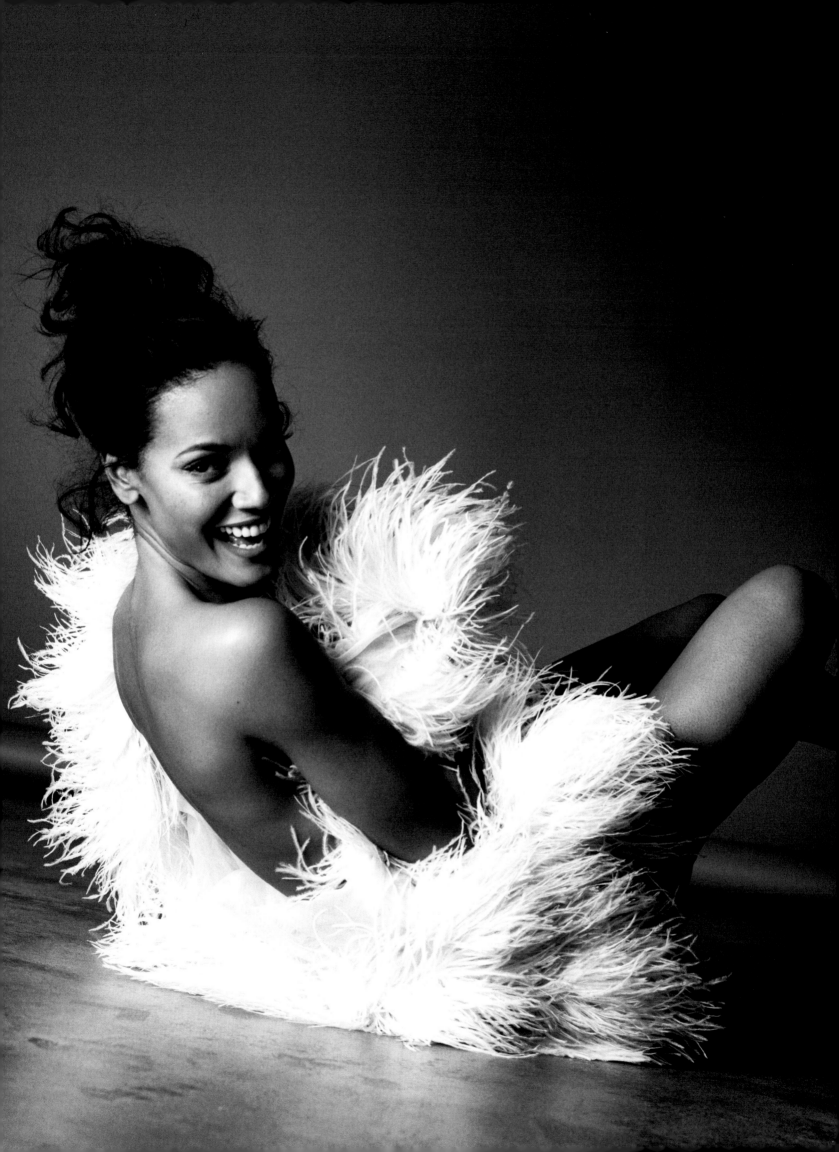

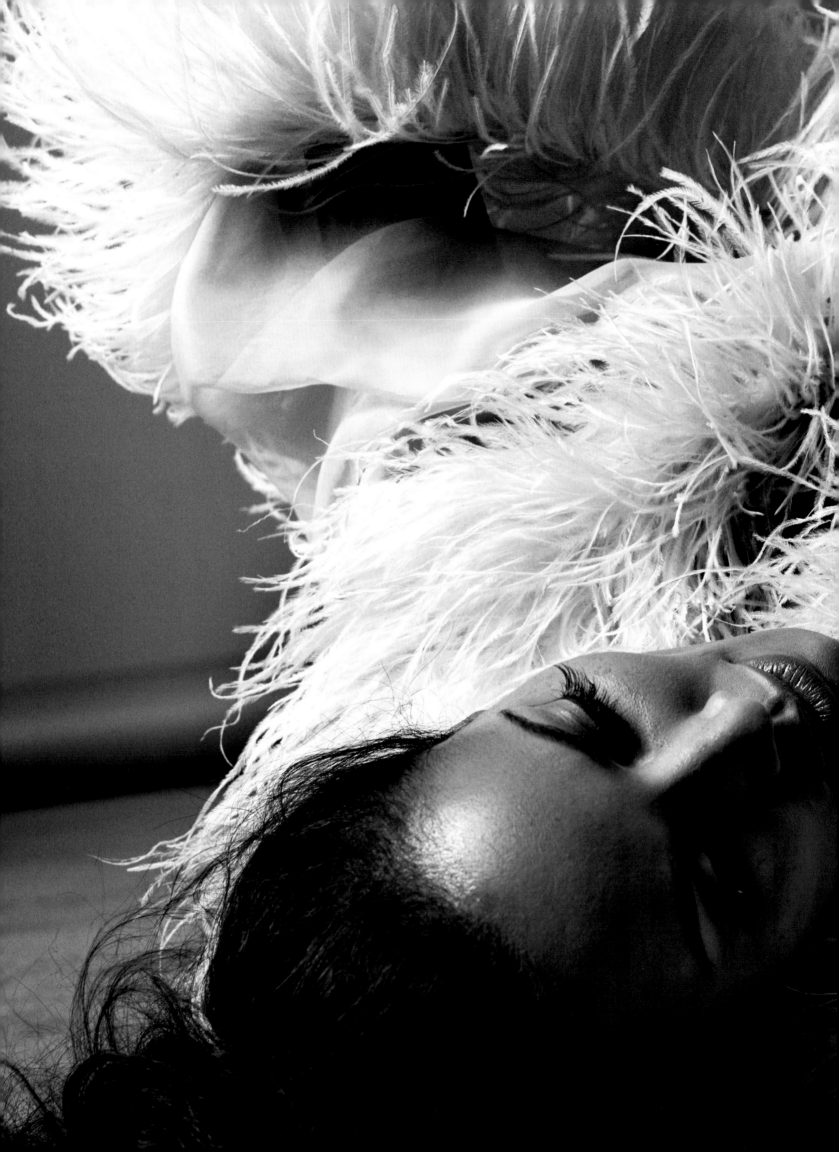

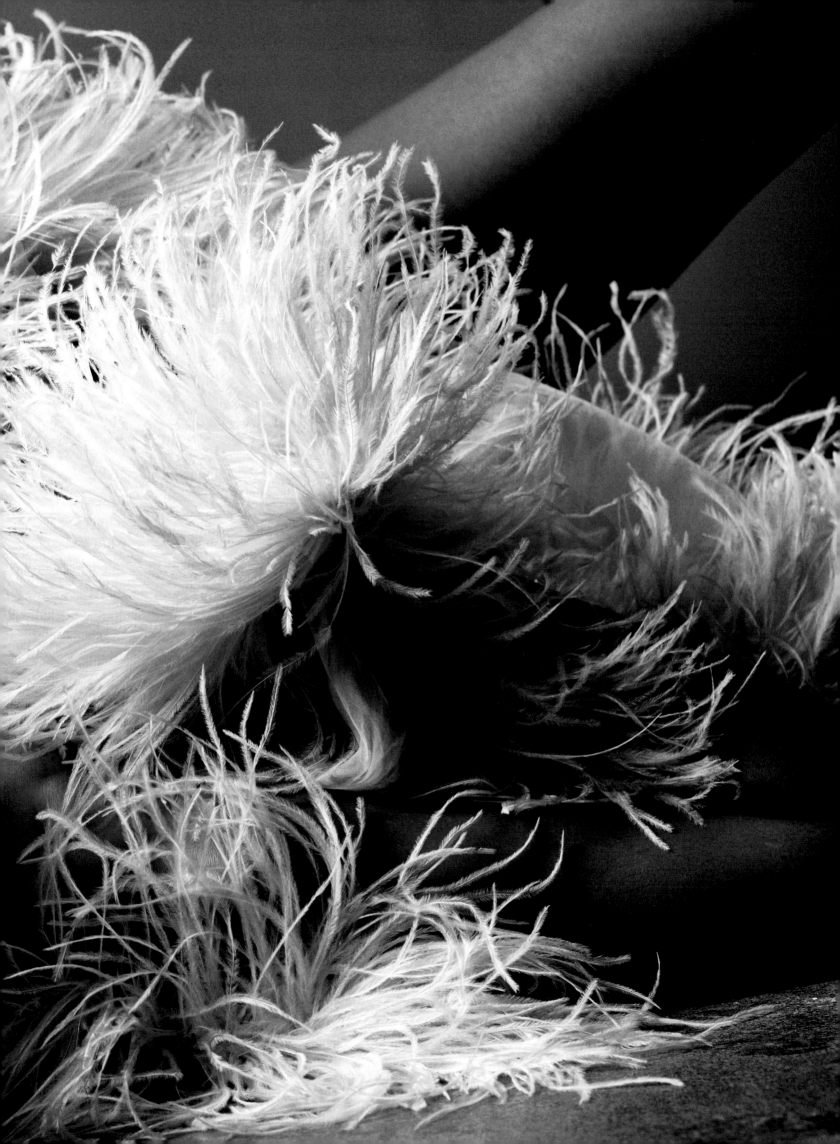

"I know the magnitude
of the effects that being poor
can have on someone's life."

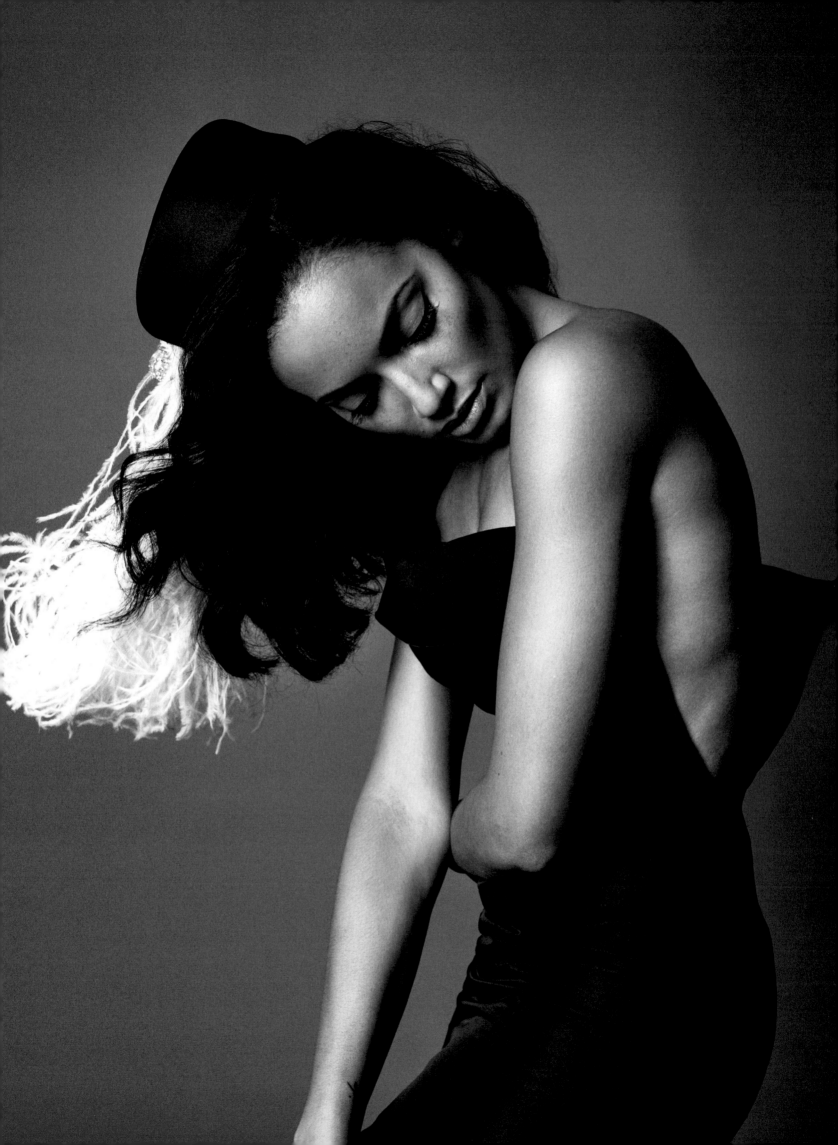

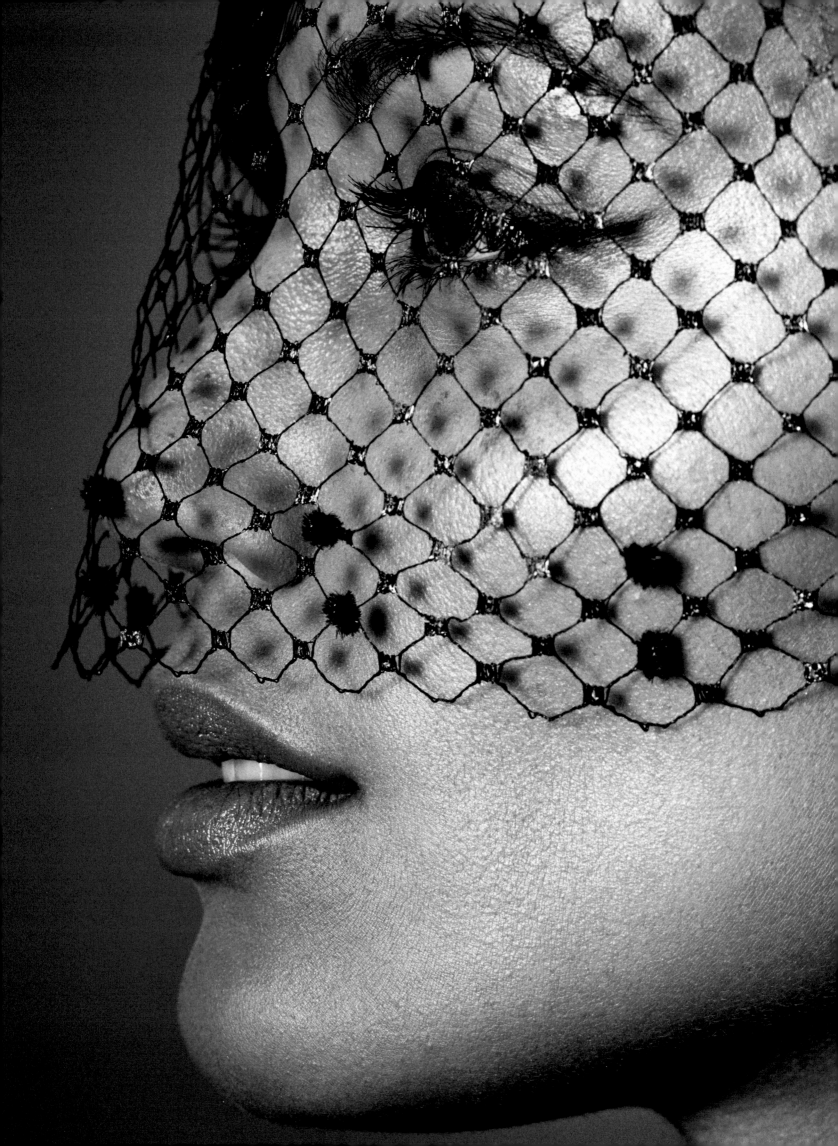

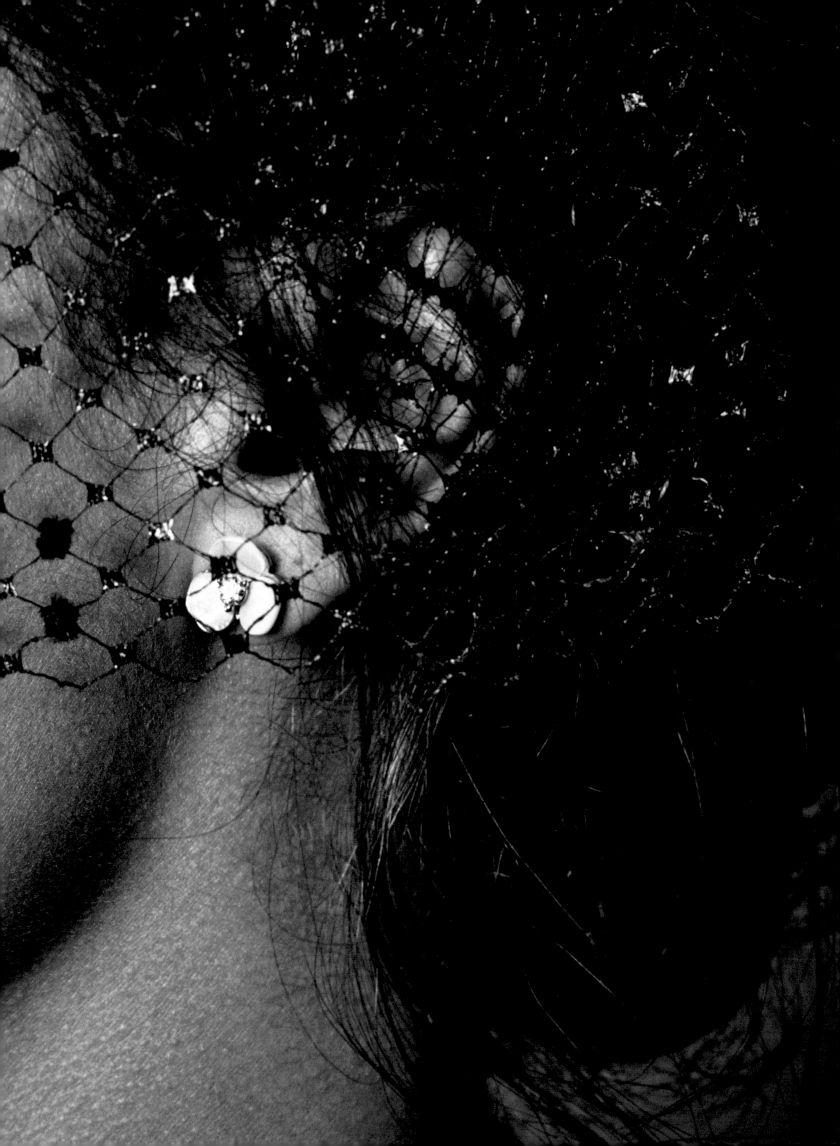

"People don't understand how one smile can change someone's whole day. Especially when they're in that environment. They want to feel human like everyone else."

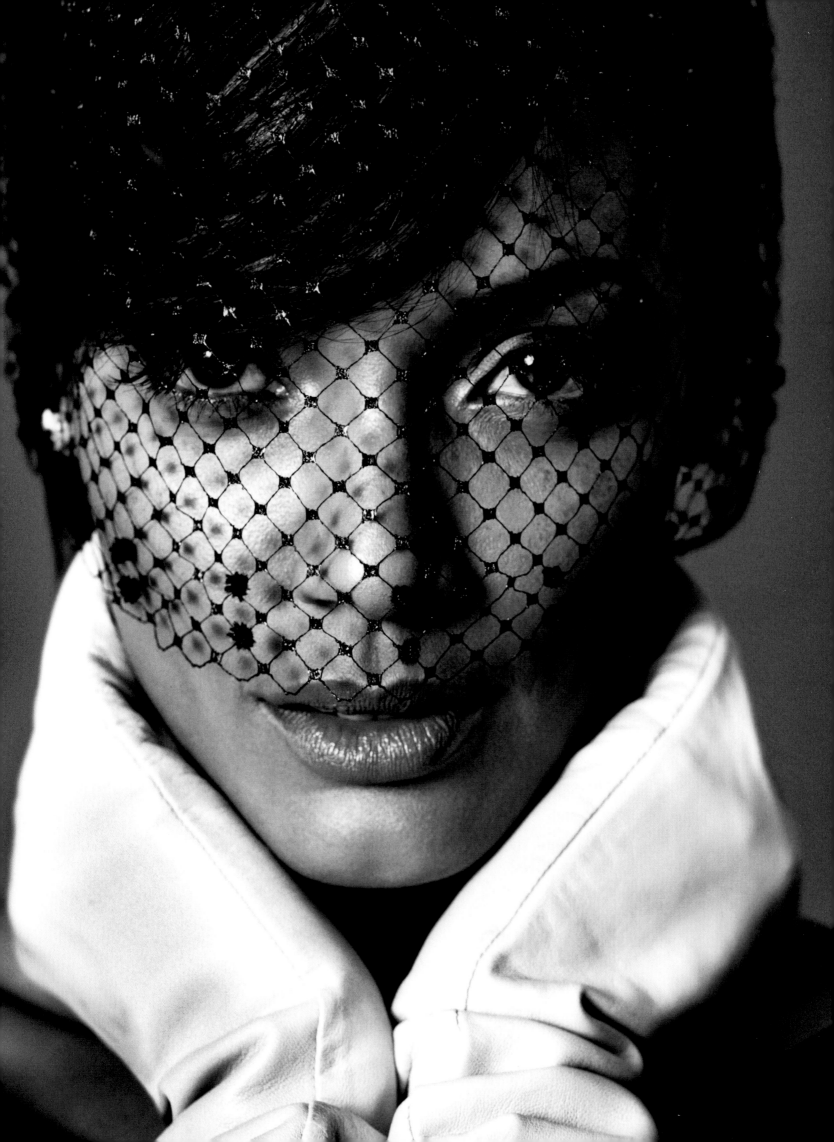

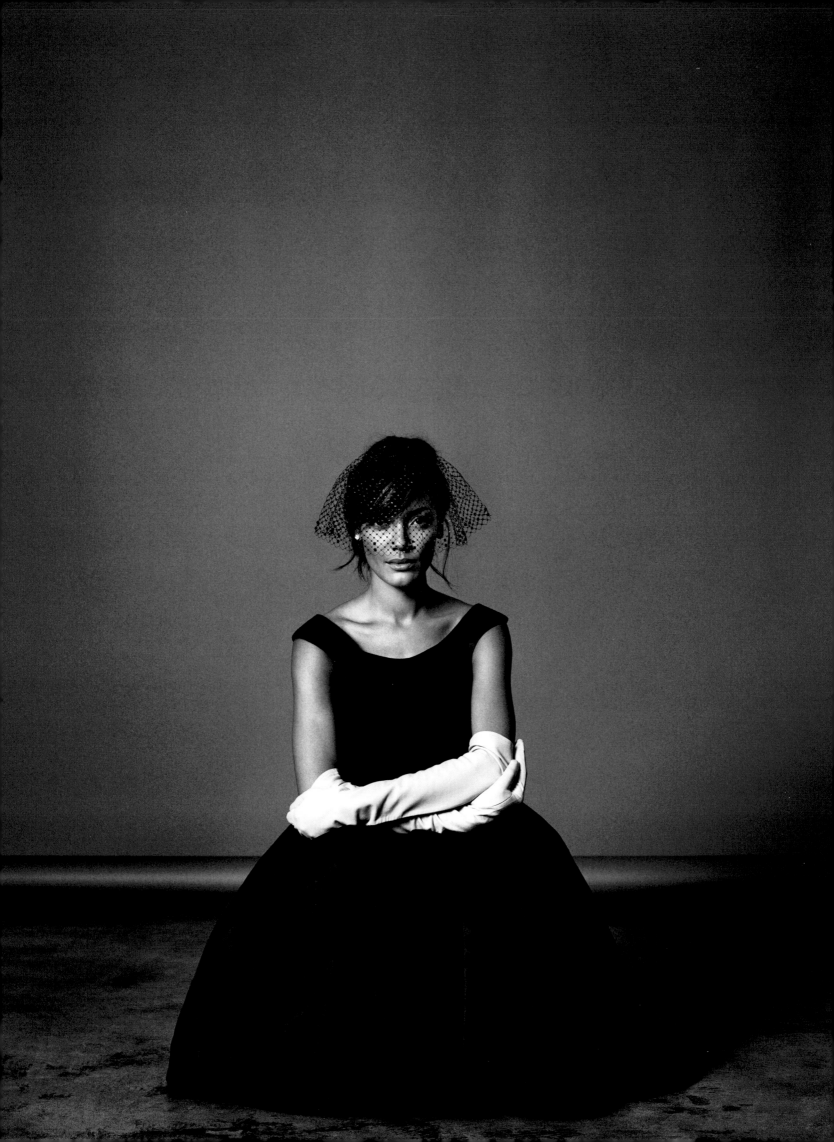

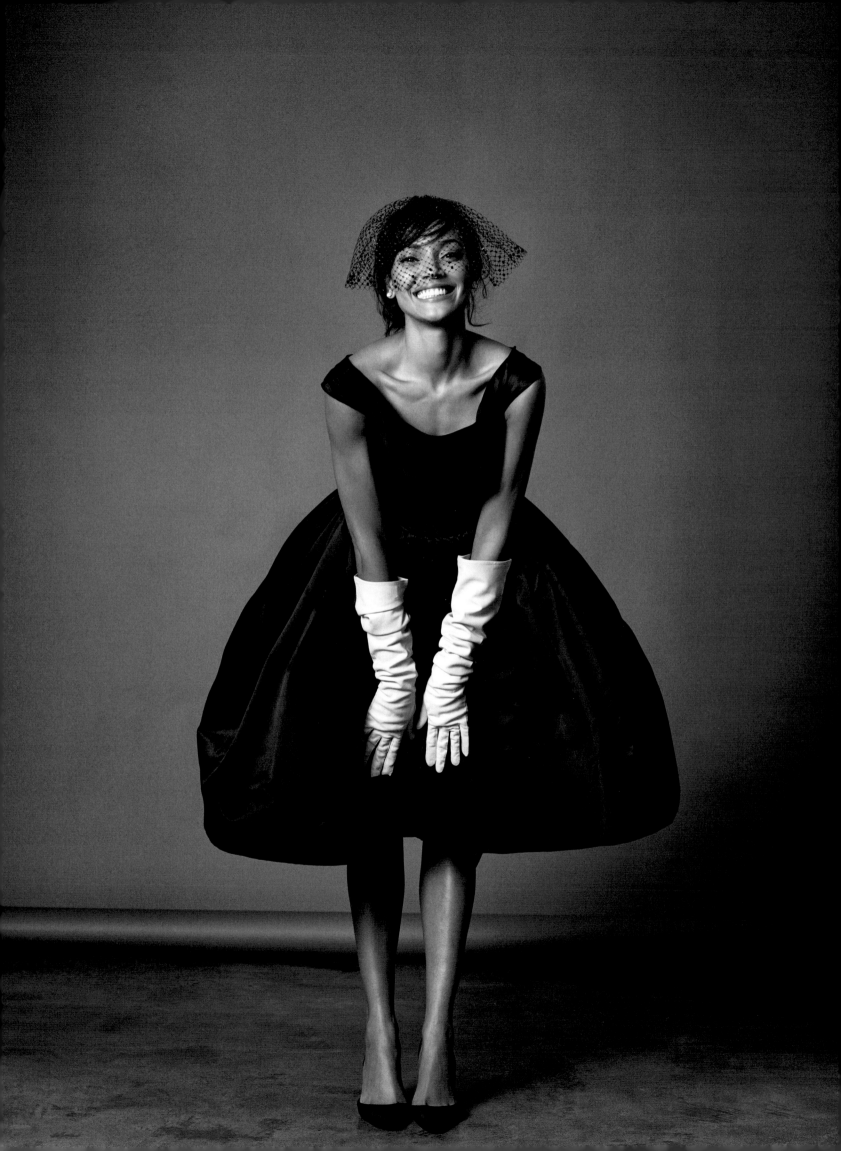

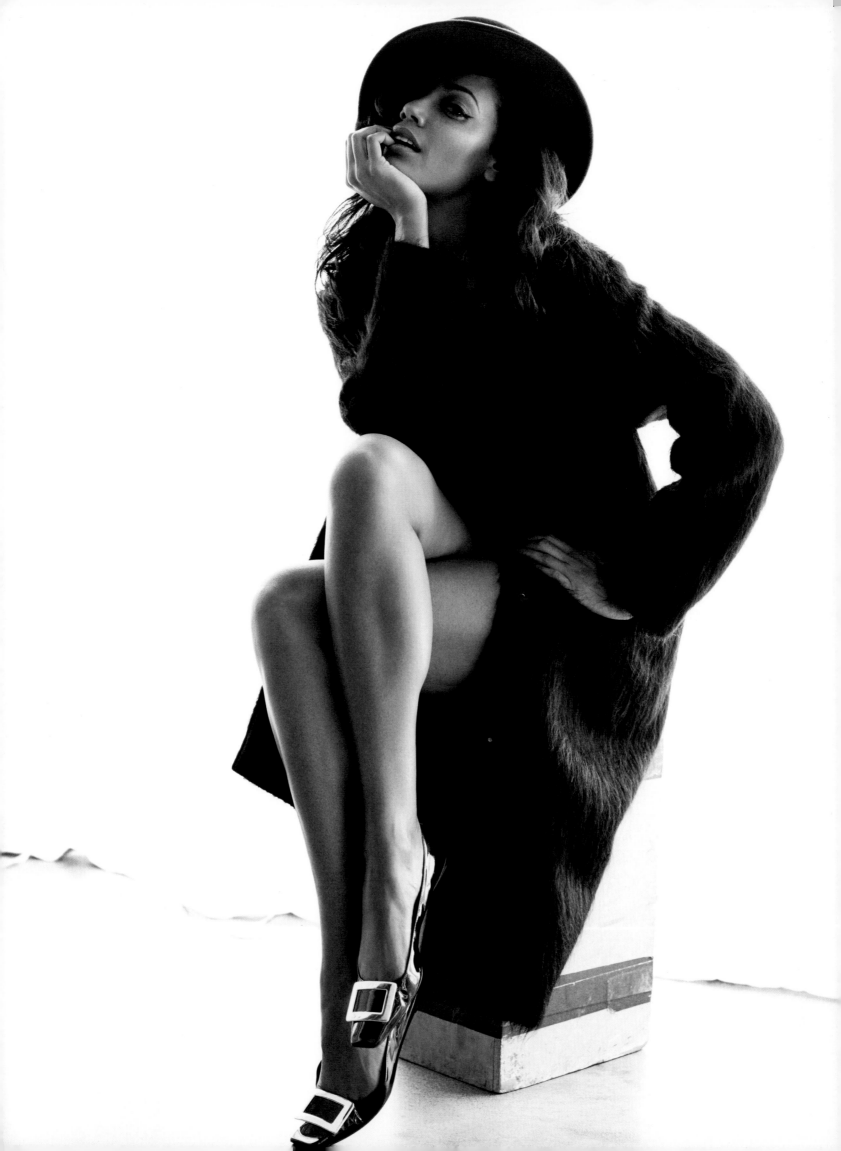

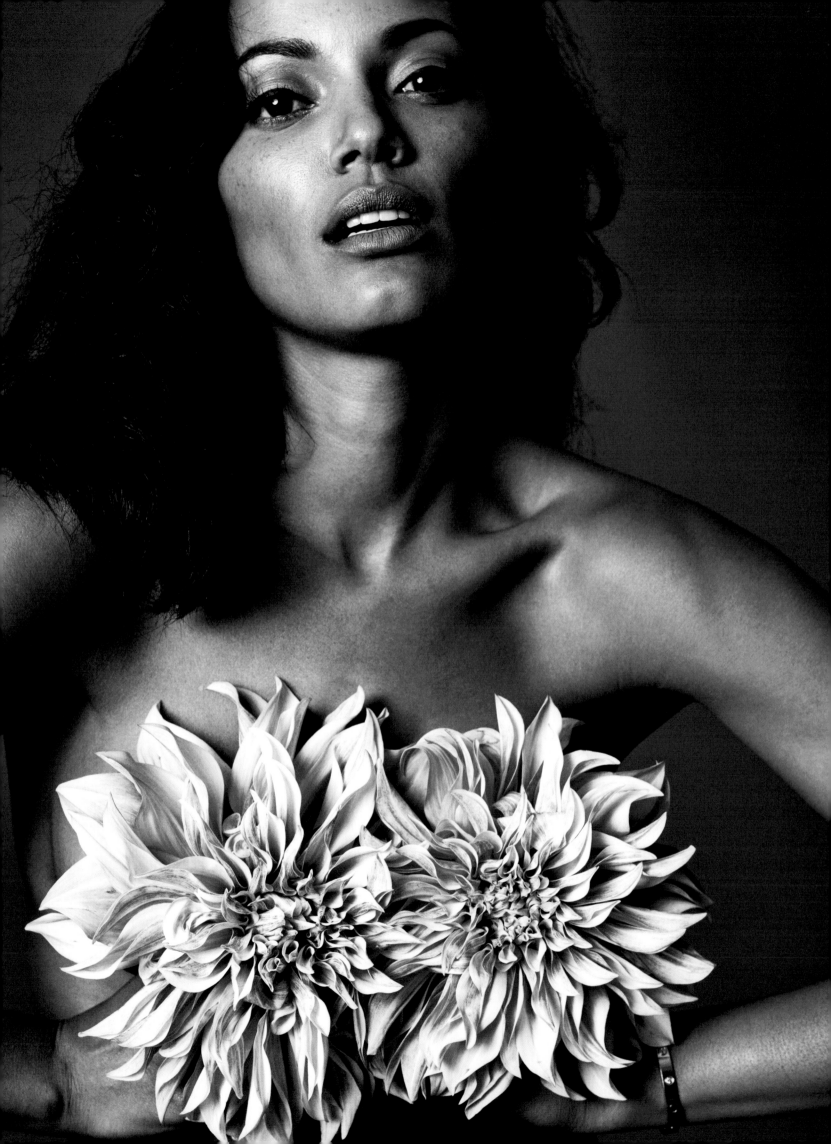

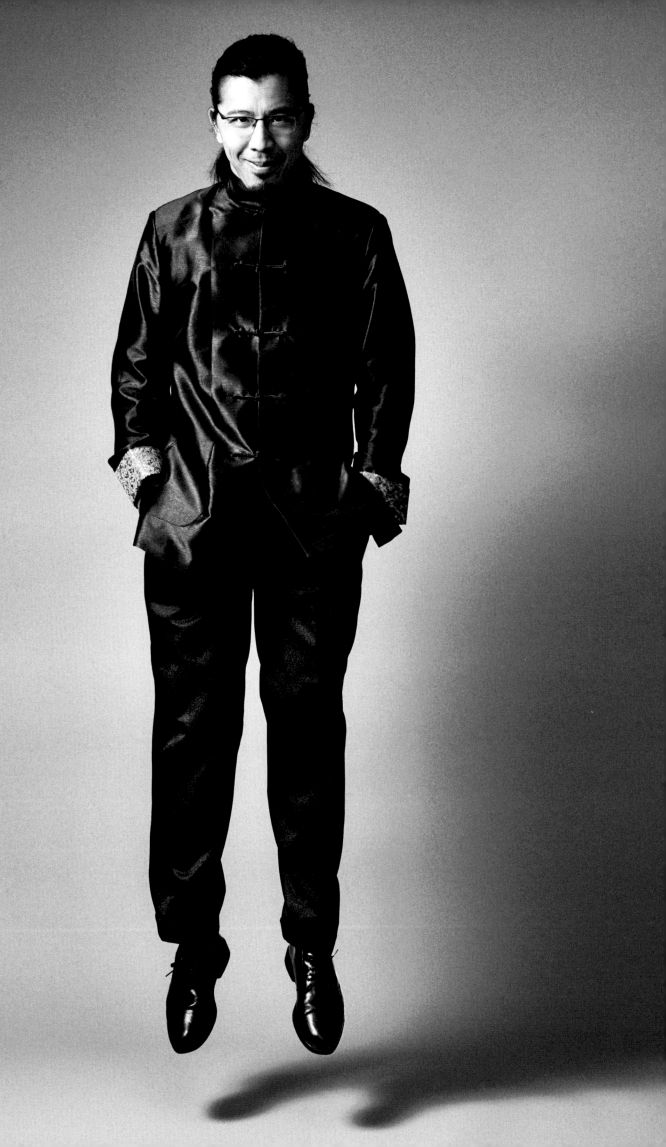

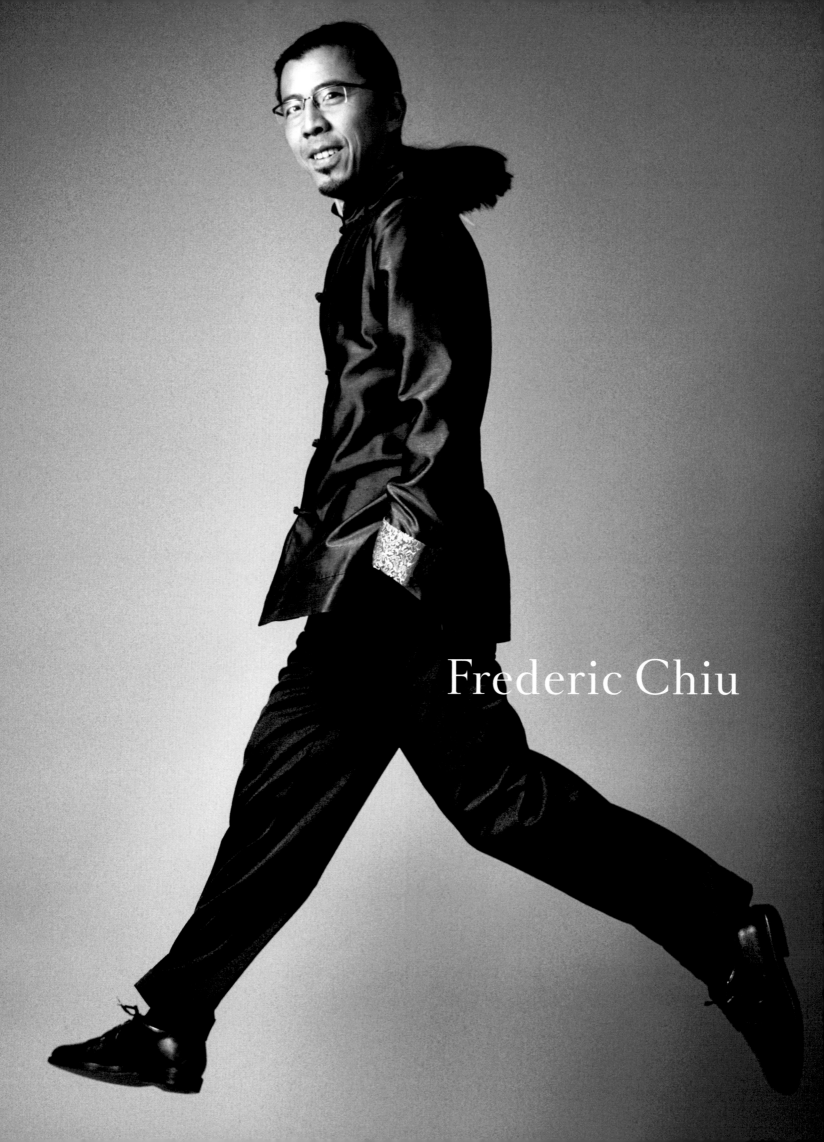

Frederic Chiu

When I first met Frederic I was struck by his gentle, kind face and intense intelligence combined with a mischievous smile. One senses his dedication and mastery of music almost without hearing him play a single note. Frederic is an internationally acclaimed concert pianist. The commitment to practice and the eternal striving for perfection in his art is something that I find awe-inspiring.

I have always been interested in the idea that if one practices something long enough one can become a master. Malcolm Gladwell, the journalist and author, once wrote that humans need to spend ten thousand hours in order to master something. Frederic started putting in those hours early, learning to play the piano when he was six years old. He was an obedient child from a Chinese-American household where children were brought up to respect their parents and there was no talking back. Although Frederic modestly suggests that he played "pretty well right from the beginning," his school years involved long hours of practice after classes and during the holidays. One senses that his was a close family unit but that there was nevertheless a loneliness that was part of his early life.

Frederic graduated from one teacher to the next and went to Indiana University, where he was already taking classes, an hour away from his home. It is one of the best music schools in the country, and while there he met one of the top pianists of his generation, who subsequently became his teacher at the prestigious Juilliard School. Frederic describes his advance in music as a kind of progression, something that happened to him rather than a clear goal he set out to achieve, and something he never questioned until his career was already taking off. "In my mid-to-late-twenties I realized I could do something else, but, in fact, I play the piano really well and I'm interested in it and I'm already playing concerts and have made a recording and have a manager. The fact that I came to that understanding really motivated me. All of a sudden I was thinking about, how can I take my career even further? How can I really focus on that versus thinking I'll do it because I'm supposed to do it?"

Frederic inspires me because he is concerned with bravery and authenticity as an artist. When he entered the Van Cliburn Competition, one of the most challenging competitions in the world of classical piano playing (it is held every four years and features musicians from all over the globe) he insisted on playing in his own unique style rather than a more traditional one. He played twentieth century pieces and piano transcriptions rather than the classic Beethoven and Chopin, and with a maverick flair. The result was that he lost the competition but the stir his performance >

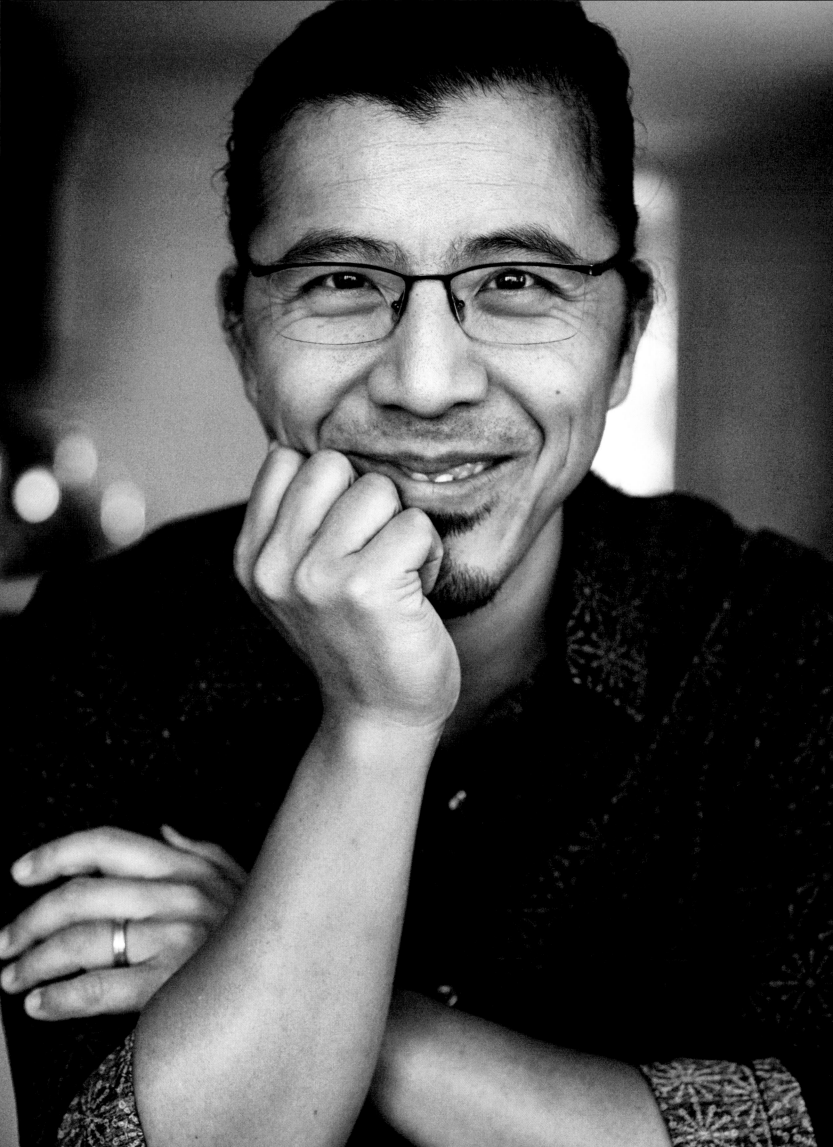

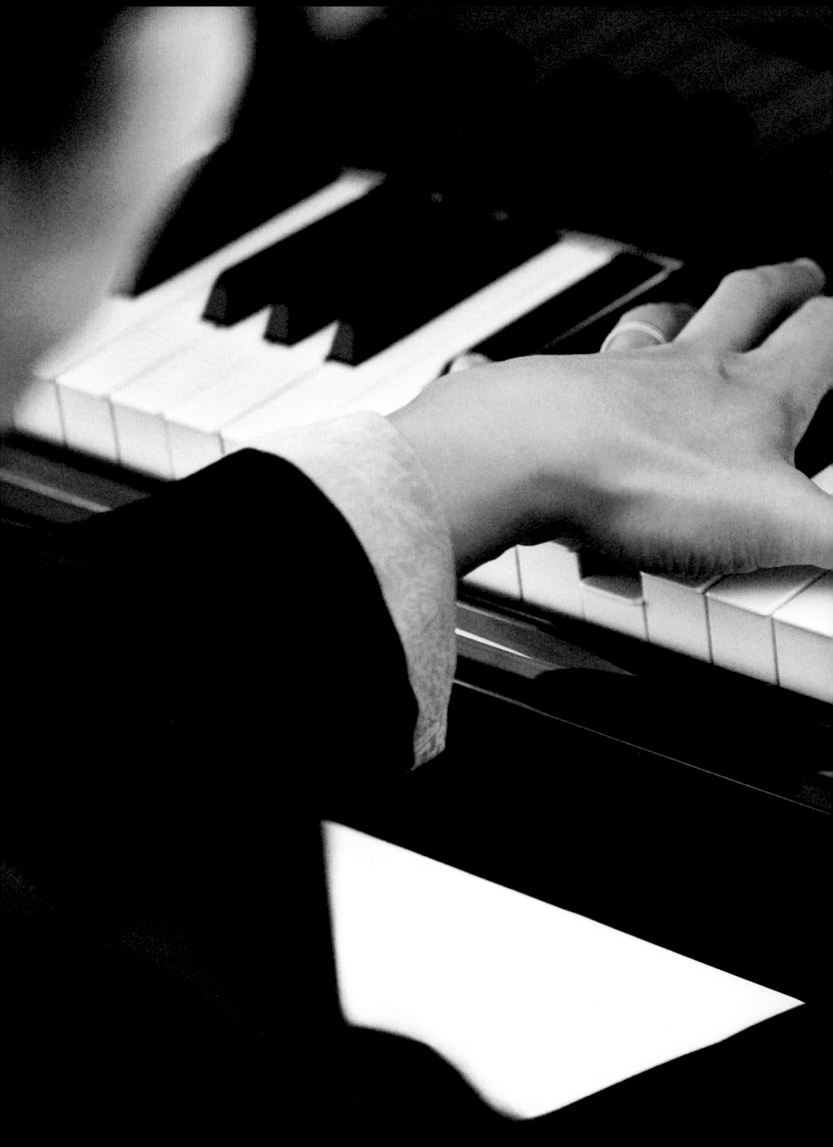

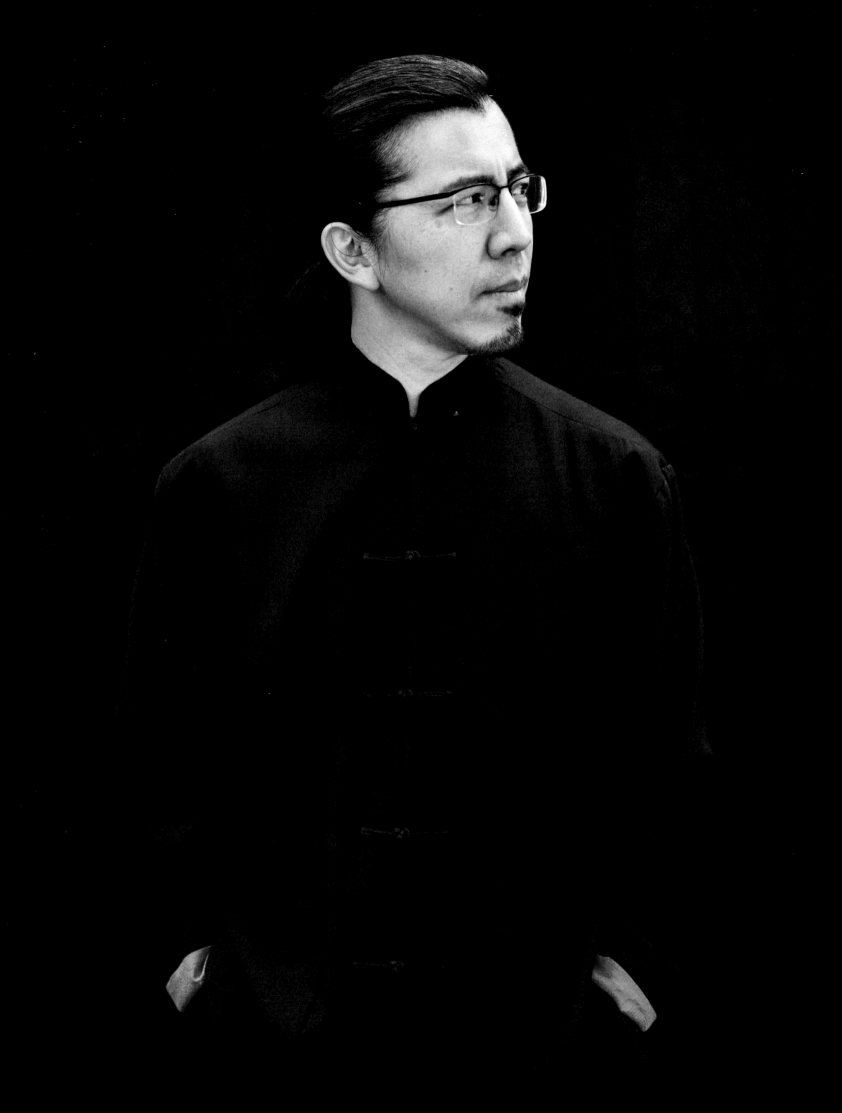

"I think you have to have artistic bravery if you really want to present a unique vision."

created resulted in a front-page story about him in the Arts and Leisure section of the *New York Times*. There are profound lessons for me here, because if Frederic had been a lesser artist he may have elected to perform in a more conventional way, but would not have created the ripple effect that would ultimately define him.

Frederic says, "I think you have to have artistic bravery if you really want to present a unique vision. Anybody who wants to go out there with their own opinion, knowing that there are opposing opinions, or in the absence of any knowledge of anybody's opinion, you have to have bravery. You have to be out there and have confidence because you're investing so much time and energy into something and you don't know in advance how people will respond." Frederic has now reached a new phase in his musical journey. He still practices at the piano as intensely as ever but has added a new layer to the process. He now practices in his head as well. His wife Jeanine Esposito, an artist, can ask him at any time of day, whether he is doing the dishes or opening the mail, what is he listening to? And always he has a precise piece he is playing in his mind.

Frederic is aware that the life of a concert pianist can be solitary and isolating. He describes "the risk of cutting yourself off from others because it's possible to spend your whole life studying the piano repertoire and not even get half way through it. There's so much out there." Nowadays, though, he sees his future as one where he is collaborating more with other artists and art forms. This feels like a more happy existence for Frederic; he strikes me as a man at one with himself. As he says, "I think the real creativity comes when you brush up against other people and your ideas brush up against opposing ideas. It's the rubbing, it's the friction that changes you. ♥

"Real creativity
comes when you brush up
against other people
and your ideas brush up
against opposing ideas.
It's the rubbing, it's the friction
that changes you."

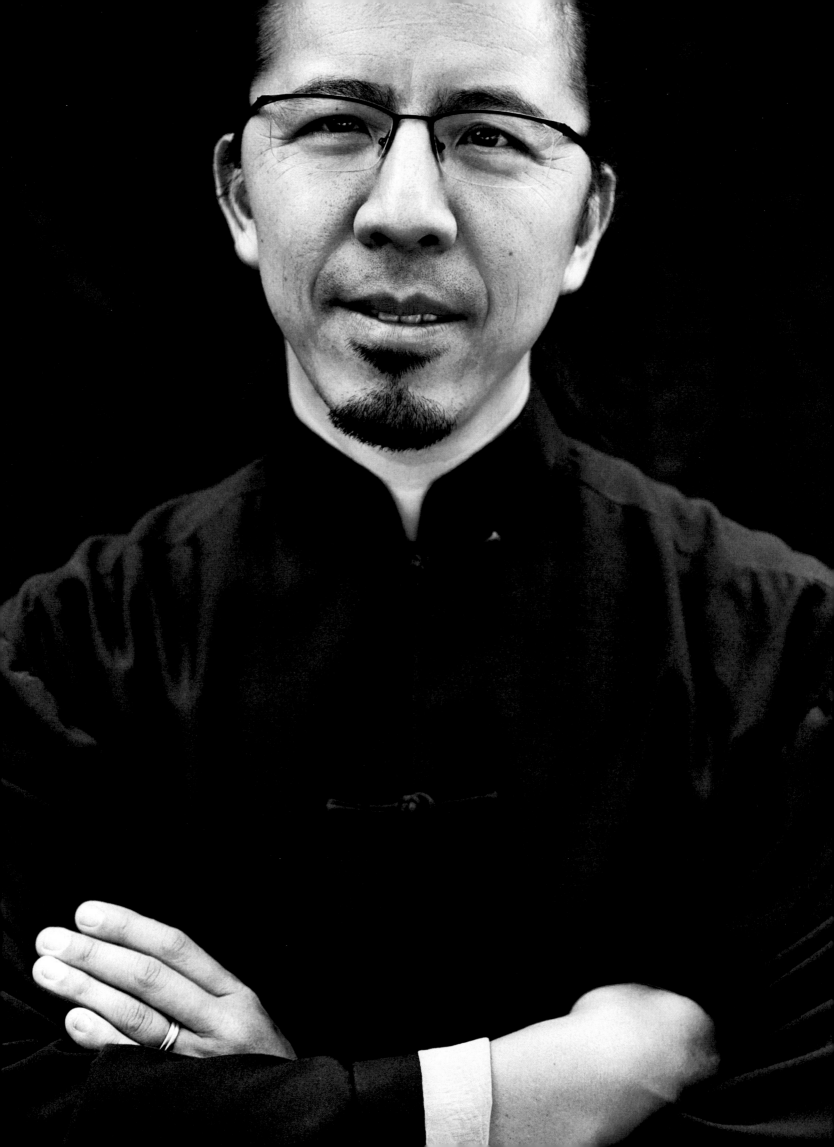

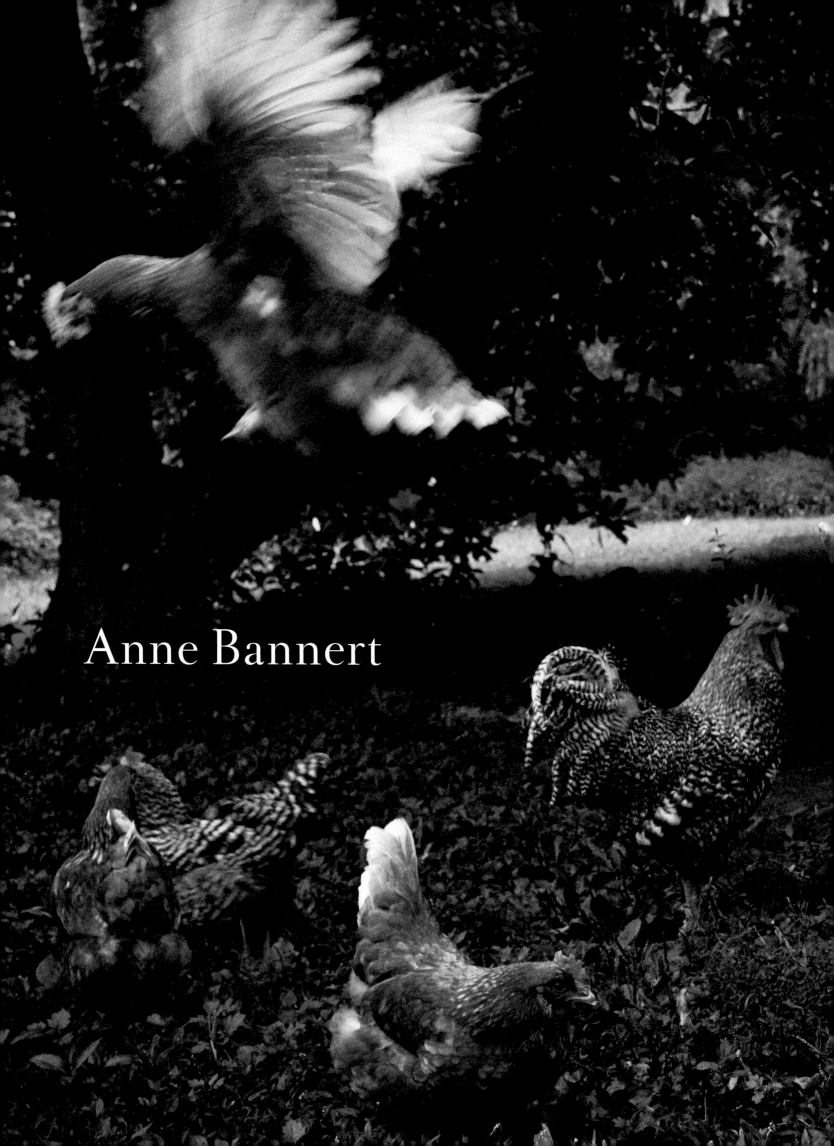

Anne Bannert

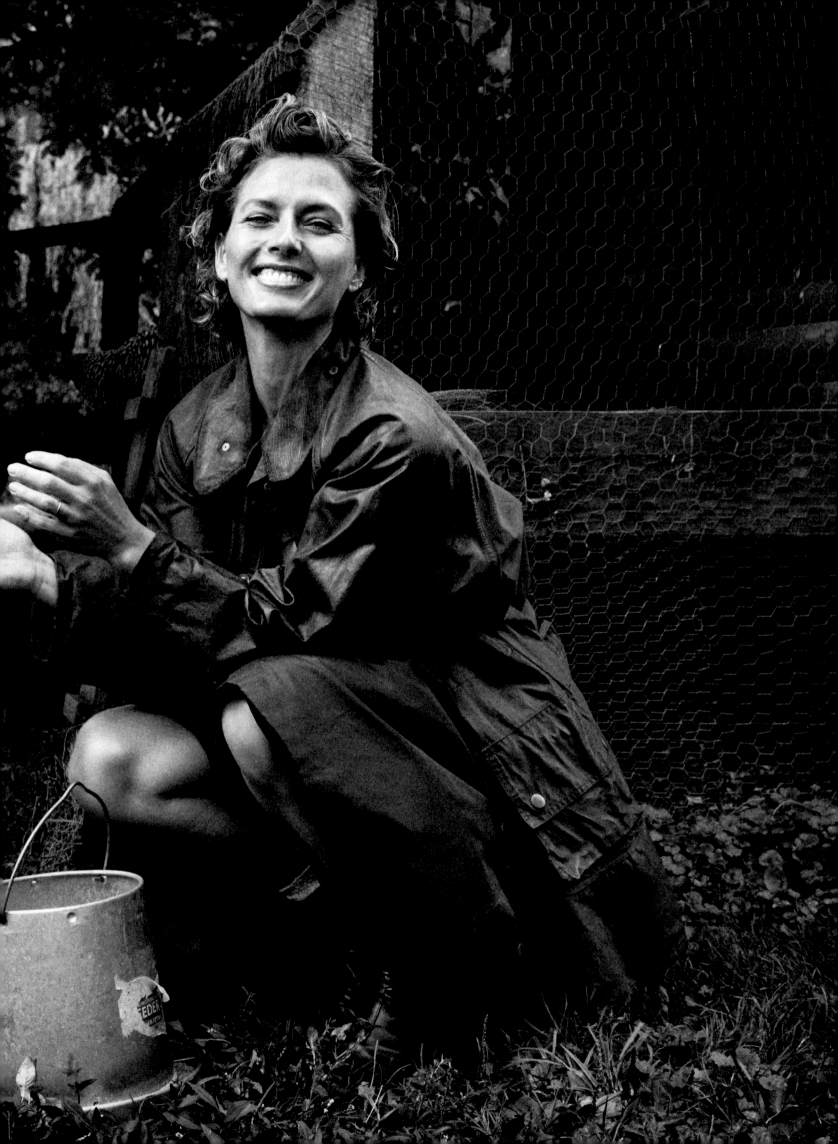

Anne is a human dynamo. She is constantly up ladders painting her house and clearing drains; she runs her vegetable garden with her native German efficiency; she welds metal because she likes to repair things rather than throw them out; she services her 1970s & 1980s Mercedes and 1984 AMC Wagoneer truck; she carves wood; she manages the three acres on which she lives in a converted 1800s barn with her husband Alberto (refusing the help of landscapers because she wants to make sure the garden retains its rustic flavor). She has two dogs, three cats, a flock of hens, and rides horses. She also models and runs her house as a location home for photoshoots. So with all this it is hard to imagine the person sitting in front of me was severely ill ten years ago.

Anne recalls that when she was about twenty-one she was diagnosed with Lyme disease. She was prescribed a dose of antibiotics and assumed the disease would run its course. The symptoms were mild at first. Occasionally she would forget something at the grocery store, lapses that she put down to aging, but after she had her son in her mid-twenties and was trying to finish her college degree as a single mother, she describes an almost imperceptible yet unrelenting decline. "I remember each day I got up, I got my kid to school, I ran to campus, studied, came back at 5:00, cooked dinner for my son, put him to bed and then I studied all night or I got up at 4:00 in the morning and studied. My behavior was wholly goal-oriented, and I remember thinking, 'Oh, that's funny. For weeks now I've been eating a little piece of white bread and a hunk of cheese for lunch and I don't look any different than before.' I wondered why people made so much work of eating when you could save so much time skimping on nutrition. That ended up being my big mistake."

"I had terrible migraines and my whole body would ache. I would never feel good, never ever. There were days when I couldn't get out of bed, or reach a glass of water that was next to me on a table. None of the many doctors I saw could help me. They would run tests for mono or tell me I had the flu. At one point they said 'Why don't you see somebody for psychological counseling?' I did that. I did everything that I possibly could but the suggestion was always that it was psychosomatic because nothing was showing up in tests or blood work."

Shortly afterwards Anne met her second husband, Alberto, and moved to Connecticut. Despite finding the "love of her life" her health continued to worsen. Anne reached a point where she says "I wanted to write my will because I knew I was dying and nobody thought there was anything wrong with me. I remember thinking, damn it, I know I'm not crazy. I'm getting sicker and sicker. I need to go at this differently."

>

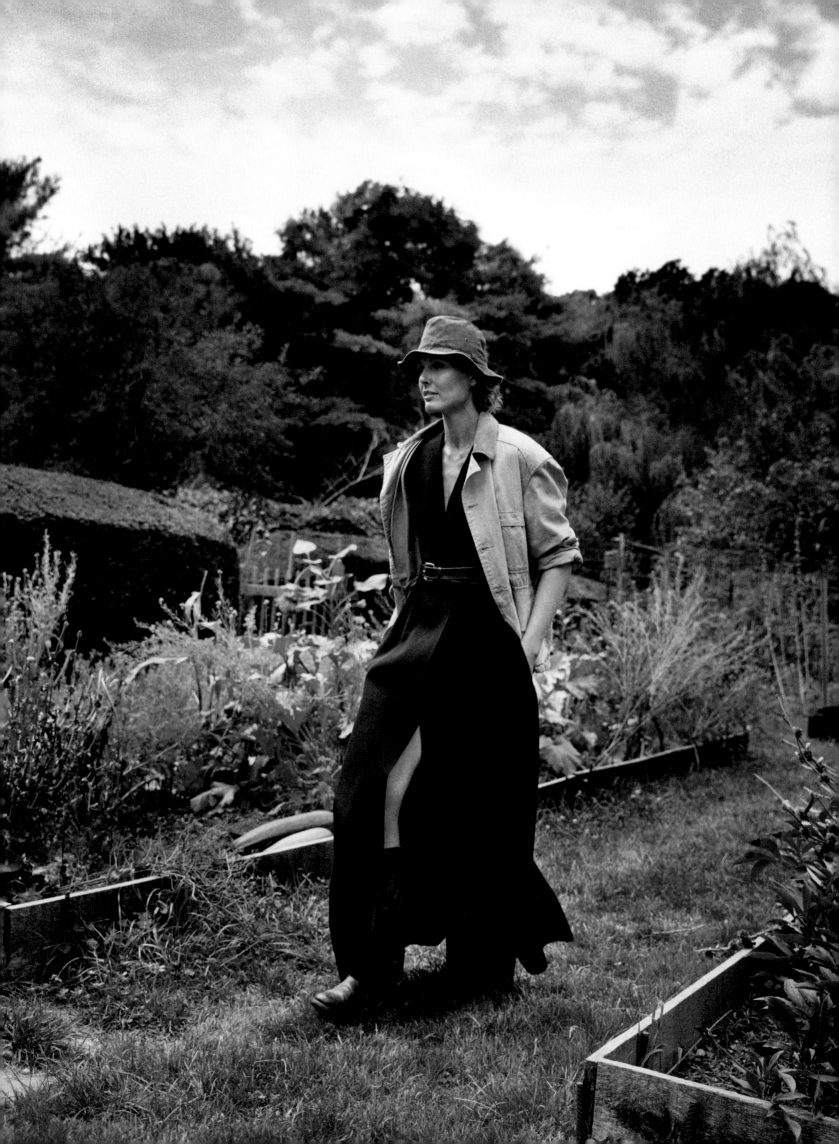

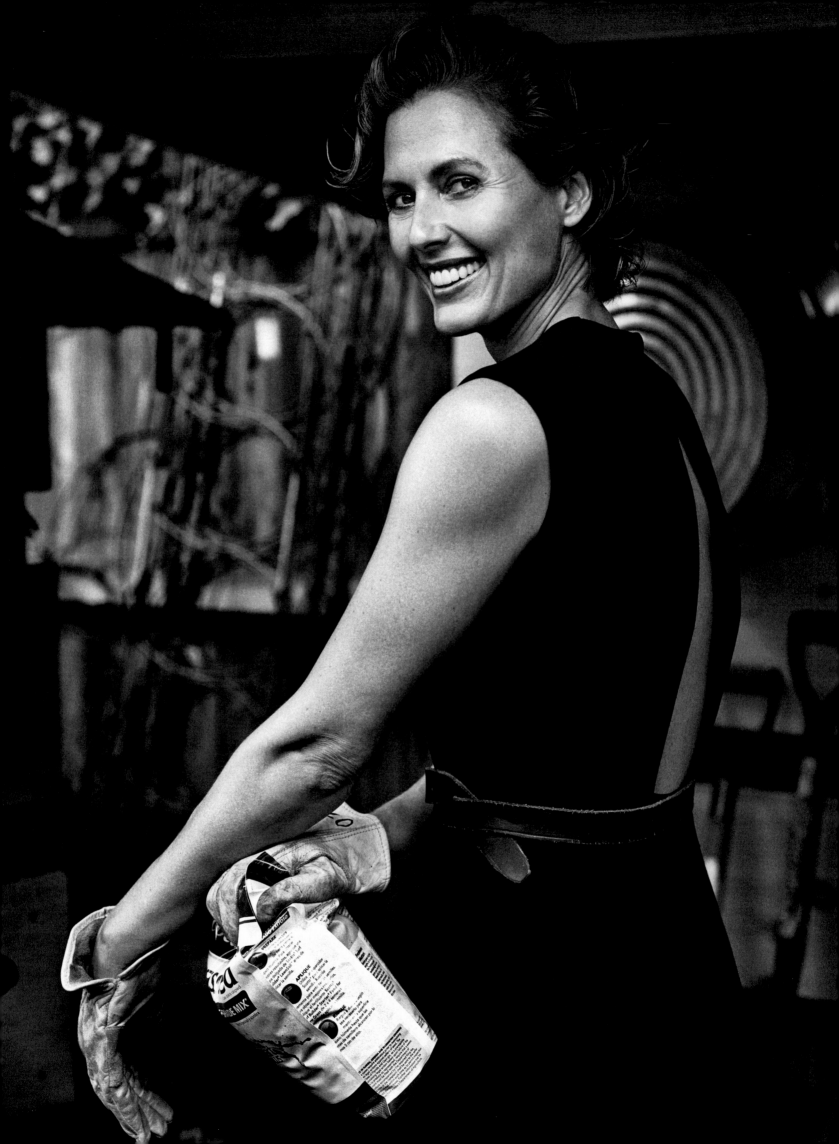

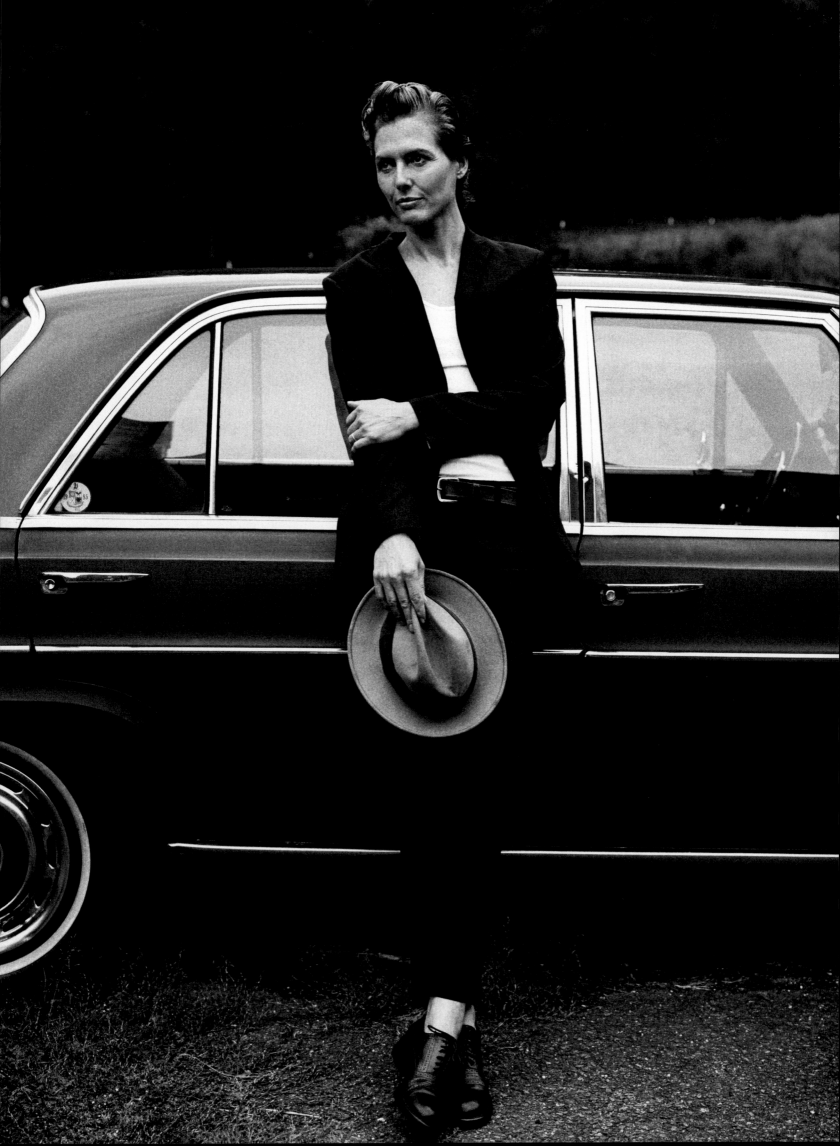

"There were days
when I couldn't get out of bed,
or reach a glass of water
that was next to me on a table."

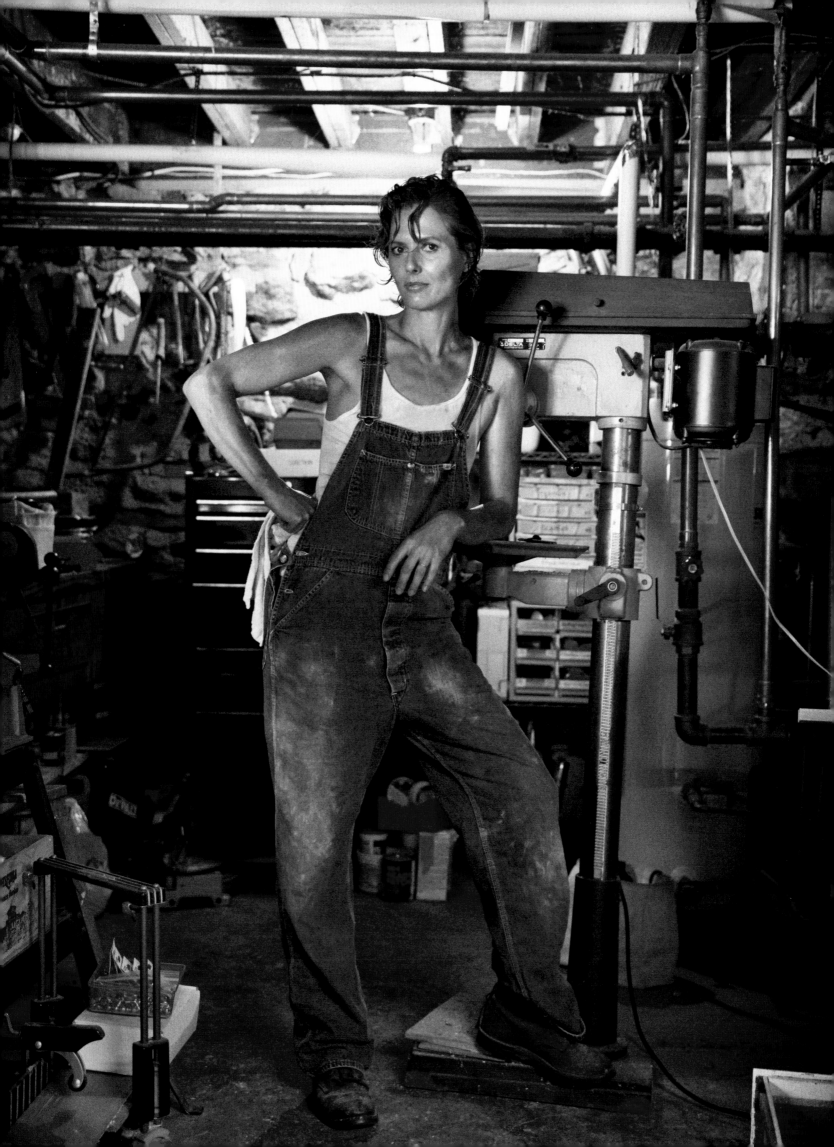

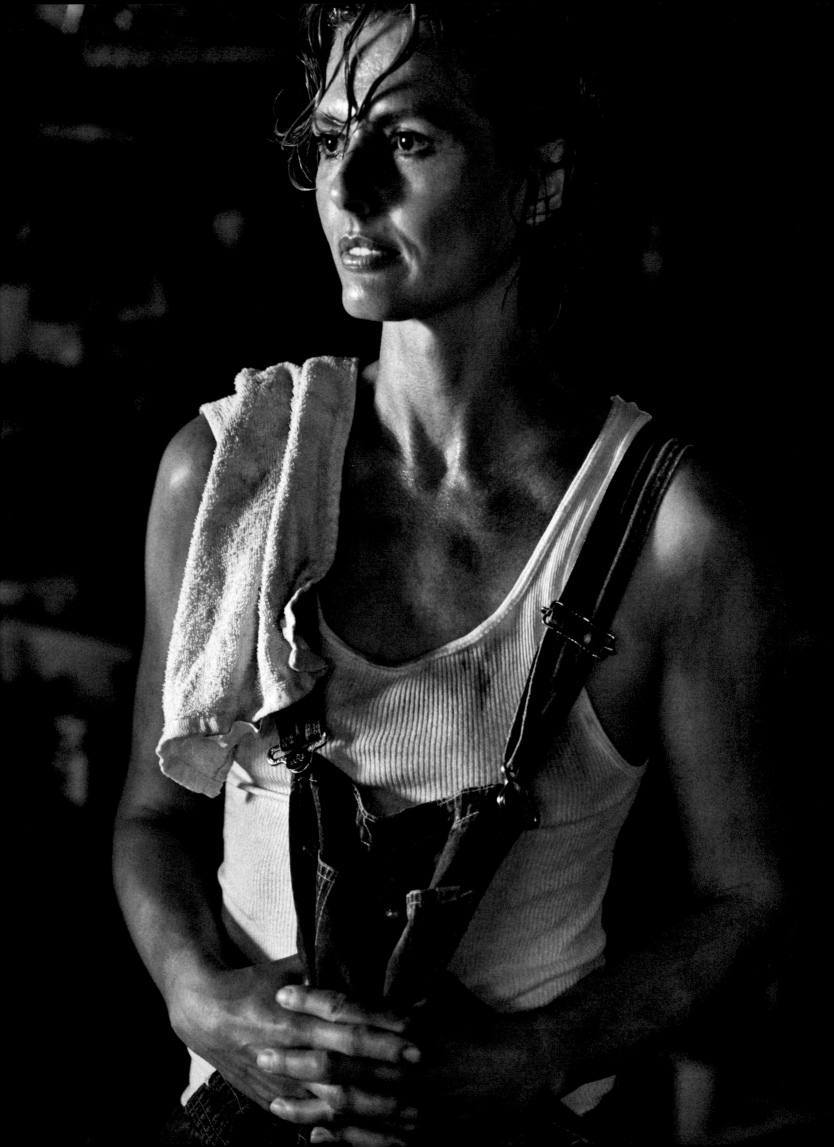

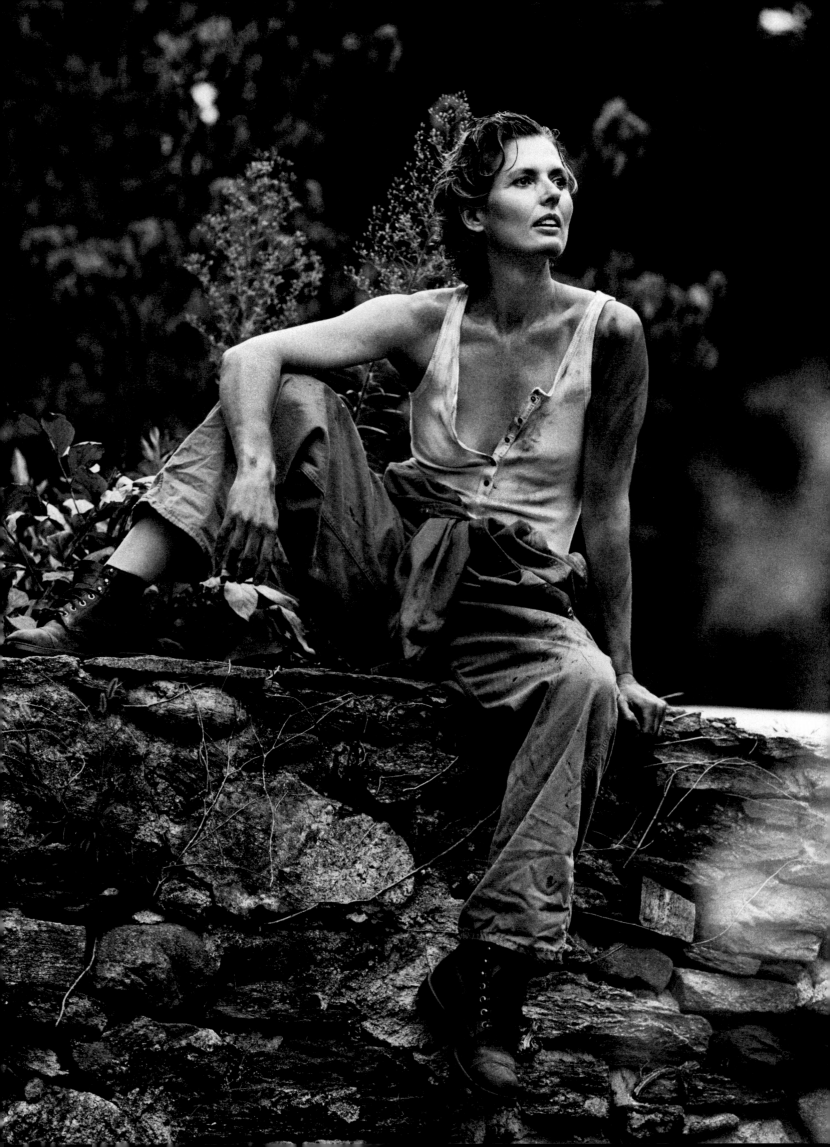

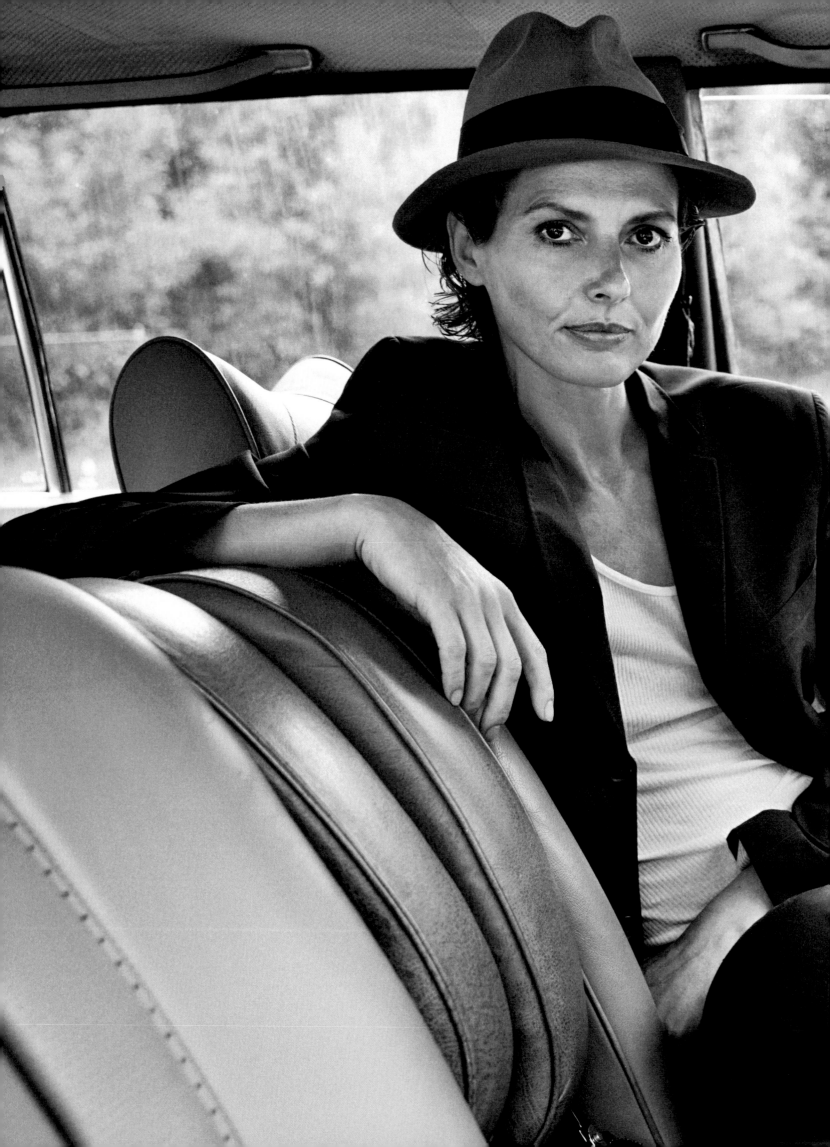

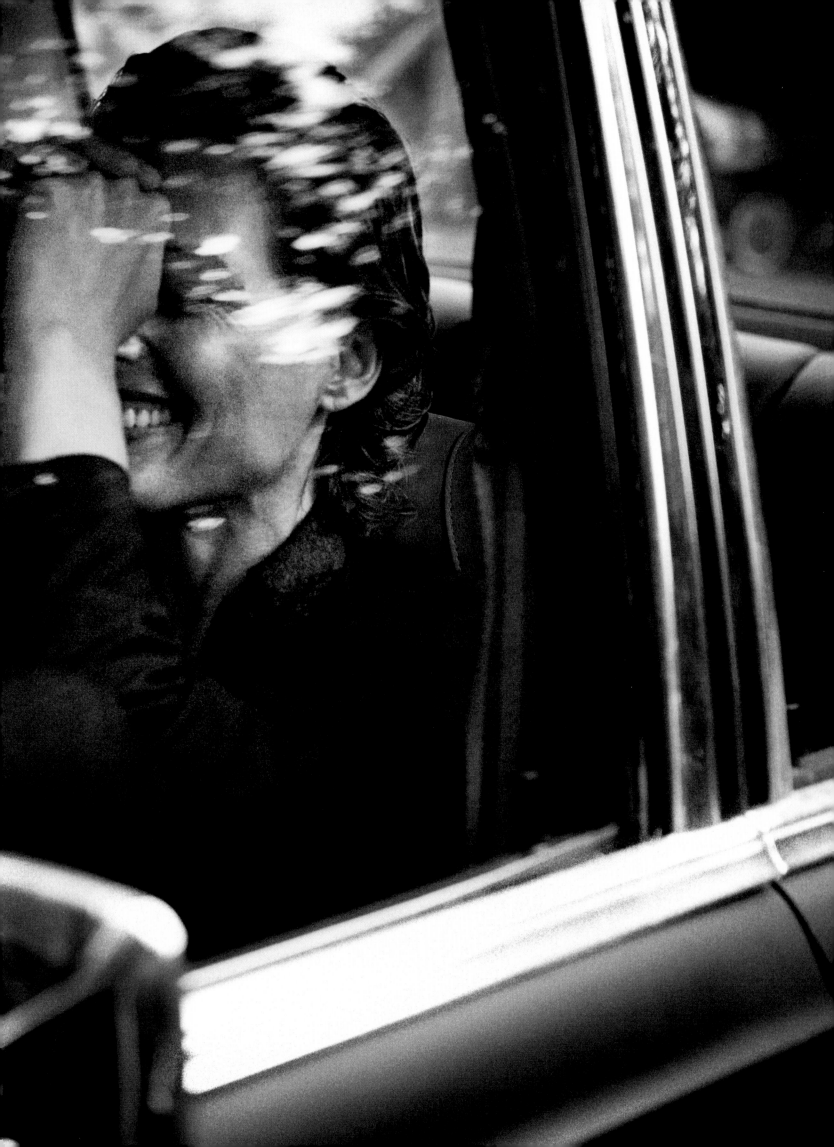

"I remember thinking, damn it, I know I'm not crazy."

By chance one of Alberto's clients gave her a book called *Dr. Rau's Guide to Optimal Health*, which had recently been written up in *Vogue*. Anne accepted it just to be polite, thinking something so simple could not solve a problem so severe. But she decided there was nothing left to lose by reading it. The book was a guide to strengthening your immune system by cooking simple, light, easily digestible food—like the stewed zucchini her mother used to make for dinner when Anne was a child in Germany. There was also an emphasis on raw foods. It was a gradual change, but she noticed that when she followed this diet for a test period, she began feeling better. She stopped having migraines and had more energy. What she learned could be reduced to a simple idea: "If it comes in a box and you buy it off a very long shelf at a grocery store, that's not food. Food is something you could be growing in your own backyard. It comes from the earth. It's from a tree or grows in soil or it's an animal you catch."

By following these principles, Anne regained her physical strength and mental clarity. She was able to renovate her house floor to ceiling, and learned how to play polo, which is extremely physically demanding. She realized that, "This is how much fun I can have if I forego the supposed pleasure of eating processed and convenience food. No bucket of french fries tastes so good that I am willing to forgo the joys that good health affords me."

Eventually, with the help of naturopathic medicine and proper nutrition, her immune system conquered the Lyme disease. Anne now sees the value in taking care of one's body, even when it requires extra work to buy or grow natural foods and prepare them. For her, the time and effort involved are "so insignificant compared to the massive inconveniences that the loss of health and energy present." She says, "Of course, some people still don't believe that healthy food is a foundation to health, but once you run yourself into the ground and you do the math, I think there has to be something wrong with your logic if you don't start changing the way you eat." ♥

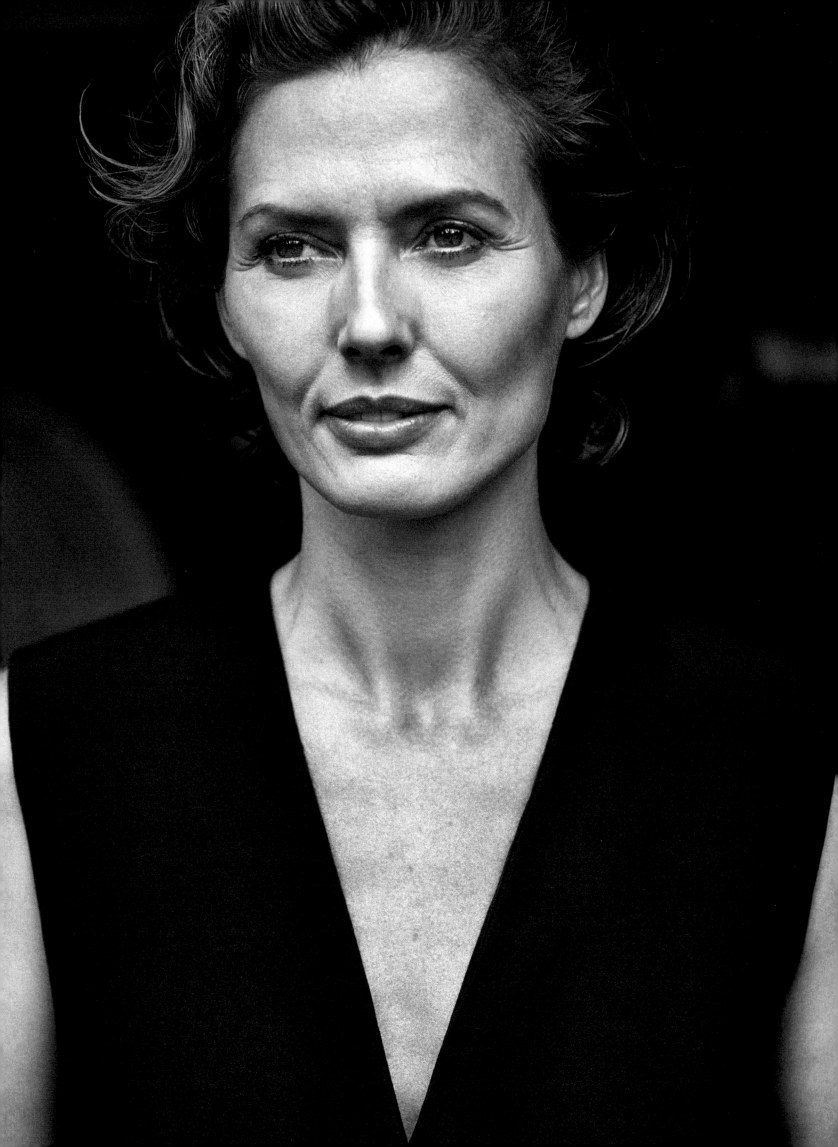

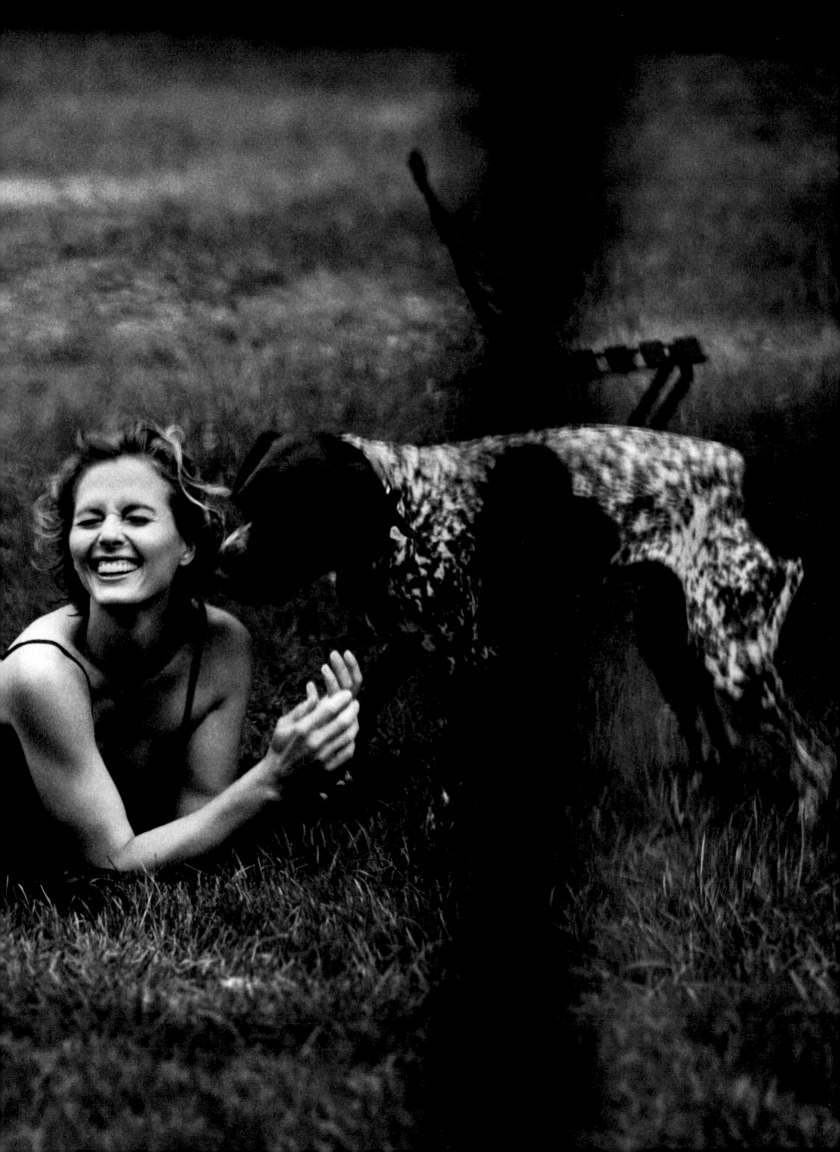

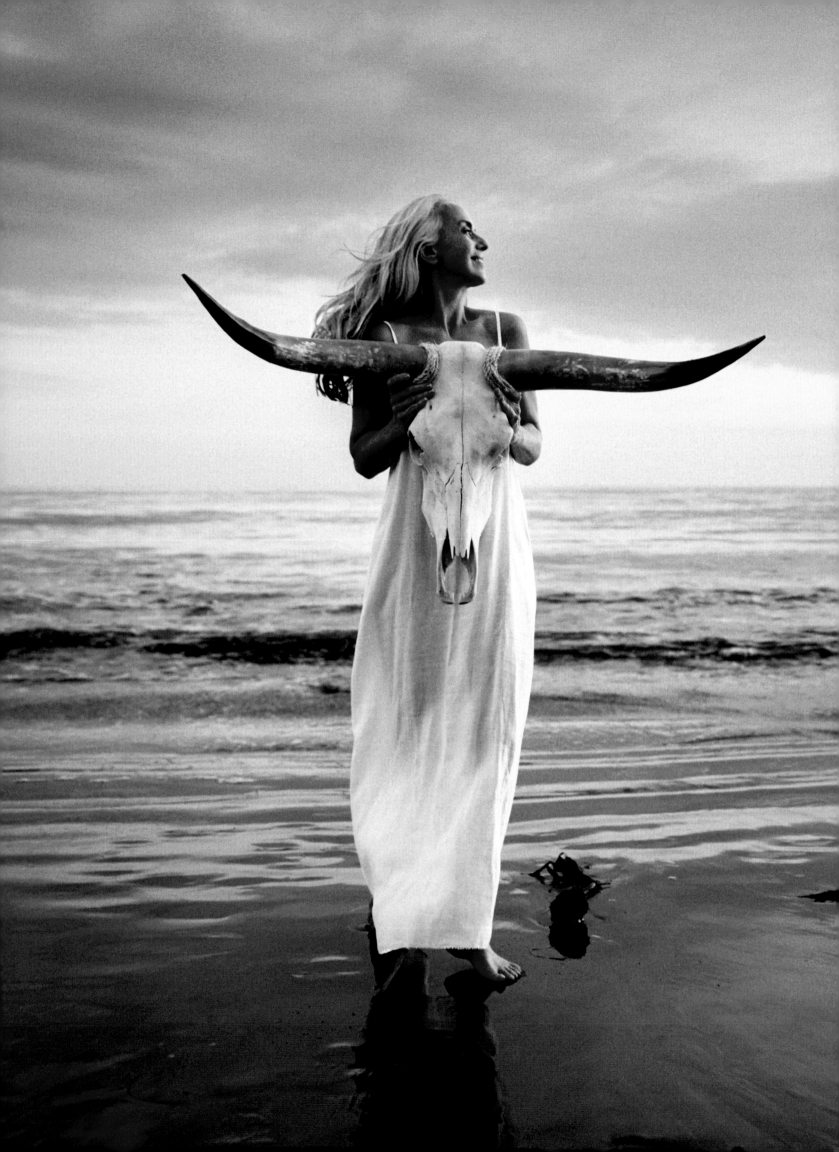

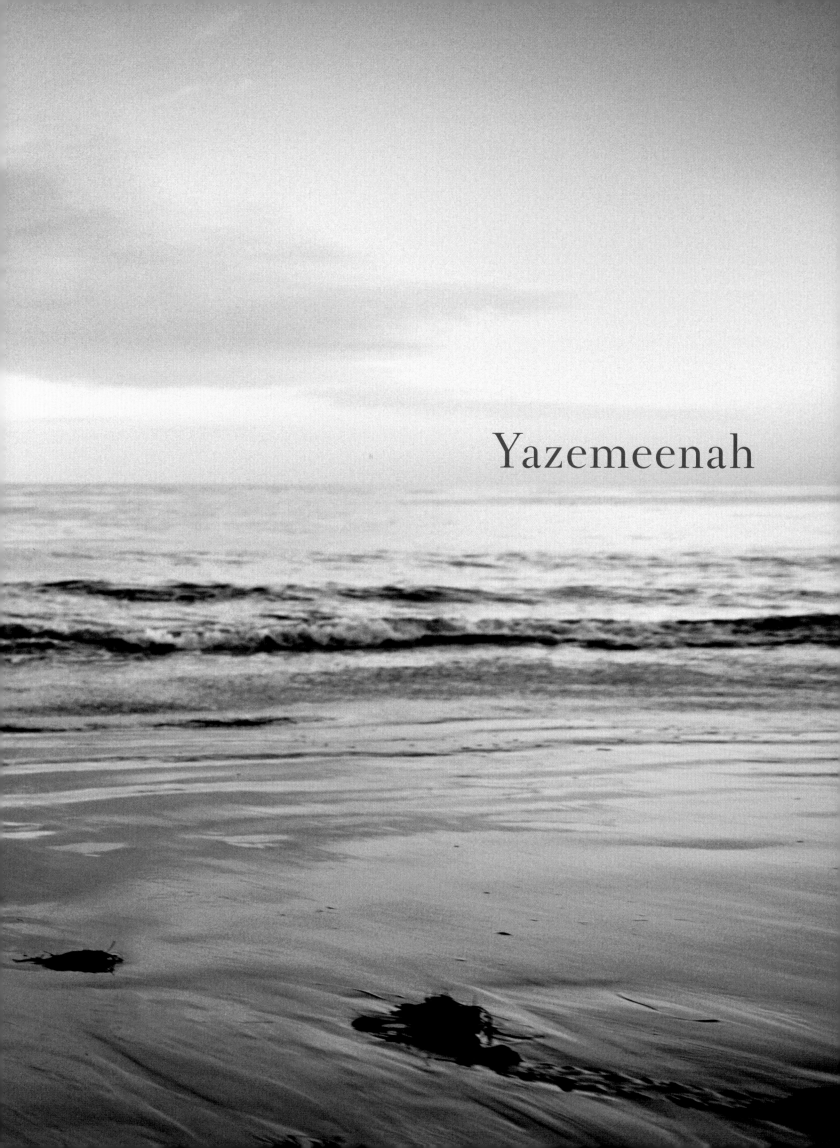

Yazemeenah

Yazemeenah has a striking appearance. She is an actress and a model, but it is her work as an art photographer that most interests me. Her work often revolves around self-portraits in nature. She is often nude and interacting with her surroundings as if she is part of the landscape. When she was seven or eight years old she began framing pictures with the family camera. "My family didn't have a lot of money, so we only had one roll of film for the year: it was for Easter, Christmas, birthdays. So when the camera was empty, I would still hold the camera and pretend to take pictures, framing."

Yazemeenah grew up with her grandparents, who ran a restaurant by a beach in Corsica. At the time there was no electricity or running water. Drinking water came from a spring, and the family bathed and did laundry in the local river. They would grow their own vegetables. These early memories of communing with nature taught Yazemeenah how to see light. This is how she describes it to me:

"I remember going to the spring and there was a big fig tree. You have the leaves and you have the sun coming through them. And the spring water came from the rocks and was falling into the jug. The light was touching the water, sparkling. And I was fascinated. I always look for that in my pictures. I always look to find a way, by backlight or by reflection, to have this magic thing of a flair or the light reflecting off the water. And I always kept that; I always looked for that. The relationship we have with nature when we are little, we keep it all our lives."

She has continued to live by the beach, now in north Malibu, where the desert meets the ocean, because she believes she is nourished by the land, the water and the light. When composing one of her self-portraits in the deserts she describes the process: "It's not me who decides where to shoot. It's the land that tells me where to stop. I'm driving and suddenly something inside tells me to stop there. I love this process of not knowing. And I say, okay, do I do nude or do I do a dress? I start with a dressed picture and after, if there is nobody around, I ask if I can be nude. It's like making love with the land. It's really an intimate relationship."

Yazemeenah believes her art connects her to all that is spiritual in life. It is as if she is a channel for divine energy. "I think it's the divine part within ourselves where we're pushed to create art for our daily life. Everything I see, I crop it in a picture. Art for me is making beauty with what is there—it's like being really present and enjoying what I do in the present moment. When I do a picture and it's random I don't know what I'm taking. But I know that somewhere, like when the land told me to stop there, I'm a channel for something that is working through me and makes me do these things. I feel this even more strongly now as I have started to make videos of myself."

She shared words which have continued to inspire me. "Doing pictures as an artist, you must be doing what you really want to do. You are not directed by someone; you just do what you want to do. Whatever makes you like, 'Oh, I love it!' then you do it. In fact it comes from your heart." ♥

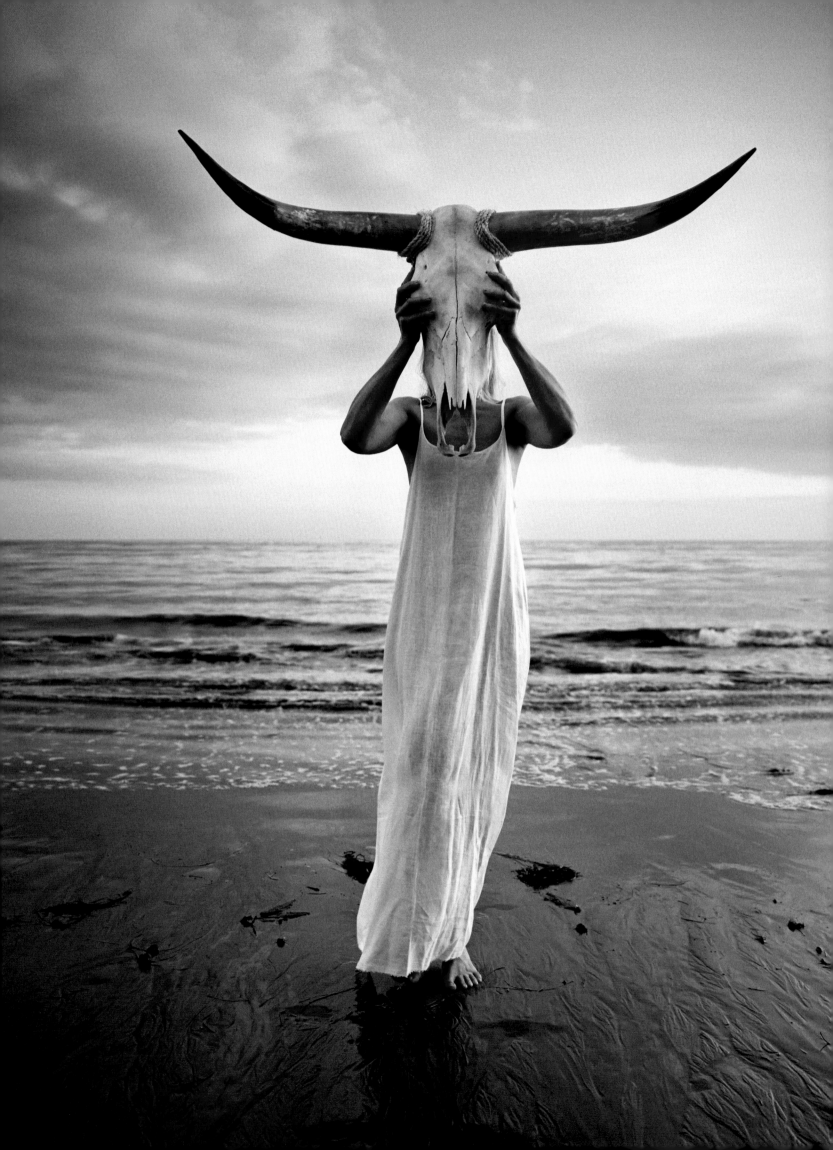

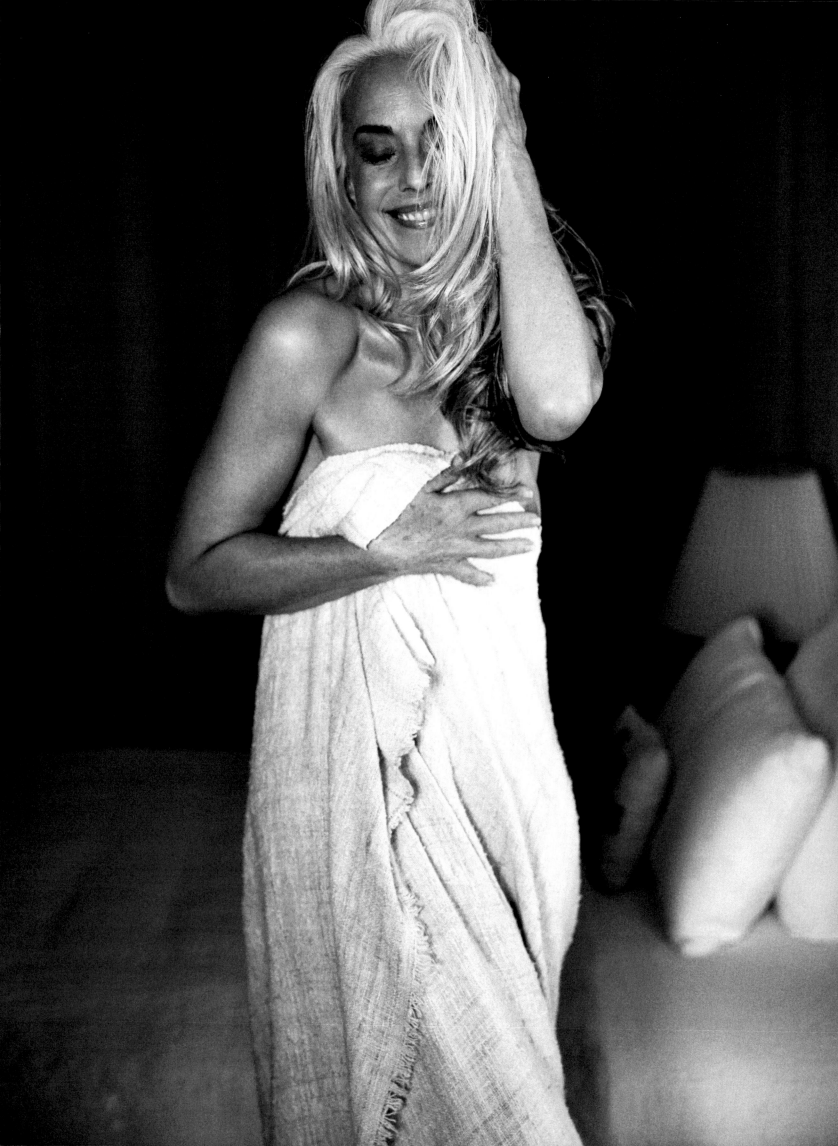

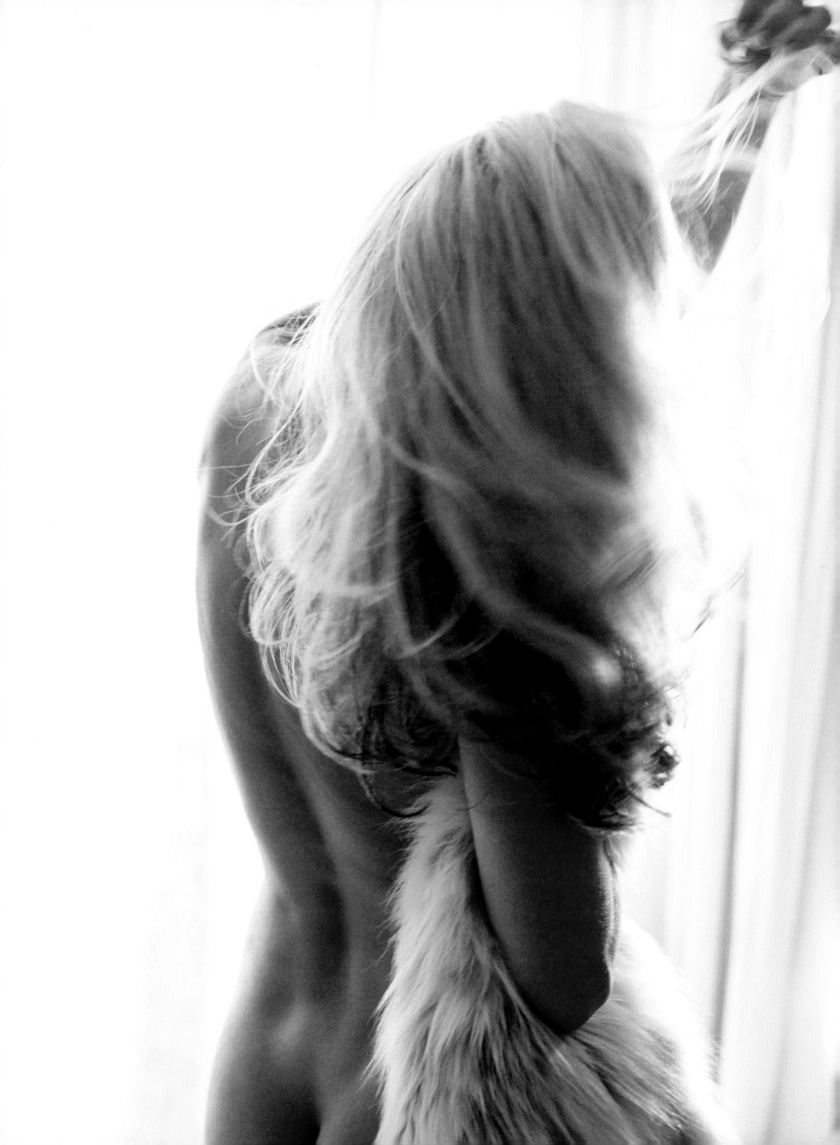

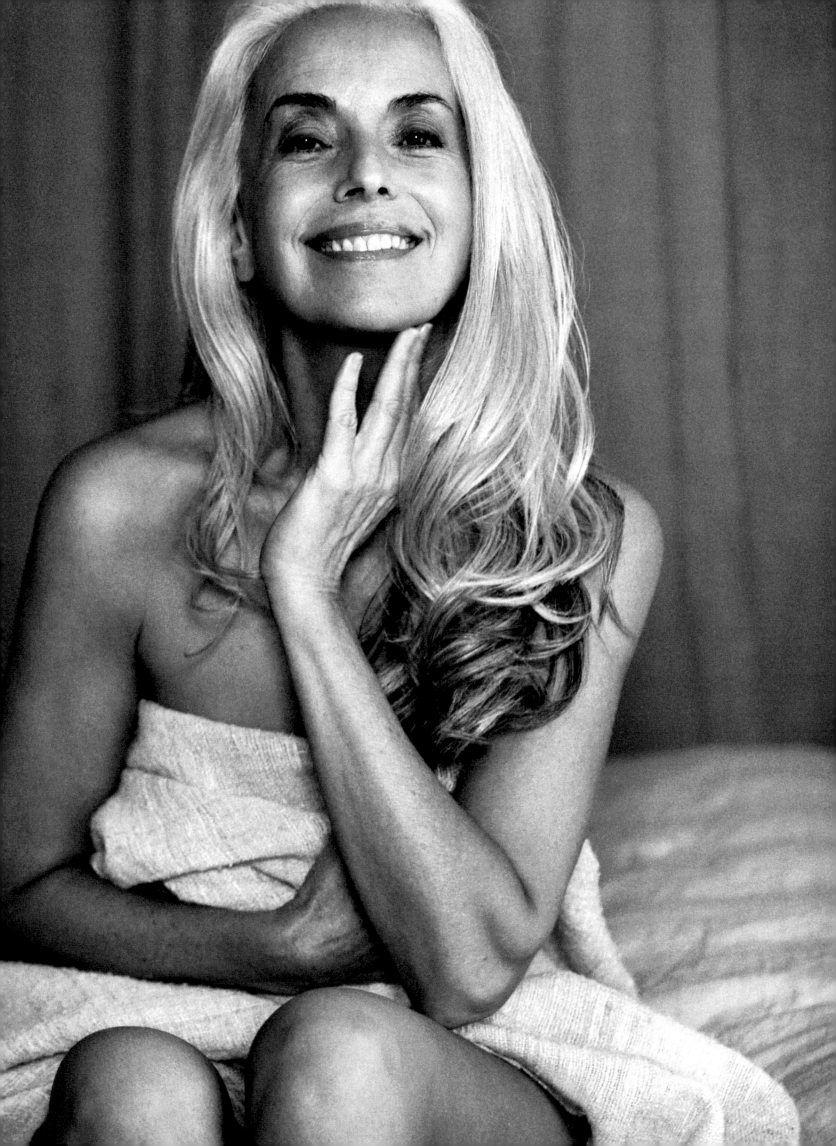

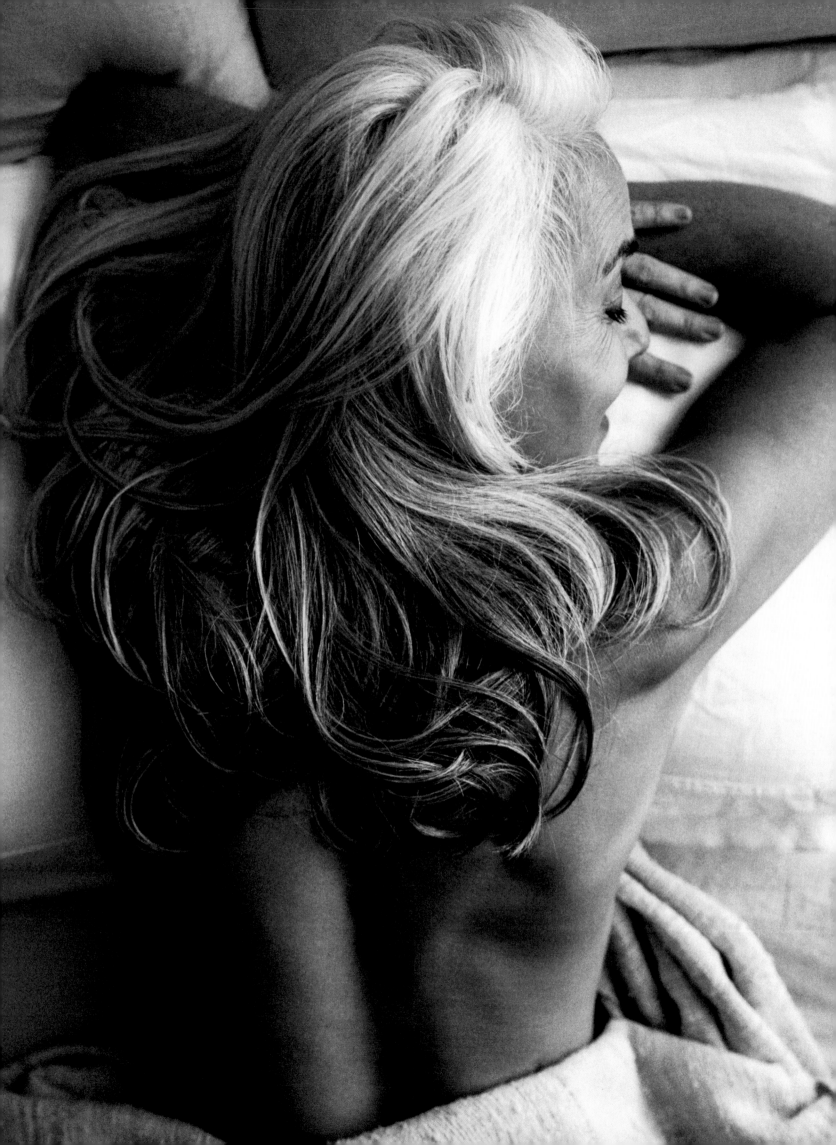

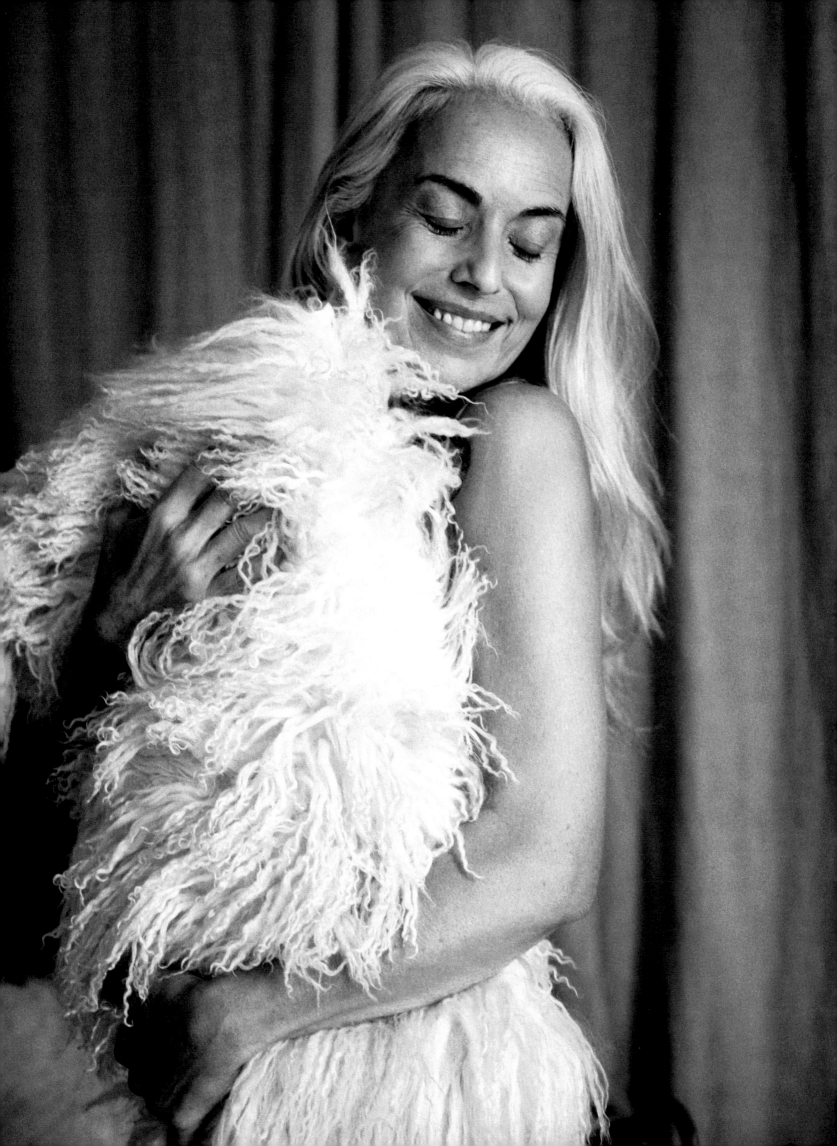

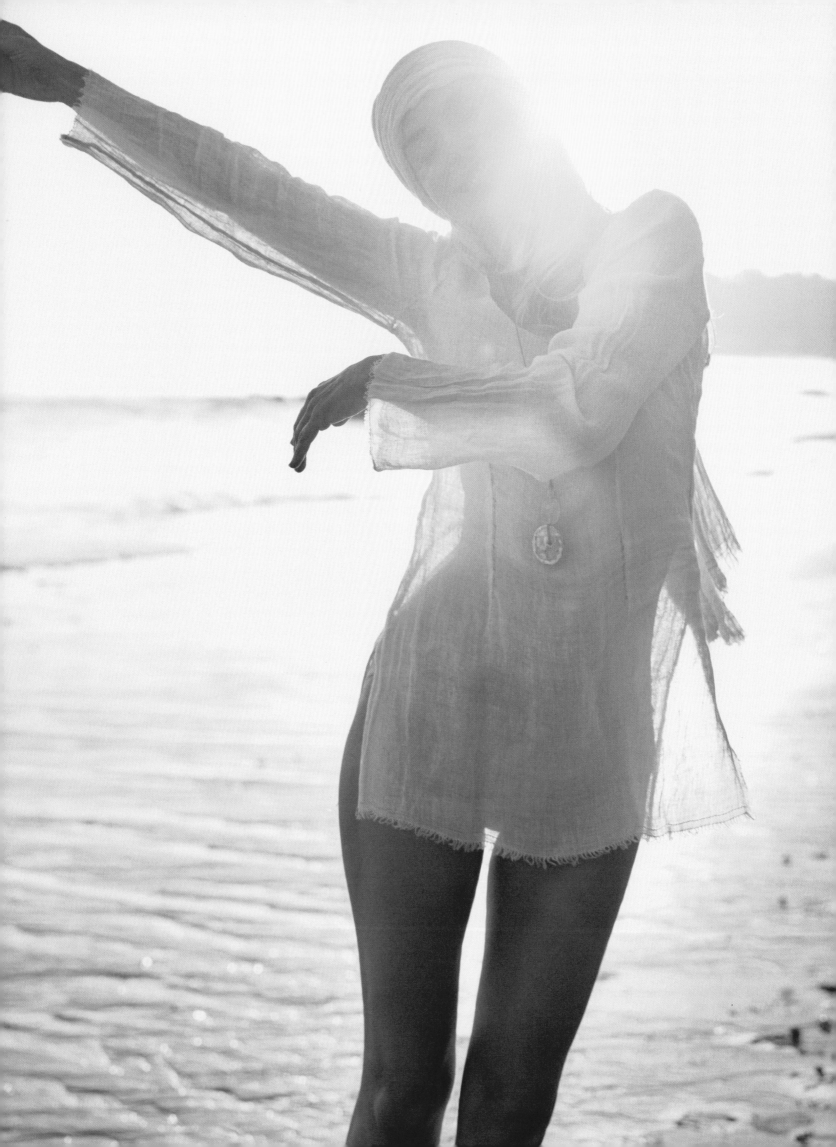

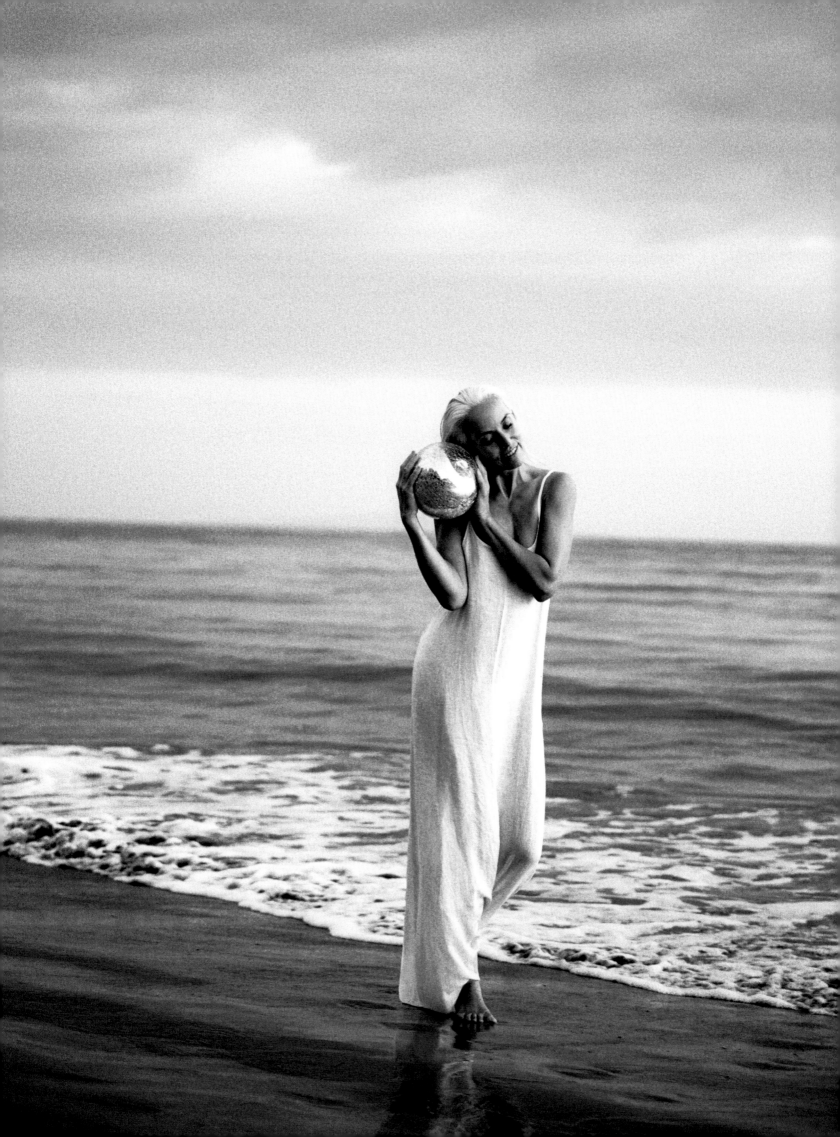

"I think it's the divine part
within ourselves
where we're pushed
to create art for our daily life."

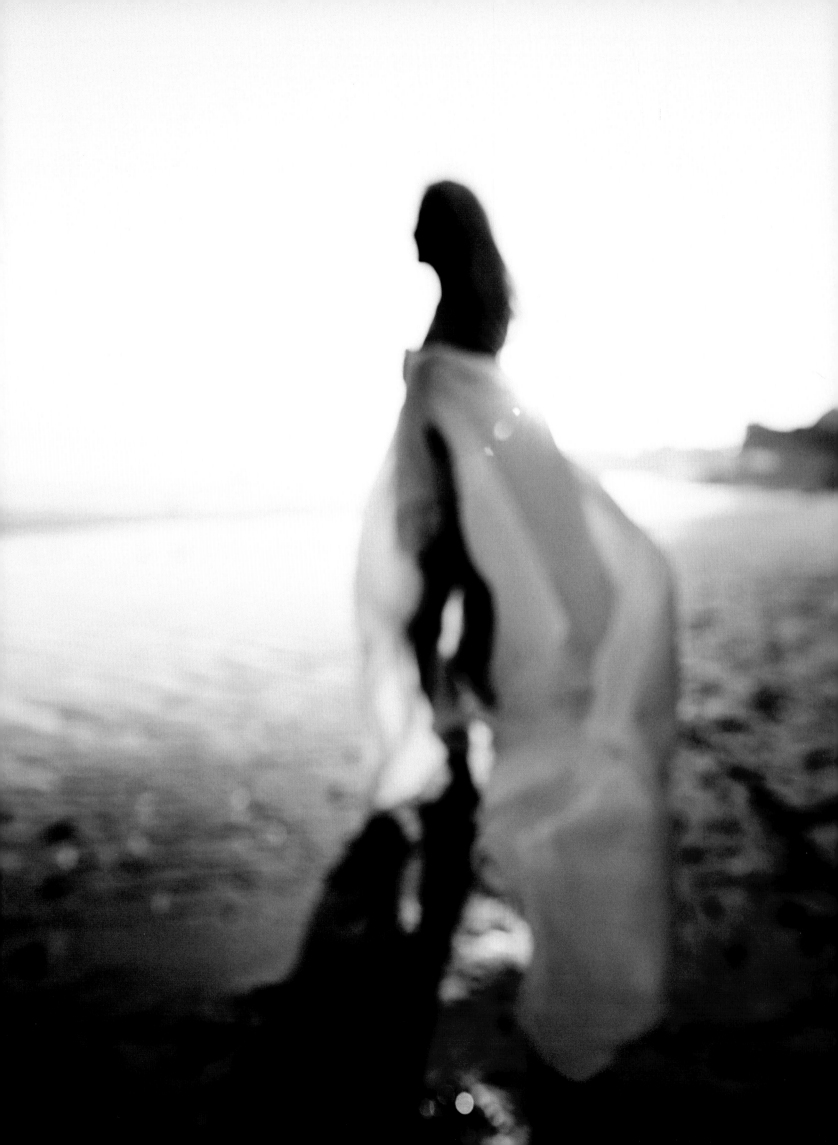

I have been truly astounded by all the help and support I have received for this project. I would like to extend my thanks to everyone who has been involved. I am deeply indebted to the contributors, who gave generously of their time and opened both their hearts and minds to me with their stories. In talking to each one of you, I realized that you had a special story for me and I thank you immensely.

In addition I would like to thank all those other talented individuals who have worked behind the scenes and who have helped make this project a reality. You are all amazing people and I am profoundly grateful to all of you: Abner James, Alberto Hamonet, Alex Dow, Alex Hopkins, Alexander Galan, Alfredo Fernandez, Allen Zaki, Allie Smith, Andrea Albertini, Andrea Walker, Andreas Carrere, Andrew Logan, Anne Bannert, Annie Rourke, Anthony Tudisco, April Hughes, Barbara Fialho, Bekah Jenkins, Brenda Tyson, Caitlin Thorton, Charles Laird, Chris Medina, Claudia Charles, Cornelius Danzey, Cory Bautista, Cory Bond, David Eristavi, David Nixon, Damiani, Emma Rudolph, Emmanuel Lafay, Eric Gabriel, Evyan Metzner, Frederic Chiu, Gary Arnold, Gina Licata, Hudson Studios, Industria Studios, J. Horton, Jack Craymer, Jake Standley, James Donovan, Jenke Ahmed Tailly, Jessica Dean, Joe Tripi, John Clendenen, Julia Ferrier, Katie Craymer, Kevin Walker, Kelley Proscio, Kelly Hill, Kelsey Deenihan, Kohle Yohannan, Kristin Dedorson, Lacy Redway, Landon Drean, Lawrence Cassel, Leanne Hirsh, Leslie J. Morava, Lisa Schiffman, Lorandy, Megan Costello, Melanie Demarco, Melissa McGill, Melissa Tolentino, Michele Pryor, Munemi Imai, Natalie McGuire, Niki Taylor, Noah Blough, Pamela Berry, Patricia Martinez, Ptah Shabaf, Qinrui Hua, Rachel Arseneault, Roberto Morelli, Rodney Charles, Ruth Fernandez, Sarah Laird, Sam Stransky, Selita Ebanks, Shintaro Teraoka, Shirley Breaux, Smooch NYC, Stacy Powers, Stephan Rouyer, Steve Bauerfeind, Thomas McKiver, Tricia Sherman, Ubah Hassan, Walker Brockington, Wenky Li, Yasmin Rams, Yazemeenah Rossi, Yumiko Hikage, Zoe Craymer.

I especially would like to thank my patient publishers, Damiani, and in particular Andrea Albertini, who has shown great faith and understanding for this work. I also extend a special thank you to Alexander Galan, without whom I doubt this book would have ever got off the ground.

I have been truly blessed by my wonderful and talented designer Pamela Berry, who has shown inspired artistic judgment and supreme skill in image selection and layout. This would not have been half the book without your guidance and support.

I would also like to profoundly thank my editor Andrea Walker, who has scrutinized and directed my stumbling efforts with the words and helped me to tell the stories of all my wonderful collaborators in the book.

A special thank you to Alex Dow for his unique artistic and technical expertise in helping me to create these images. You have an unparalleled knowledge of the photographic process for creating timeless imagery.

My heartfelt thanks to all at SmoochNYC, for their amazing digital artwork that contributed to the final imagery.

Finally, an eternal debt of gratitude to my wife Zoe and children Jack and Katie, for their endless support and encouragement to follow my dreams.